WILD ART

DAVID CARRIER
JOACHIM PISSARRO

Φ

'SOME PEOPLE BECOME COPS BECAUSE THEY WANT TO MAKE THE WORLD A BETTER PLACE. SOME PEOPLE BECOME VANDALS BECAUSE THEY WANT TO MAKE THE WORLD A BETTER LOOKING PLACE.'

– BANKSY

'THE FIRST QUESTION I ASK MYSELF WHEN SOMETHING DOESN'T SEEM TO BE BEAUTIFUL IS WHY DO I THINK IT'S NOT BEAUTIFUL? AND VERY SHORTLY YOU DISCOVER THAT THERE IS NO REASON. IF WE CAN CONQUER THAT DISLIKE, OR BEGIN TO LIKE WHAT WE DID DISLIKE, THEN THE WORLD IS MORE OPEN. THAT PATH – OF INCREASING ONE'S ENJOYMENT OF LIFE – IS THE PATH, I THINK, WE ALL BEST TAKE: TO USE ART NOT AS SELF-EXPRESSION, BUT AS SELF-ALTERATION; TO BECOME MORE OPEN.'

– JOHN CAGE

'I ALWAYS STRIVE TO CELEBRATE THE BEAUTY IN NATURE AND THE BEST OF HUMANKIND … ARTISTS, TRADITIONALLY, HAVE ALWAYS PROMOTED THE CONCEPT OF THE IDEAL WITHIN SOCIETY.'

– THOMAS KINKADE

'ALL TOO MANY OF US ARE EXCESSIVELY HUMBLE IN FRONT OF ART, FEARING TO MAKE FOOLS OF OURSELVES IF WE ARE UNABLE TO SEE THE VIRTUE OF ONE PIECE OR THE FAULTS OF ANOTHER. BUT OF WHAT USE IS ART APPRECIATION IF IT DOES NOT GIVE VOICE TO OUR OWN PERSONAL REACTION?'

– SISTER WENDY BECKETT

CONTENTS

WHAT IS WILD ART?

'ART OFTEN MEANS NOTHING MORE THAN THINGS DISPLAYED IN GALLERIES, YET THERE ARE ARTISTS WHOSE WORK CAN ALSO BE SOMETHING HAPPENING IN THE STREET, THE DESERT, A VILLAGE, ON THE INTERNET, ANYWHERE … ART IS NOT ALWAYS THINGS MADE BY PEOPLE WHO CALL THEMSELVES ARTISTS.'
– BARRY SCHWABSKY

Wild art is the vast proliferation of art forms that occur beyond the perimeters of the established art world. It is graffiti, car art, body art, ice and sand sculpture, flash mobs and burlesque acts. It is portraits made from bottle tops, dresses made from meat, paintings made by animals, light shows, wild buildings that are more art than function, carnivals, giant artworks that can only be truly appreciated from the air, tiny artworks that sit on a pin head, and so much more.

These are forms of art that tend to escape the attention of art experts, art academics, art curators and art critics. They fall short of catching the eyes or ears of mainstream cultural channels.

Yet these wild forms of art are created by people who should be considered artists, just as the great masters of traditional painting and sculpture are. These are people who have developed considerable skills in their respective media, whether it be the street, a plate of food, a pile of sand or a block of ice, and their creations evoke awe and admiration, just as a visitor to an art gallery might experience.

In understanding what wild art truly is, it is first important to clarify what it is not:

Wild art is not 'outsider art'
Wild art is not 'self-taught art'
Wild art is not 'naive art'

It is simply art that does not fit into the narrow confines of the established art world. The artworks featured in this book are the misfits of the art world. They are often spectacular and frequently provoke strong reactions. Their visual powers are obvious, direct and immediate; some are mesmerizing, some shocking, some weird and some hilarious. Together they all share one common denominator: they do not leave their viewers indifferent. This is what makes them so interesting.

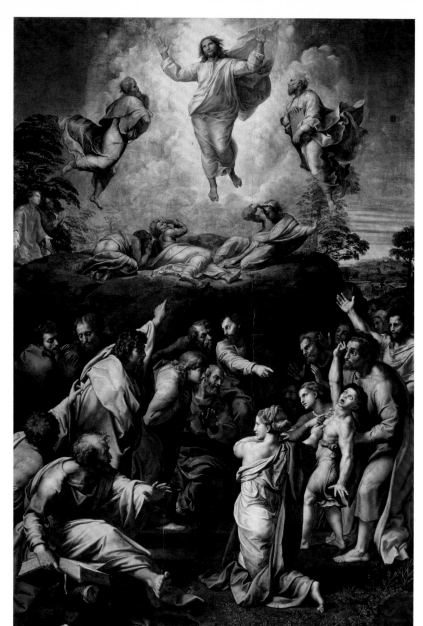

Raphael,
Transfiguration,
Vatican City, Rome,
1516-20

The established art world is much concerned with the changing status of
art shown in art galleries and museums. Critics, curators and collectors
devote a great deal of attention to determining the leading emerging
artists. Their colleagues in art history are much preoccupied with
considering the implications of these judgements for museum collections.
It is a well-groomed world governed by a complex bureaucratic system,
where artistic output is filtered and tamed by 'experts' and then
presented to the wider public through the exhibition system. Works
such as Raphael's *Transfiguration* (1516-20) sit at the centre. There
is constant discussion and theoretical discourse by art historians to
sustain the validity of such works.

By contrast, there is no such system of validation within the wild art
world. It is the wild vegetation to the manicured lawns of the art world.
The vast majority of artistic output – that is, objects created with the
primary goal of aesthetic pleasure – is excluded from the art world and

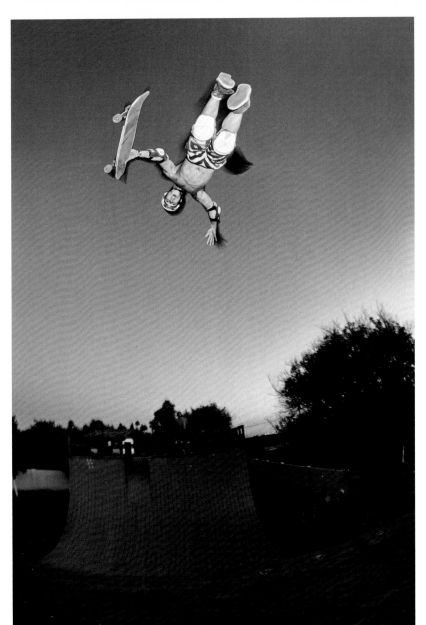

Christian Hosoi,
Trick Christ Air,
photographed by
J. Grant Brittain,
Mesa, Arizona, 1987

never features in art books, galleries or museums. It is largely unseen and under-appreciated. The mainstream art world has trained us to ignore whole genres and species of objects because they do not fit its criteria of acceptability.

We believe that we should not limit ourselves to this established art world, but rather open our minds to the idea that there are multiple art worlds, each with their own system of values, and that it is perfectly possible to appreciate art from more than one world. A viewer can experience the same intense joy from looking at skateboarder Christian Hosoi's awe-inspiring acrobatic *Trick Christ Air* performances as at Raphael's great masterpiece. Artists such as Hosoi do not need the accolades or recognition of the established art world: they are already very successful in their own spheres, but it is to our own cultural detriment if we decide to ignore such wild art because we are trapped within a single monolithic system of artistic values.

This book is not about pitting one world against its opposite, the art world versus the non-art world. That opposition itself is obsolete and irrelevant, for there are not just one or two worlds but multiple art worlds and cultures that produce uncharted streams of artwork. This book's chapters highlight many of these different cultures, each of them producing an extraordinarily diverse array of objects and situations.

These creations, objects and artworks are made in order to provoke some kind of aesthetic response, and if we widen our definition of art to include all works that are created for aesthetic judgement then we enlarge the range of art possibilities. Considering aesthetic experiences in the streets, in restaurants, in toilets, or in temples, on a beach, on the Arctic sea ice - all over the world and in innumerable forms - we see *how much more* there is to be seen than the art displayed in traditional museums.

The chapters in this book broadly follow some of the different strands of creation that we were able to identify during the course of our research, and no doubt more can be found by our readers. Each of these art worlds is constituted in a similar way, each possessing its own criteria of validity and its hierarchical structure. It is as difficult to get to the top of the sand art world as it is to become recognized as the topmost ice artist, a tattoo artist of international renown or a major skateboard artist. The different art forms generate their own culture without any need for recognition from the mainstream art world. Each is the product and reflection of its own vernacular culture: raw, unpredictable and uncontrollable, yet highly competitive, demanding and exclusive.

The lines between art and wild art are of course blurred. Any one of the wild works of art featured in this book could enter the art world. Indeed, for the last century in particular the art world has increasingly 'taken in' artists that were previously excluded. Life within the art world is exciting because of these constant revolutions, in which an aesthetic system is no sooner presented than it becomes obsolete. But what has been maintained through all of these changes in taste is a distinction in kind between the art world and the wild art world. It is that distinction which this book seeks to question. There is no difference between judging a tattoo, graffiti or a sand sculpture and an abstract painting in a museum.

In recent decades the boundaries of the art world have become even more porous. Previously 'wild' art objects have begun to move into galleries and museums and the mainstream art world has, over the past few decades, started to pay lip service to the multifarious forms of the alternative art worlds. Because there can be no set, final and universal criteria defining art, this process has to be understood in historical terms, and in the individual introductions to the ten chapters we explain what might be called the historical logic of each of these wild art categories. In some revealing cases works by individual artists have already penetrated within the mainstream art world. Yet to say that these boundaries are porous is not to signal that they are arbitrary.

A particularly powerful example of how porous, confused and unnecessary the art world boundaries are, can be found at the very onset of modern art. In 1942 Alfred H. Barr, Jr, then director of The Museum of Modern Art (MoMA), New York, proposed acquiring and displaying a decorated shoeshine stand by Italian immigrant Joe Milone on the recommendation of sculptor Louise Nevelson. However, the acquisition was obstructed by the museum's administration, leading Barr to explain his decision:

Joe Milone's shoeshine furniture is as festive as a Christmas tree, as jubilant as a circus wagon. It is like a lavish wedding cake, a baroque shrine or a super-juke box … Yet it is purer, more personal and simple-hearted than any of these. We must respect the enthusiasm and devotion of the man who made it as much as we enjoy the result.

11

Joe Milone and his
shoeshine equip-
ment as included
in the exhibition
'Joe Milone's Shoe
Shine Stand'at The
Museum of Modern Art
(MoMA), New York,
1942/3

The task of this book has been to track down the Joe Milones of today.
Those extraordinary talents, whose imaginary powers exceed the boundaries
of our own imagination, and whose work has largely remained unconsidered.
In this book we explore this extraordinarily vast field – a kind of new
cultural frontier, mostly unmapped, uncharted – and offer a sample of
what might be enjoyed for anyone who keeps their minds and eyes opened.

Working on this book has changed our own everyday experience of visual
life. We have begun to pay more attention to art in the street, to
tattoos and to the myriad other art forms found outside the galleries and
museums. 'There was a time,' Kant wrote, 'when I … despised the common
people, who are ignorant of everything. It was Rousseau who disabused me.
This illusory superiority vanished, and I have learned to honour men.'
Our experience has been similar. We have learned to become 'unsophisti-
cated' art lovers.

'GRAFFITI IS NOT THE LOWEST FORM OF ART. DESPITE HAVING TO CREEP ABOUT AT NIGHT AND LIE TO YOUR MUM, IT'S ACTUALLY THE MOST HONEST ART FORM AVAILABLE. THERE IS NO ELITISM OR HYPE. IT EXHIBITS ON SOME OF THE BEST WALLS A TOWN HAS TO OFFER AND NOBODY IS PUT OFF BY THE PRICE OF ADMISSION.'
– BANKSY

There is perhaps no better, or more welcoming, stage for the recent explosion of wild art than the street. Whether it be its sidewalks or walls, wild art transports itself through the urban labyrinths at the speed of *macrocystis pyrifera*, one of the fastest-growing living things in the world.

Wild art formations have not only taken over the streets, transforming their static urban appearances, but also every possible mode of transportation propelling us from street to street. These modes of transport have become a platform for some often astounding forms of wild art: from subway trains to cars, buses, even surfboards, every *moving* vehicle may be selected – legally or not – as a stimulus for aesthetic expressions that fall out of the ordinary. In this sense, the streets and their available transport can be said to *move us* in more ways than one.

This book's claim is simple: all art forms *may* be worth looking at. With no better place to start than the art of the streets, let us look at *trompe l'oeil* murals in the streets and graffiti on walls. If you keep your eyes open, looking at these two forms of art will soon reveal an unexpected, multifarious depth of complexities, styles and intentions that are worlds apart in terms of techniques, possible support and even audiences.

As Banksy notes, this is art that can reach everyone. There are no limitations on who can see it, financial or otherwise. Ironically, Banksy's own art seems to have become a victim of its success and is now auctioned and eagerly collected. This assimilation into the art world means that his work can no longer truly be considered wild art.

Not everyone is enamoured with this kind of art. Discussions about its aesthetic merits usually devolve into the unsolvable dichotomy of art vs. vandalism. We tend to think of graffiti as a very recent form of creative expression, the product of rebellious minority-youth in the contemporary city, the wild products of 'inner-city kids' (that sociological euphemism that sounds good but means nothing). In fact, drawing on walls goes back to the source of all art, and we know from Latin literature that it was pervasive in the streets of Rome during the early years of the Empire.

However, it was 2000 years later, in the late 1960s and through the 1970s, that graffiti underwent a drastic explosion of scale and style, serendipitously mushrooming globally in all urban areas and their outskirts, and often requiring extreme agility in order to reach their destined, highly visible concrete and metal surfaces. What everyone previously knew as graffiti, the artless stuff found in lavatories or simply scratched in the wall, suddenly became an arena for aesthetic competition between young 'writers', or 'taggers'. In just a few short years New York subway graffiti evolved stylistically from small 'tags'

to bolder, brighter, bigger and better designs, with entire subway cars serving as canvases for masterpieces of aerosol art. Analogous with tattoo artists who etch 'sleeves' of coloured ink on their customers' limbs, the graffiti writers suddenly devoured every single subway car in the New York MTA system, giving each car its unique 'sleeve' of colours, forms and arabesques of all kinds, leaving almost nothing untouched.

Despite its wild points of origin and its lack of recognition among most of the mainstream art world's official agents, graffiti generated its own circles of connoisseurs, critics and champions. Through popular culture, this New York-style of graffiti art spread all over the world, sprouting adherents and imitators from Paris to Tokyo, Los Angeles to Buenos Aires, blending with local styles, each with their own interpretation.

Besides the New York-style, spray-can graffiti, which is mainly focused on letter-forms and is essentially a very stylized, large-scale form of calligraphy, many other types of art take over the streets, from icono-graphic imagery, stencils, stickers, three-dimensional sculptures and conceptual street art to tech-savvy, laser-beam graffiti.

A common feature of most streets is of course the motor vehicle. In 2010 the global number of cars has for the first time jumped to over a billion vehicles. China boasts the second largest car population, with 78 million vehicles, while the United States continues to have by far the largest vehicle population in the world, with 239.8 million cars. While these figures are obviously the source of legitimate environmental concerns, they also indicate that the automobile is one of the most prevalent objects on the planet, and as such acts as a mirror for the personal aesthetic preferences of owners and drivers.

If we consider that just one per cent of these vehicles worldwide provide a support, or a channel, for some kind of personal message, aesthetic expression or any kind of artistic creativity, a staggering ten million motor vehicles, in some way or another, carry art. They convey an artistic message before they convey their passenger load. Banal utilitarian vehicles thus become movable paintings and sculptures, expressions of personal taste.

Cars are the perfect vehicles for wild art because in addition to the exponential burst in production of cars, the world also now knows the largest population of car carcasses: the phenomenon of obsolescence in cars is very rapid and has obvious economic implications. It is very tempting for a large number of car owners, all the more so if they are gifted as mechanics, to want to meddle with these mass-produced metal creatures to express their own innermost personal aesthetic.

Of course, art in the streets is not just limited to graffiti and motor vehicles; it can take a range of other forms too. Art on surfboards is closely akin to forms of street art in that it is a mode of personal expression on an object whose primary function is not aesthetic, but which can nevertheless be used very successfully in this way.

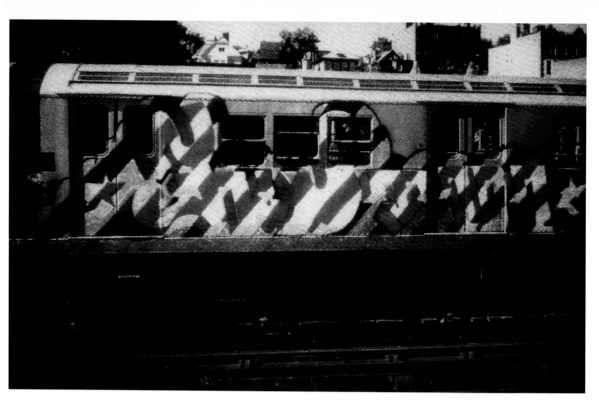

This rather dated photograph still manages to hint at the stunning and meticulously designed three-dimensional striped masterpiece by Flint 707, which was painted in the summer of 1973. The use of perspective and shadow gives the illusion that the letters are protruding from the train's surface, making them 'pop'. Flint was in his teens when he painted this revolutionary piece, which inspired the work of many other artists such as SuperStrut, Phase 2, Riff 170, Purple Haze 168 and Killer 1.

The work of the LA Fine Arts Squad, *Isle of California*, which dates from 1971-2, is located at 1616 Butler Avenue, just south of Santa Monica Boulevard in Los Angeles. The painted mural is a venerated form of public art with a long history, from the Florentine frescos to the Mexican muralists. The LA Fine Arts Squad (Victor Henderson, Terry Schoonhoven and James Frazan) wanted to bring painting out of elite galleries and into the streets. They considered their murals a form of 'street theatre'. But rather than an uplifting subject matter as favoured by many community murals, this scene depicts the nightmare of many Californians, the Golden State being swallowed into the sea in a post-'Big One' earth-quake disaster scene.

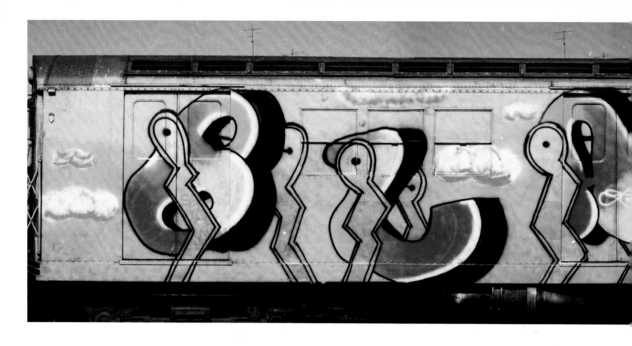

Blade is one of the most respected master writers of the subway graffiti movement. This 'swinging letter', whole-car masterpiece ran in the summer of 1980. The innovative design showed the letters of his name swinging on hinges, as if the subway car was a carnival ride.

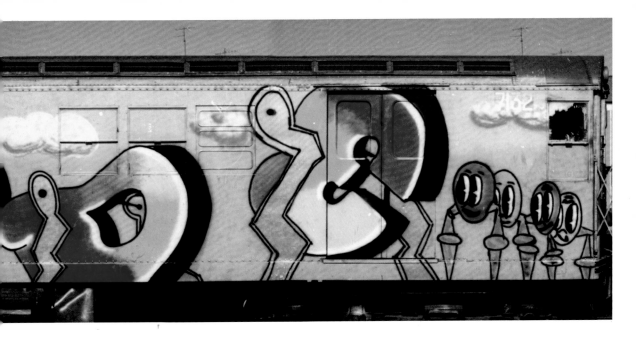

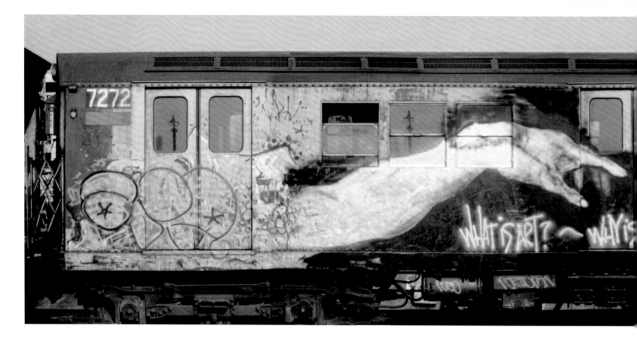

What is Art, Why is Art? was a New York subway train painted by the graffiti artist Chris 'Freedom' Pape in 1983. This piece, his 'farewell train' to subway graffiti, references Michelangelo's Sistine Chapel ceiling and lasted only a week before the Transit Authority had it removed. Pape is now a leading expert on the history of New York subway graffiti and maintains an extensive archive.

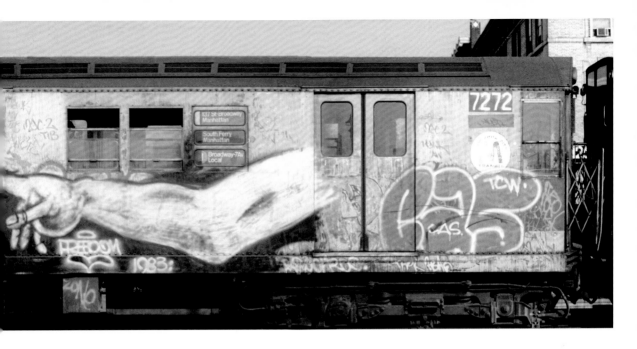

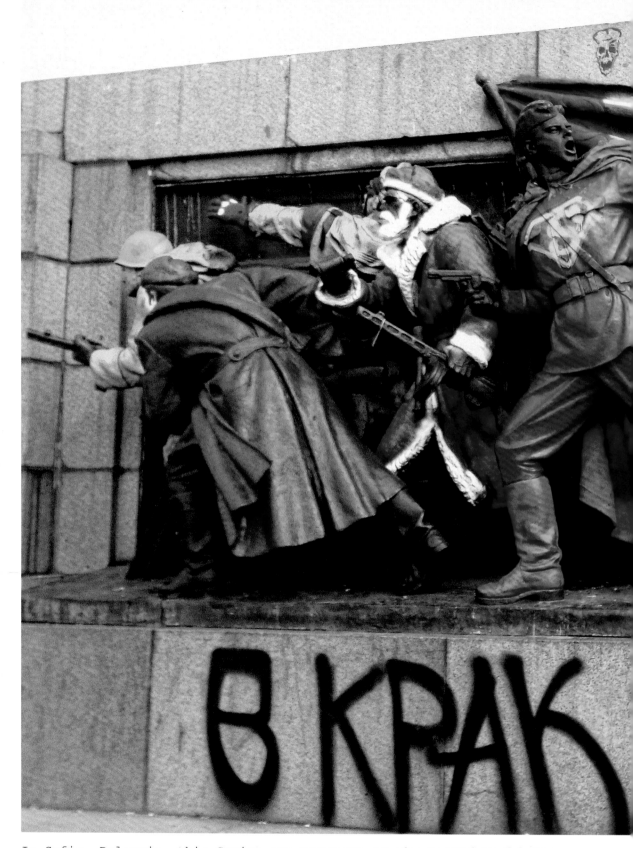

In Sofia, Bulgaria, this Soviet-era monument to the Second World War
attracted new-found attention when an anonymous street artist spray-
painted the soldier figures to resemble a legion of mythological American
icons: comic-book characters or pop culture effigies ranging from Santa
Claus to Ronald McDonald and Superman. The artist seems to have intended
to 'update' this war monument to reflect Bulgaria's current capitalist
obsessions, as his slogan below reads, '*In Step With The Times*'. It is
interesting to note the political charge of this impressive work, which

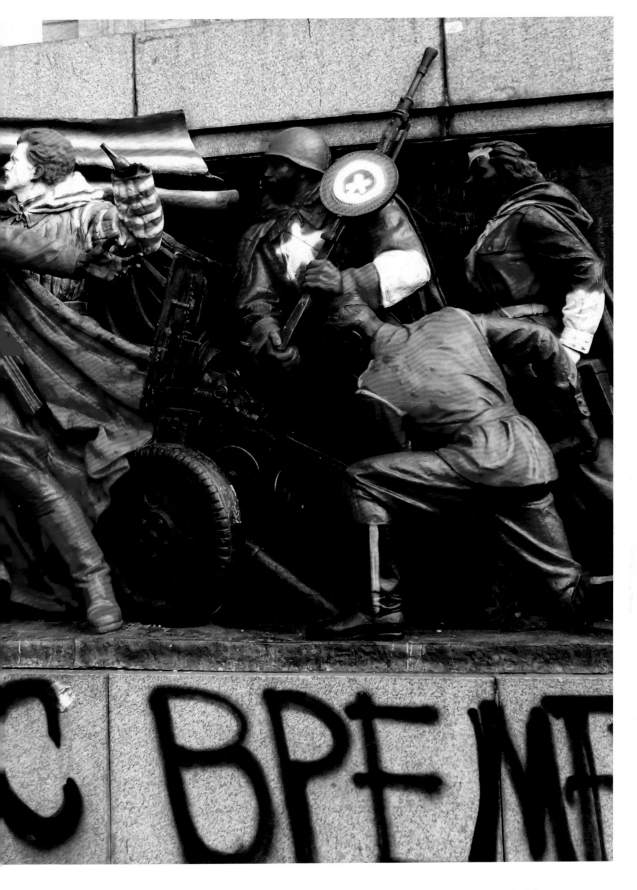

demonstrates how graffiti can been used across the world to deliver
caustic, bitter messages against ruling systems. In this instance,
a sophisticated public intervention conveys that there is not an exit
out of the Americanization of world culture, suggesting that the real
victors of Stalingrad in December 1942 were not the Soviet Red Army,
but a band of characters whose existence is the product of American
dreams and fantasies.

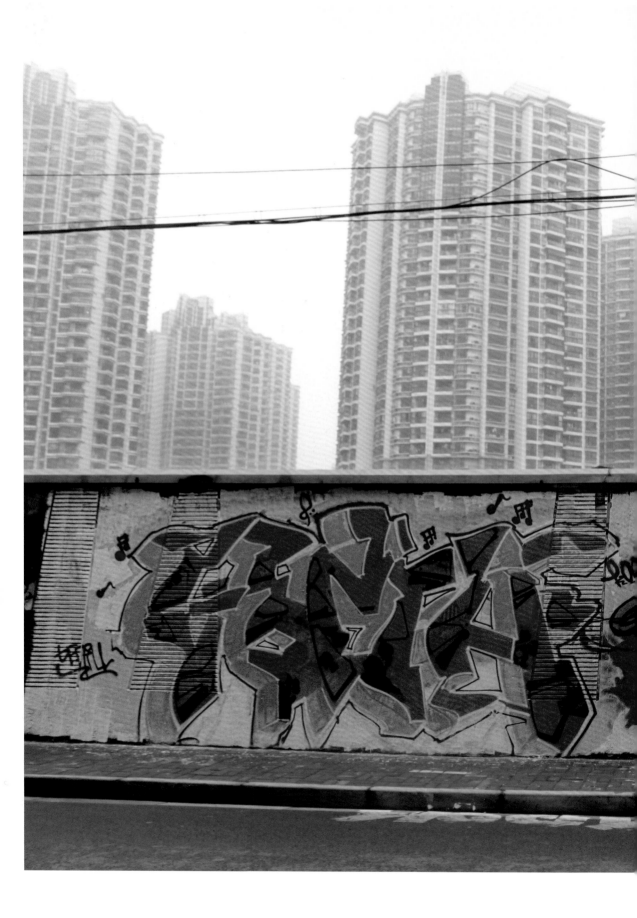

New York-style graffiti spread throughout the world as a global youth culture often connected to hip hop music. Graffiti is even found in China, where careful controls frame and limit all political protests. Geniu and Which painted this piece in Beijing in 2010.

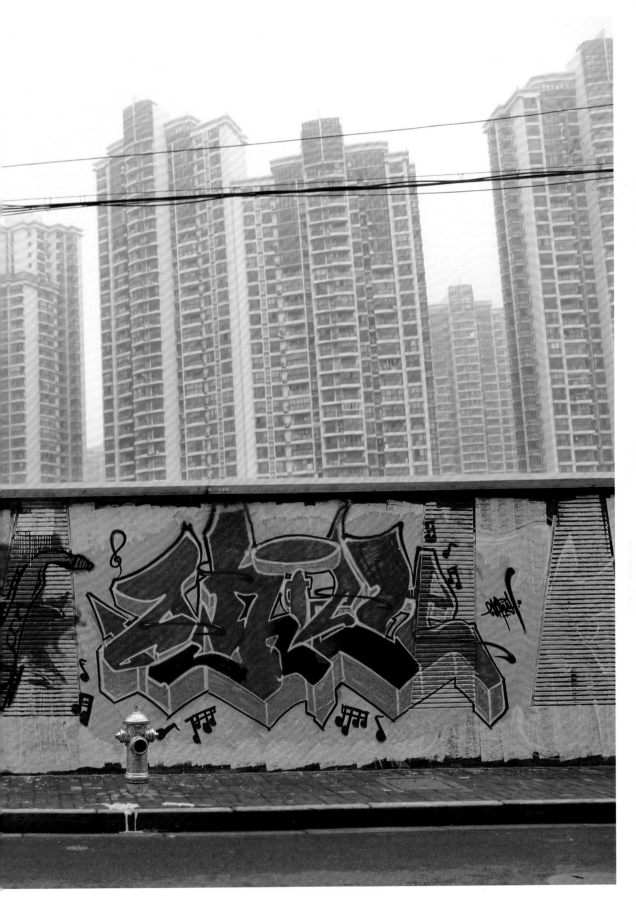

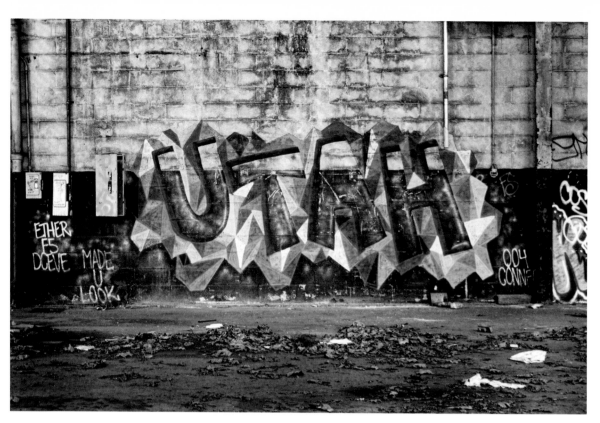

'MADE U LOOK' is what the graffiti writer, Utah, wrote next to this double-take-inducing piece found on a wall in Queens, New York. This clever design incorporated the distinct look of the wall into the letters themselves – an unusual take on graffiti, which usually seeks to cover, rather than reveal. In 2009 Utah was caught and sentenced to jail for her graffiti, ultimately serving twelve months. After her release, when asked about what she thought about graffiti she replied: '*Um, I think it's awesome! Wait, is that the wrong answer … darn, a year in jail and I still can't get it right … Seriously though, I don't feel any differently about it than I did before. Which is to say I don't really feel any way about it, beyond that it's a super fun thing to do.* '

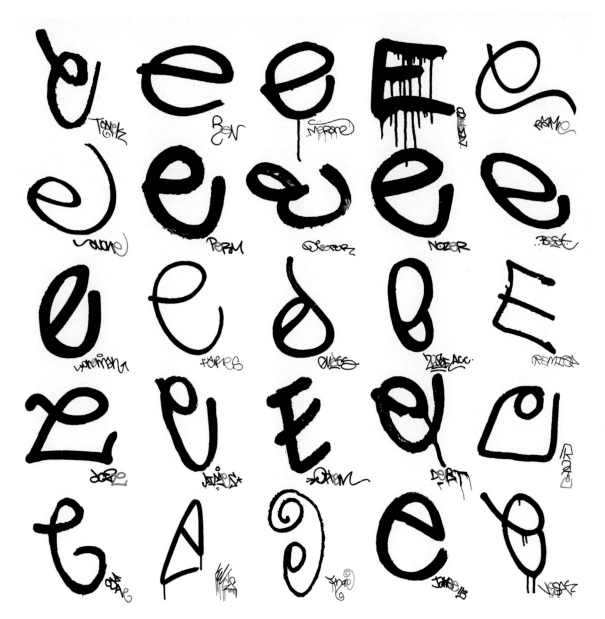

A key feature of New York-style graffiti is the 'handstyle' of lettering, which is unique to each artist. Individual characters are deconstructed, flourished, embellished, distorted and disguised. Evan Roth undertook a study of handstyles in Paris, showing the diversity of forms in the simplest (and most underappreciated) form of graffiti - tagging. His resulting work, *Graffiti Taxonomy*, was exhibited on the glass facade of the Fondation Cartier pour l'Art Contemporain as part of the Paris museum's, 'Born in the Streets' exhibition of graffiti art in 2009. Here we can see examples of the letter 'e'. Roth's work briefly allowed this wild street art to find a place in the established art world.

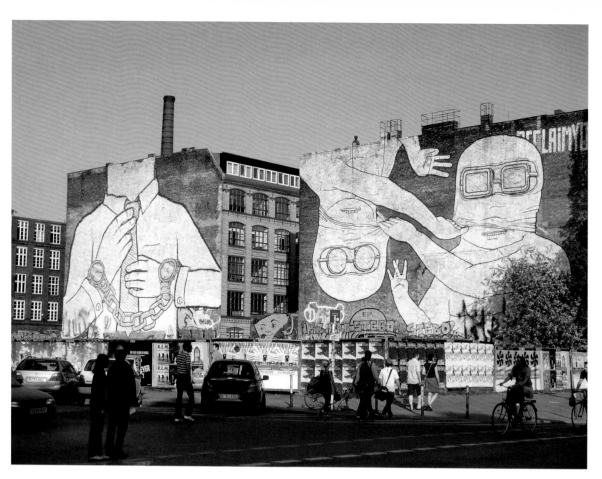

Argentina-born, Bologna-based artist Blu is known for his massive murals, often with nuanced political messages. The scale of his works is made possible through the collaboration of helpful friends, and the use of vast amounts of house paint and telescopic rollers. The artist has participated in some gallery shows, but prefers to paint directly for the public. This work, in the Kreuzberg area of Berlin, was made in 2008. Blu's work often provokes controversy, and he recently clashed with the art world when he was invited to create a large outdoor mural for the Los Angeles Museum of Contemporary Art's 'Art in the Streets' exhibit. Due to the unsubtle political content of his mural (it depicted the coffins of soldiers draped with dollar bills) and its potential for upsetting the community nearby (it faced a hospital for veterans), it was abruptly ordered to be painted over by the museum's director Jeffrey Deitch. Blu subsequently refused to paint a new mural.

This prohibitively tall piece of street furniture was illicitly installed for one day on a street in New York by the artist Brad Downey. By wearing 'official' construction-worker clothes, he was able to bolt down his sculpture *Take a Seat* without attracting attention. Downey has created street furniture installations in cities around the world, from London to Atlanta. He is also a filmmaker and street art advocate; he has produced a street art documentary and regularly lectures about unsanctioned artwork.

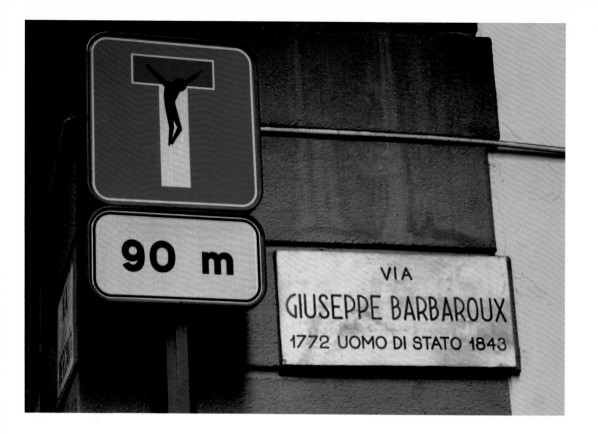

Some of the most successful street art uses the language of municipal signage to create powerful juxtapositions. The French-born street artist Clet Abraham, who has made his interventions in Florence a common sight, turned this street sign into a crucifix. '*Street art, or guerrilla art, needs to be reinvented in dialogue with the Renaissance city,*' he says. He views his art interventions as 'gifts' for the public.

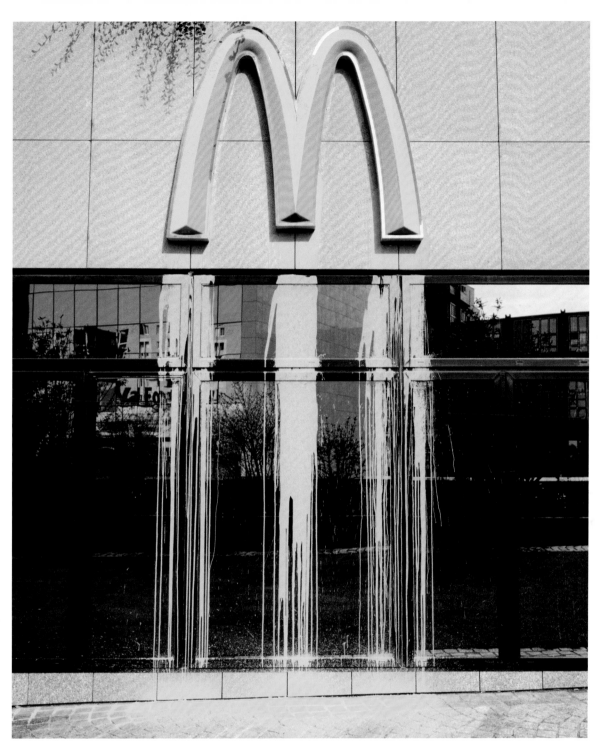

The French artist Zevs creates interventions or installations in the
street, blurring the line between vandalism and art. This simple yet very
political gesture calls into question the ever-pervasive McDonald's logo;
here turned into a 'liquidated logo'. Like the 'updated' Second World
War Memorial in Bulgaria (*see pages 22-3*) Zevs's intervention, using this
ubiquitous symbol of Americanization, reflects the widespread sentiment
of resent directed towards the perceived global 'All-American' corporate
takeover. Zevs is not, however, only concerned with political gestures,
but with form as well. Here he pays close attention to the colour and
shape of the McDonald's sign.

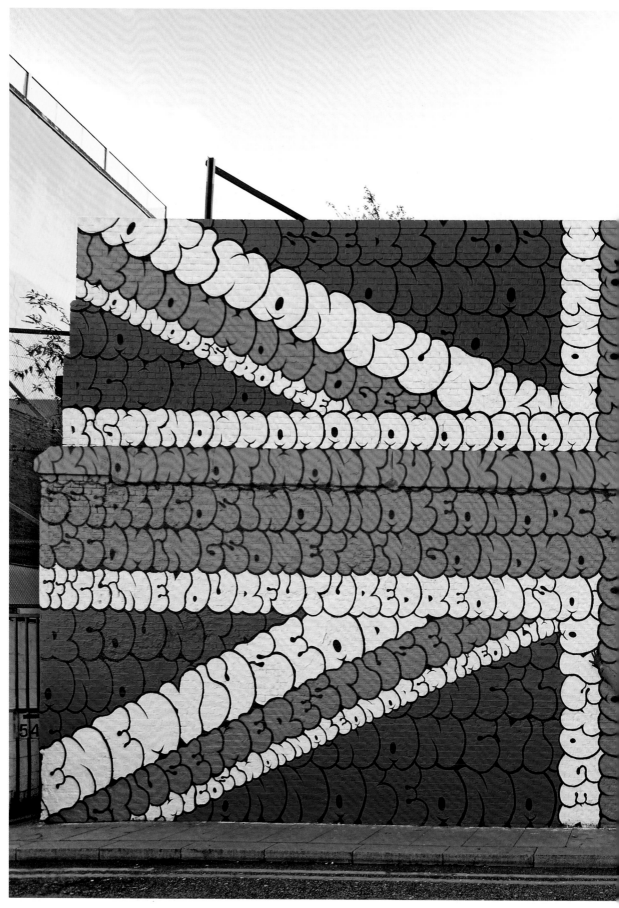

Anarchy in the UK was created by graffiti artist Tilt (*see also pages 312 and 437*) on a brick wall in London in 2012. The work measures an impressive 10 x 22 m (33 x 72 ft).In 2012, thanks to the Queen's Diamond Jubilee and the London Olympic Games, the Union Flag was highly visible and widely utilized in all forms of art, both established and wild.

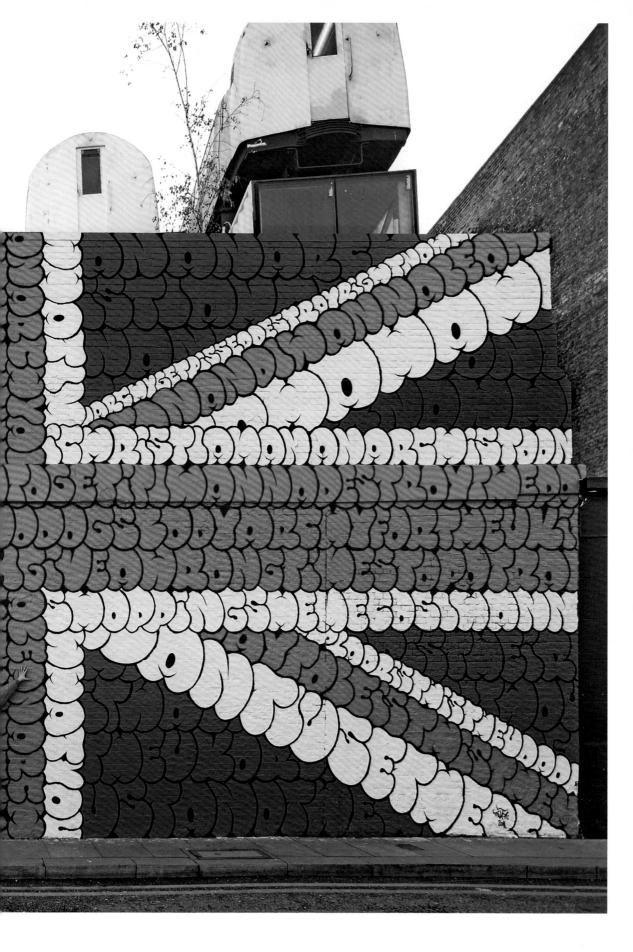

Göla Hunden, Paulo Auma and '2501' painted this children's school in Palestine. As with the previous examples, street art readily serves to illustrate causes that carry a harsh political edge, or depict bleak realities with great potency and immediacy. Here, the artists depict

strange animal hybrids in a comment on the dangers of genetically
modified food, but the enjoyably bright, carnivalesque colours render
the political matter implicit rather than forced. Hunden and Auma have
collaborated on many such murals in a project entitled *Hibrido* (Hybrid).

Street art tends to respond to the site where it is created. Here, artists have populated the deserted city of Pripyat, near the site of the nuclear disaster at Chernobyl in the Ukraine, with poignant, bitter-sweet pictures of laughing and playing children, often depicted as mere

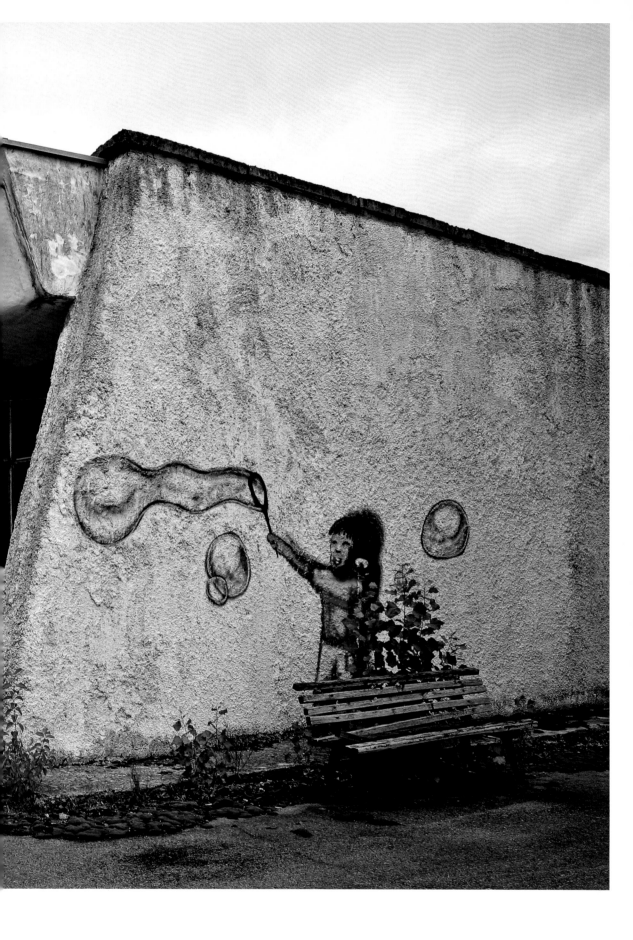

shadows. The artists were a group of anonymous tourists, who, in 2006, took advantage of their tour guide and used the opportunity to create these paintings.

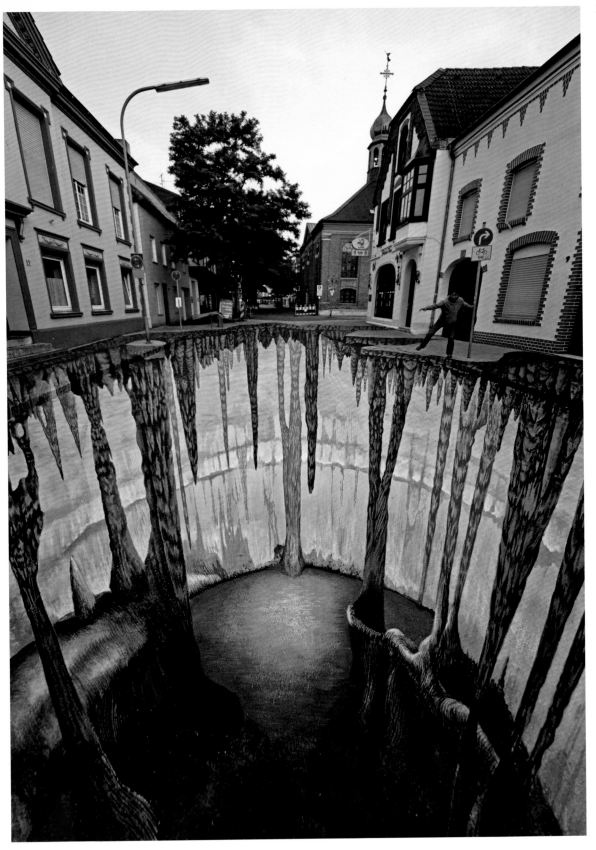

Edgar Mueller's 'Cave Projects' employ an illusionistic *trompe l'oeil* technique using just chalk on pavements. This giant fissure was created in the German town of Geldern in August 2008. Mueller has won numerous international street painting competitions and holds the title of *maestro madonnari*, or master street painter, an honour only very few artists hold worldwide. The tradition of the *madonnari* dates back to the Renaissance in sixteenth-century Italy, when itinerant artist-pilgrims painted pictures of the Madonna on city streets.

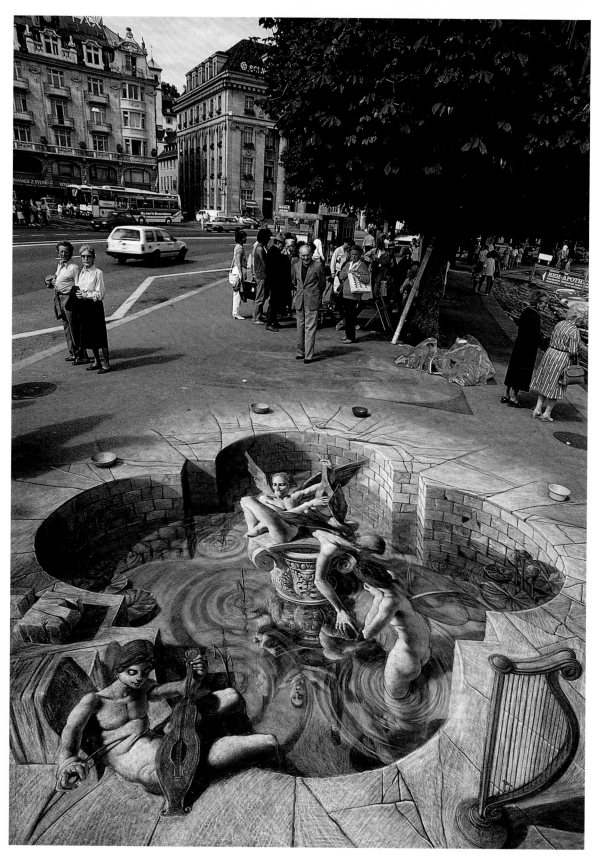

The technique of three-dimensional anamorphic street painting was
invented by artist and former NASA-employed scientific illustrator
Kurt Wenner. In the early 1980s Wenner gave up his career at NASA in
order to live in Italy and study painting. Inspired by the imposing
mannerist frescos in the Italian palazzi, his street paintings explore
Classical and Renaissance themes through original compositions that
play with perspective and distortion. This painting, *Muses*, was made in
Lucerne, Switzerland in 1985, and was featured in National Geographic's
documentary entitled 'Masterpieces in Chalk'.

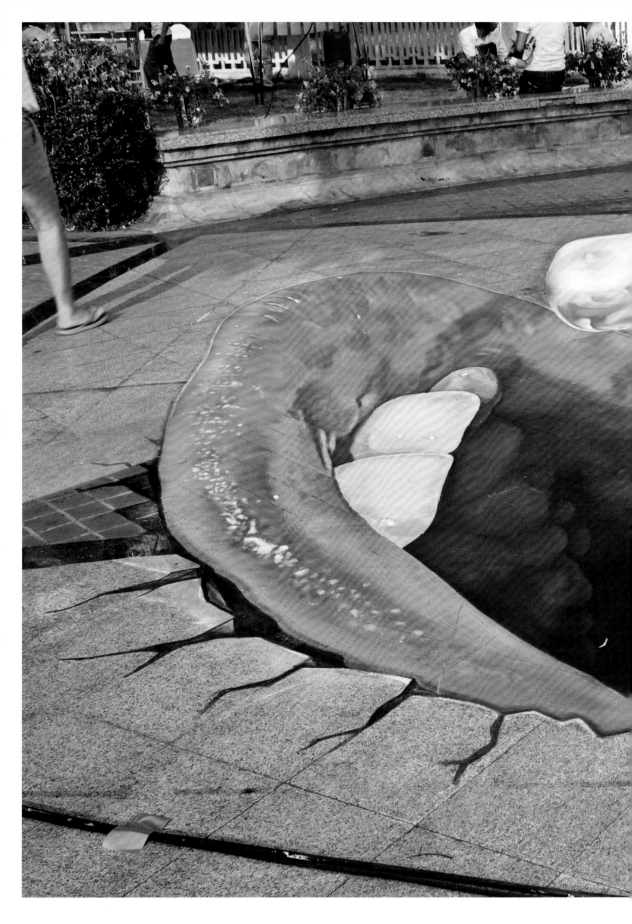

Some pavement art depicts scenes inspired by Classical painting styles while some, such as this three-dimensional image from the street festival of Chiangmai, Thailand, presents images that are more reminiscent of the work of pop artists. Here, the green and white pill, seemingly floating above the lips, appears ready to be swallowed!

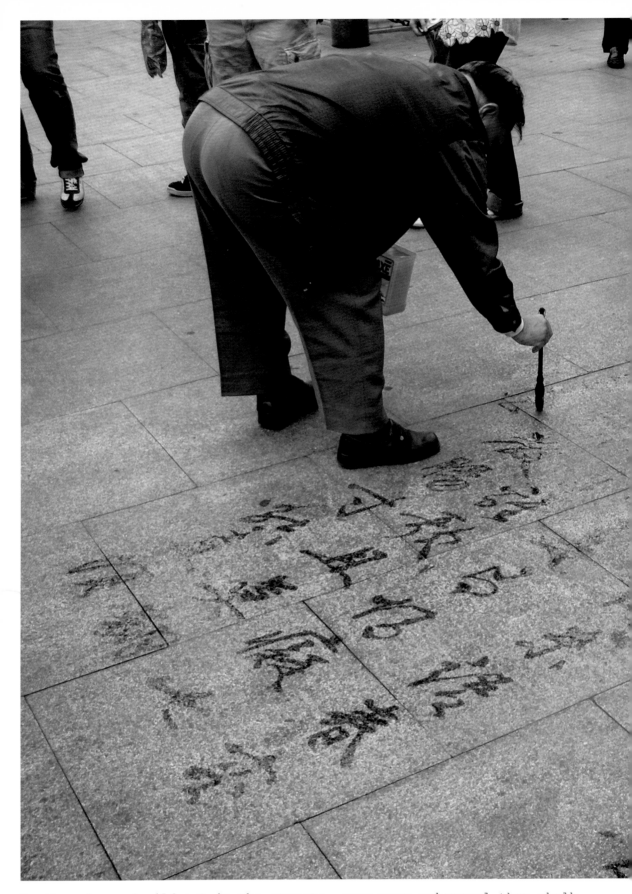

Another form of wild art in the streets, even more ephemeral than chalk art, is the traditional Chinese technique of writing with water. Every literate Chinese person will have been taught the complex rules required to write Mandarin. By writing words in public, which disappear very quickly, these wild artists create a subtle statement about the role of censorship in the People's Republic of China, even if they are not making explicitly political statements.

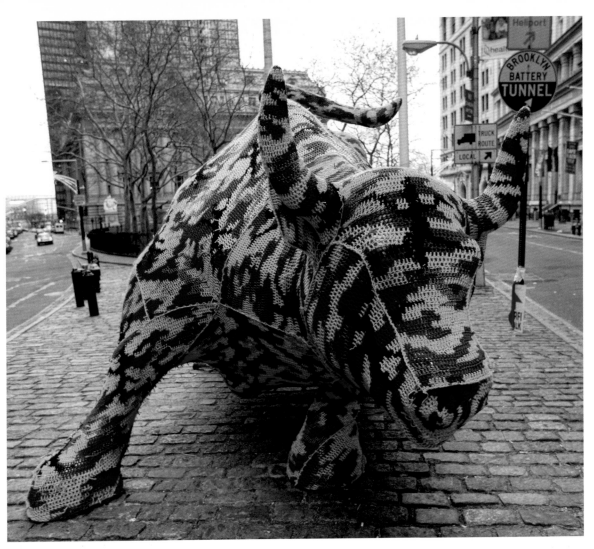

On a quiet Christmas Eve in 2010, Agata Oleksiak, known as Olek, covered this aggressivly masculine statue on New York's Wall Street with a crocheted pink and purple yarn in a camouflaged pattern. The yarn was pre-made in panels, with long socks for the horns and tail, which she then stitched together at high speed on-site to cover the whole statue. Olek has since created crochet coverings for another monumental piece of public art: in 2011 she crocheted a cosy covering for the rotating cube on Astor Place, New York. Olek passionately defends her art form to those who don't fully understand it 'I don't yarn bomb, I make art'. She has also wrapped entire installations and even covered live performers head-to-toe in knit.

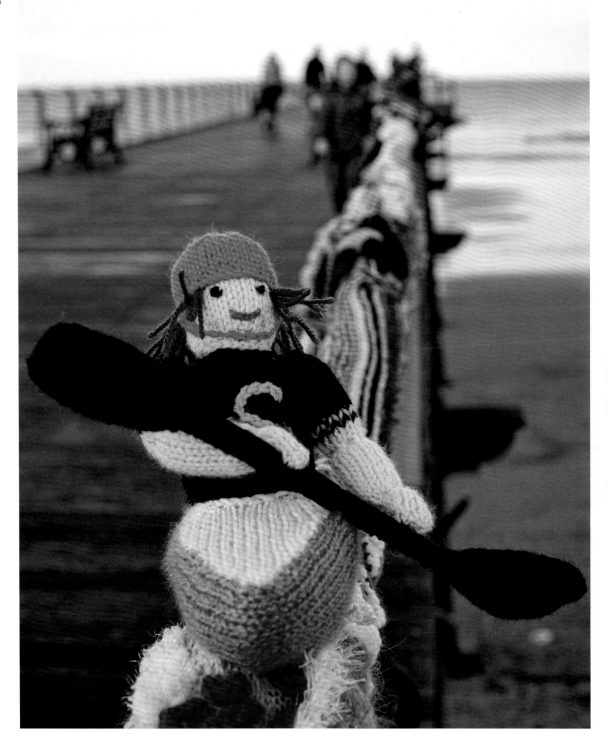

This example of wild art is from the seaside town of Saltburn in North Yorkshire. One night during the London Olympic Games in 2012 an anonymous artist attached this 50 m (164 ft) knitted artwork to the town's Victorian pier. It features carefully rendered figures taking part in all the Olympic sports, from cycling to synchronized swimming to rowing, shown here. This is not the first time that the so-called 'Saltburn Yarnbomber' has struck, having previously decorated lamp posts, railings and buildings in the town with knitted figures. To date, the identity of the artist is still a mystery.

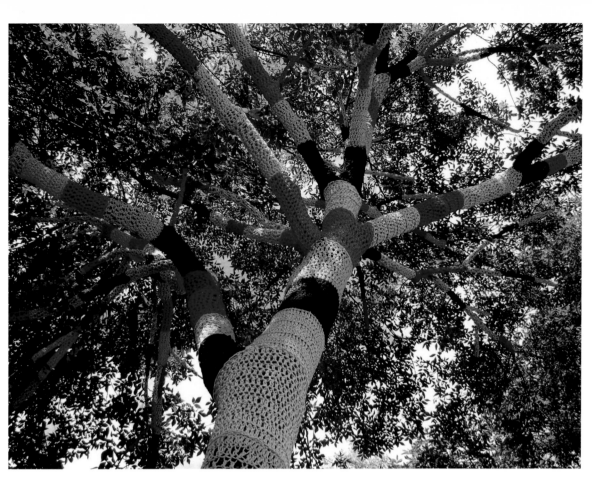

Carol Hummel's 2005 *Tree Cozy* in Cleveland was a crocheted covering for a tree's trunk and branches. Colourful, humorous and clever, the work intervenes and imposes a traditional form of women's work onto the urban environment using the language of street art, typically a male arena. Her work has the effect of softening the environment, evoking nostalgia for handmade goods and the comfort of a protective blanket while inducing a feeling of intimacy within the public realm.

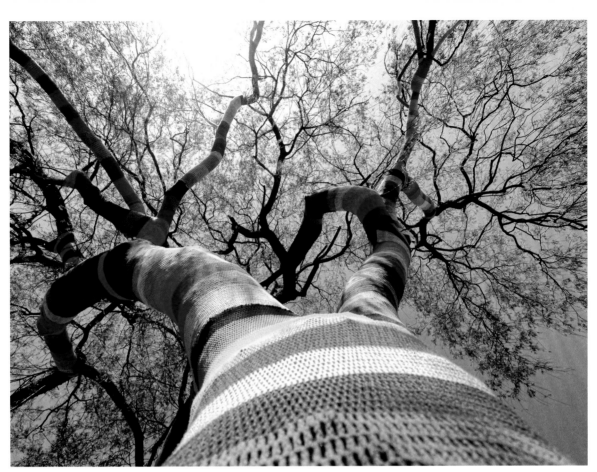

This tree 'sweater' artwork, known as *Weeping Willow*, was created by Ute Lennartz Lembeck and displayed in the town of Velbery, Germany, in 2011.

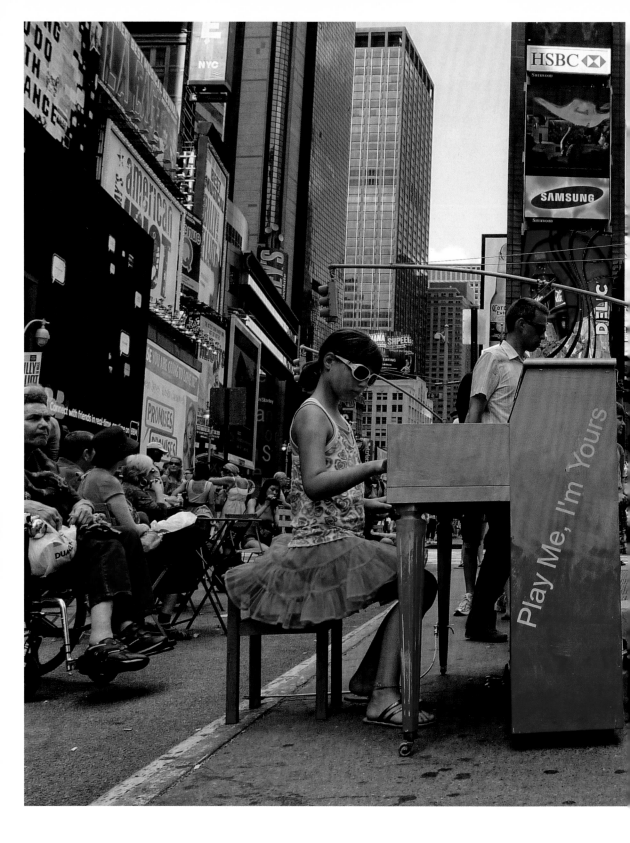

Play Me I'm Yours is a public interactive artwork by Luke Jerram. In parks, squares, bus shelters, train stations and outside pubs and football grounds, over 400 pianos have been installed in cities around the world. The public is invited to play, decorate and enjoy the pianos however they wish. Here, interestingly, a municipality acts in anticipation of the public's spontaneous creative verve, placing instruments at the disposal of 'everyone' in order to give form to these sudden bouts of inspiration. Jerram gives a platform to Joseph Beuys's much quoted, but often unheeded, statement: *Jeder Mensch ist ein Künstler* (Every Person is an Artist).

Sometimes street art is sold right outside museums and galleries.
In New York, the entrances to the Museum of Modern Art (MoMA) and the
Metropolitan Museum of Art contain many similar displays to the one shown
above. It is astonishing to watch the response of the public coming
out from the art institution to face these rows of wild street art. The
range of expressions - from total indifference to indignation, as well as
displays of open contempt - show just how varied people's responses to
wild art can be: as varied as the responses to art in museums.

Art in the streets appears over all continents and countries: here
we are in the streets of Ortakoy, Turkey. Vendors here used to peddle
Byzantine-style icon replicas; today their range of artefacts embrace a
multitude of images of global icons. In this scene, Che Guevara, Charlie
Chaplin and Marilyn Monroe are seen in the propinquity of an icon of
a saint painted on stone. These throngs of cultural icons, holy next
to secular, all vie for the aesthetic contemplation of their buyers.
They also exemplify the threads of a weirdly common global culture: the
juxtaposition of a portrait of Sitting Bull, the famous holy man, next
to what looks like Raphael's *Madonna and Child (The Ansidei Altarpiece)*
that sits under the gaze of a portrait of Ataturk, form the most unlikely
possible association. Yet this mass of undifferentiated portraits offers
a powerful indication of the hugely diverse pool of iconic images that
can become subjects of aesthetic curiosity and contemplation on a street
corner in Ortakoy.

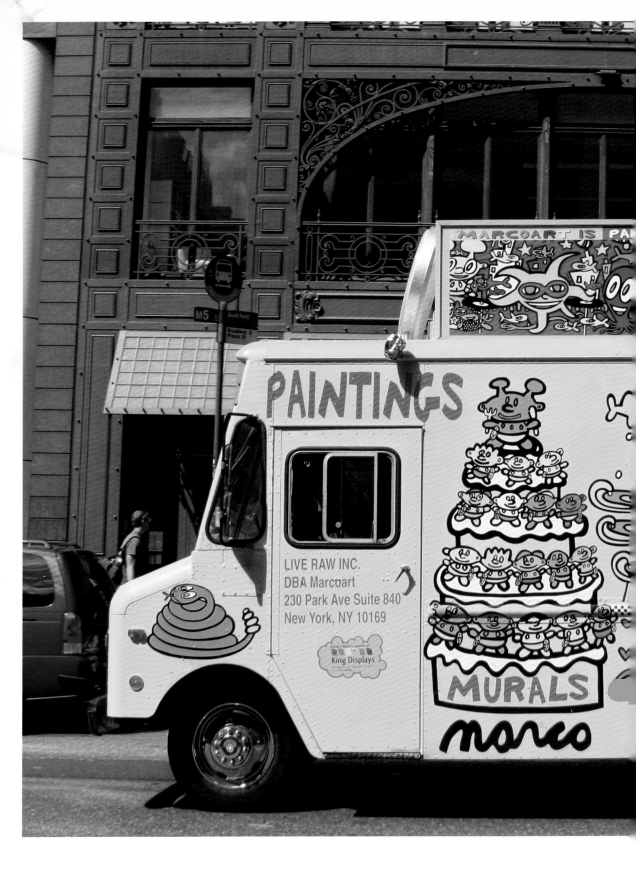

In the vicinity of the well-polished Chelsea art galleries of Manhattan, a movable museum such as the Marco art truck is an eye-stopper. Created by a wild artist, this former bread truck was transformed into a four-wheeled art store. *'There are so many food trucks around now, so I thought I would riff off that,'* said Marco, 42, from inside his truck, here parked in the Tribeca area of Manhattan. *'You order the burger; the guy makes the burger. You order the art; I make the art.'*

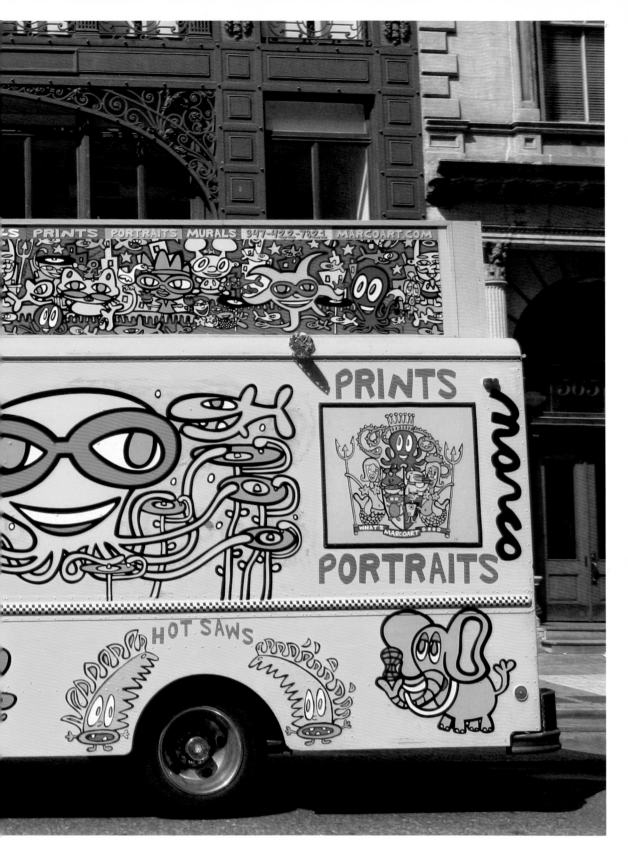

The art world fiercely defends its boundaries. When Eric Doeringer
started selling art 'bootlegs' – cheap versions of signature-style paint-
ings by other artists – in the Chelsea neighbourhood of Manhattan, art
dealers called the police, treating him as if he was selling fake Rolex
watches or Louis Vuitton bags. Indicative of its pervasive, twisted
self-irony (provided it remains under control), the official art market
adopted Doeringer's cheeky pastiches and he found himself invited to sell
his bootlegs at contemporary art fairs, such as Scope Art Fair in Miami,
Basel and New York. The art world loves provocations of all kinds, but
it has to absorb them, digest them and turn them into a production of
its own. Doeringer is now a figure *de rigueur* in the coolest fringe art
fairs: he is photographed here at Geisai Miami in 2007.

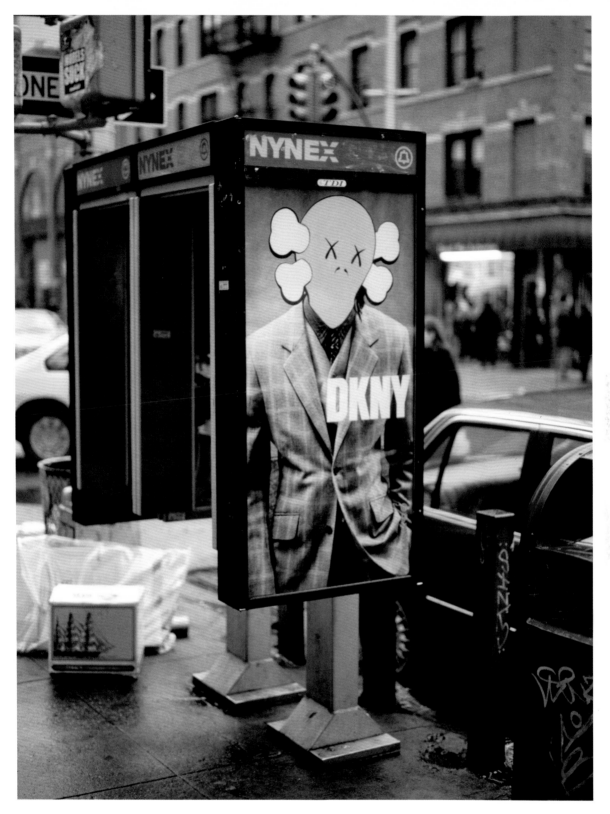

Some street artists use corporate advertising to their advantage. In this phone booth intervention from 1997 New York, Brian Donnelly, aka KAWS, famous for his blend of graffiti and slick commercialism, extracted a DKNY fashion poster (originally by Nathaniel Goldberg) and took it to his studio where he carefully painted his signature cartoon skull over the model's face. He then took it back to the phone booth and replaced the poster. The result looked perfectly natural. '*I painted with no brush strokes,*' said Donnelly, '*clean and unobtrusive, as if it were part of the ad. I wanted people to think that what I did was actually part of the ad campaign.*'

Graffiti Research Lab (GRL), consisting of James Powderly, Evan Roth and Theo Watson, uses high-tech tools such as laser beams to create graffiti. GRL offers its technology for graffiti innovations to the public for free, as open-source software. These colourful LED light magnets, called 'throwies', are one of GRL's simpler graffiti forms. To create them, all you need are some LEDs, available at any hardware store, batteries, magnets and masking tape. They can then be attached to metal as interactive street art. As this example from Gijon, Spain, in 2007 demonstrates, when the public is offered an opportunity to express themselves anonymously on walls, a burst of profanity is almost always inevitable!

Not only can trains be canvases for wild art, they can also be used to display art, as here. Tristan J. M. Hummel was the man behind Art of Track, a mobile art gallery on board a moving Chicago train. One night each year, an entire train car is given to an artist as his/her creative platform. The car then travels the Chicago system bringing art to the travelling public.

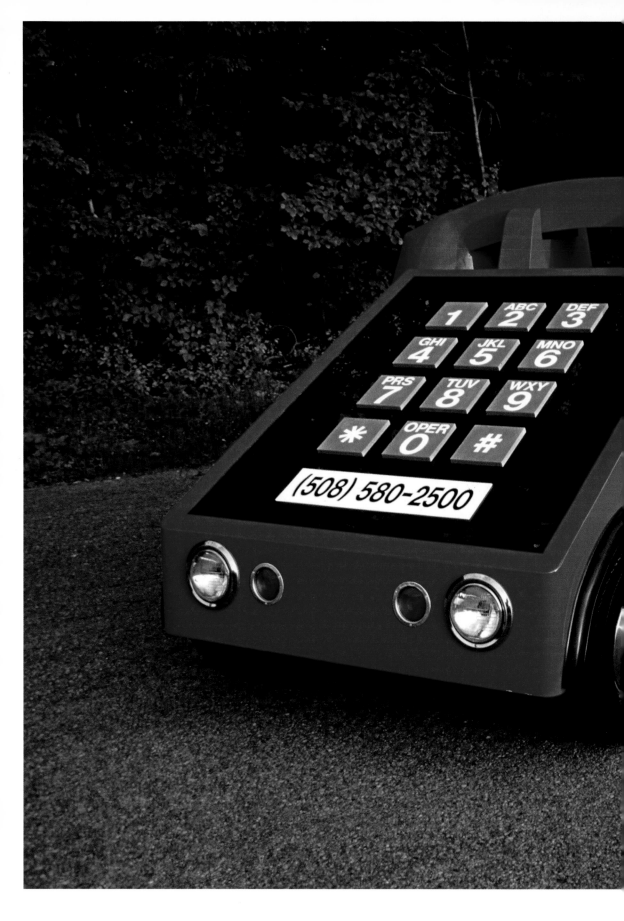

This stunning car phone (pardon the pun) belongs to Howard Davis, who is the owner of phone company Datel Communications. He built the car as a marketing tool, to transport his company's superhero-inspired character Teleman, who works tirelessly to ensure that phone bills are kept to a minimum. The original car was a blue 1975 Volkswagen Beetle and this

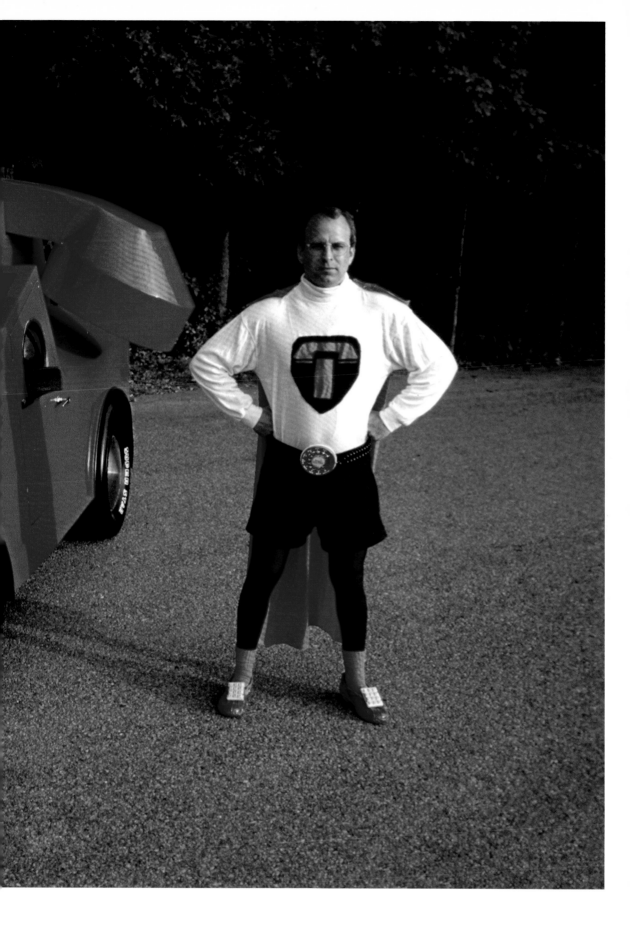

version is, unbelievably, fit for the road. The devil is in the detail: the tinted windshield doubles as the keypad of a touch-tone phone, and even the horn has been modified to sound like a telephone ring. This is marketing art with aplomb. Not so sure about the shoes, though!

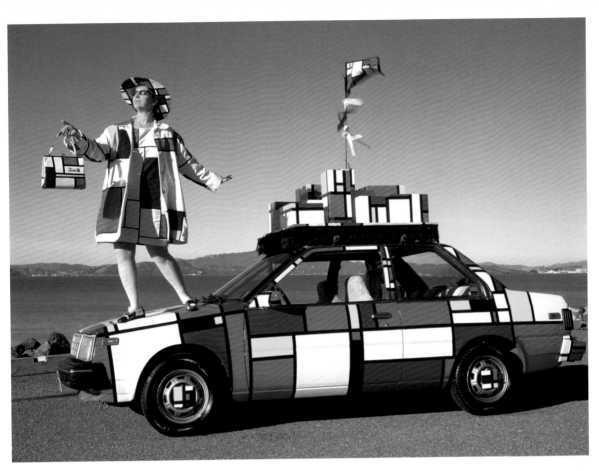

In this image of the *Mondrian Car*, the artist's famous lines and primary colour motifs are used to form an instant mobile reference. It is a spectacular example of art history and popular culture merging into one another. This mini mobile art museum speaks volumes about the popular legacy of one of the most enduring modernist artists. Unsurprisingly, many art historians who specialize in this artist tend to look upon such art forms with disdain, and lament upon such demonstrations of poor taste; the license plate itself reads 'MNDRIAN'.

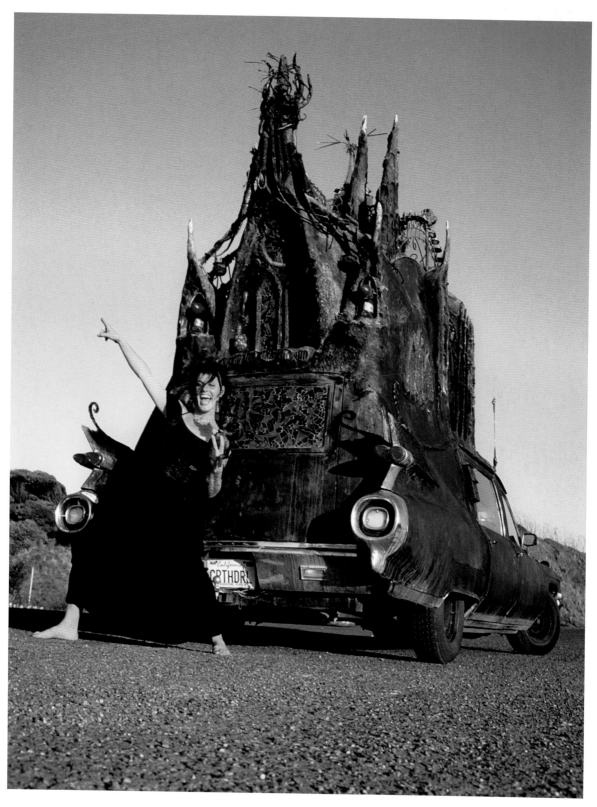

Carthedral is an awe-inspiring medieval architectural marvel on wheels. The car, especially in this image, recalls all manner of religious and mythological history. It is constructed out of a 1971 Cadillac hearse modified with 1959 Cadillac tailfins, and welded on top is a Volkswagen Beetle. *Carthedral* is essentially a fantastical Gothic cathedral on wheels complete with flying buttresses, stained-glass arched windows and gargoyles. The structure was conceived and constructed by Rebecca Caldwell.

British artist Sara Watson spray-painted a Skoda Fabia to give it the chameleon-like ability to blend into its surroundings. '*I was experimenting with the whole concept of illusion but needed something a bit more physical to make a real impact*,' said Watson on the conceptual background of *The Invisible Car*, 2009. '*People have been stopping in the street to look, and coming up and almost bumping into it, so it's had the desired effect.*' This phenomenally decorated, conceptual art car could give James Bond a run for his money.

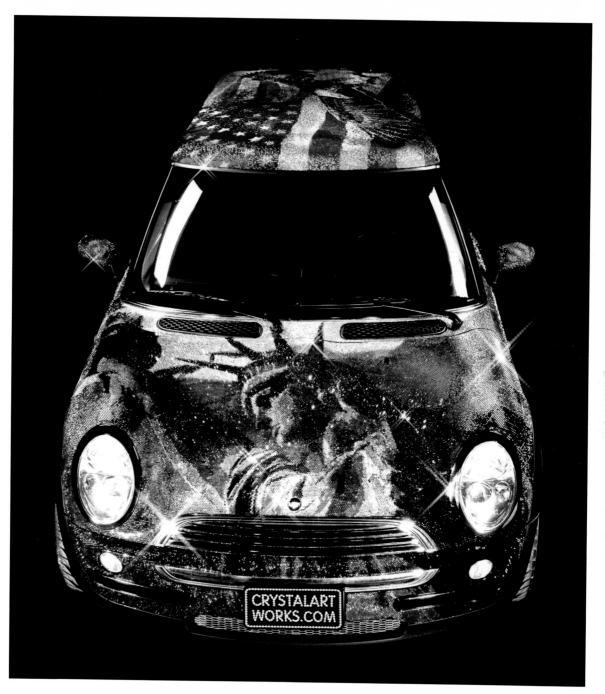

CRYSTALART
WORKS.COM

The tricked-out, pimped-up, glittering car *American Icon* depicts iconic images of the United States. Created by Ken, Tristan and Annie Burkitt, it took six months to stud this special Mini Cooper with shimmering Swarovski crystals. This has to be one of the most blinding and fantastically customized cars anywhere. It is the ultimate statement in vehicular customization, a trend that has seen owners of means, from rock stars to music icons, stylize and personalize their rides.

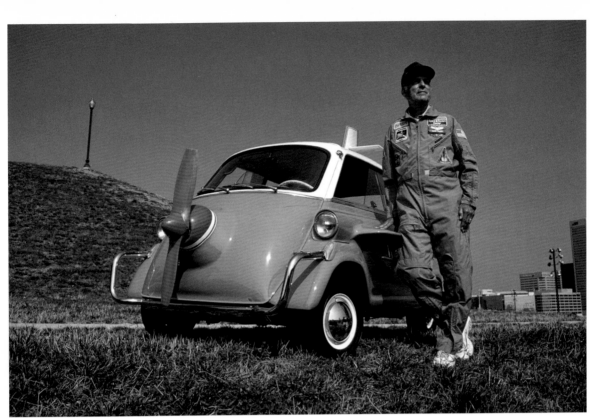

The *AeroCar 600* by Dave Major is as much aeroplane as it is car. The original 1959 BMW 600 car has been customised with a handmade propeller turned by a 12-volt electric motor, a tail from a real aeroplane and tyres from a Beech Jet 400A. Inside, it even has a custom dashboard with a working altimeter, airspeed indicator and aircraft compass!

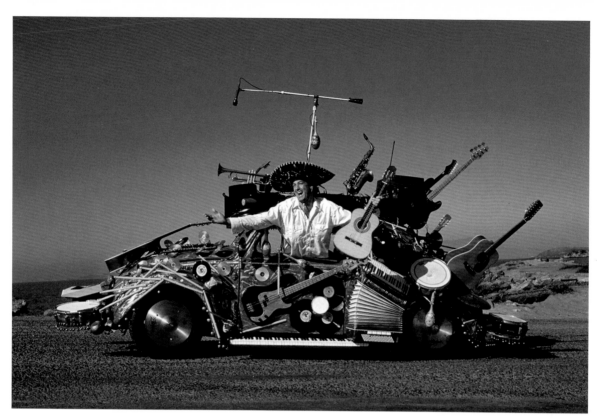

Filmmaker Harrod Blank equipped this car with an accordion, drums, electric guitars, keyboards and other functional musical instruments. He calls it *Pico De Gallo*, Spanish for spicy salsa, because the vehicle is meant to engage the public at parties and other public events. It has been on show at the Orlando Museum of Ripley's Believe It Or Not.

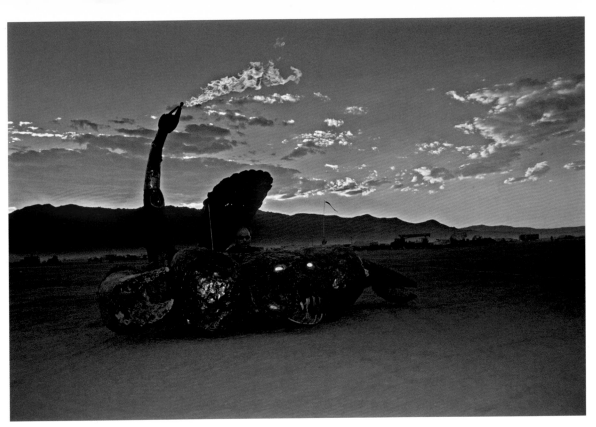

Houston sculptor Mark David Bradford, aka 'Scrapdaddy', is a well-known and highly respected sculptor, working mainly in metal. One of his passions has been creating art cars of extraordinary technical complexity and breathtaking visual impact. His work has been featured on television programmes such as 'Battle Bots' and 'Junkyard Wars', and reaches beyond the standard coat of paint, branching into hydraulics and other engineering elements, which he uses to bring his incredible vehicles to life.

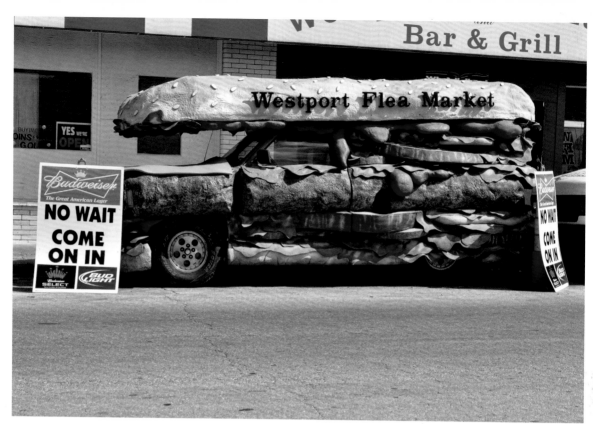

Westport Flea Market and Grill in Kansas City has been dishing out bargains and good food for almost thirty years. The Burgermobile adds a colourful and tasty helping of self-promotion. Designed by Orchid Promotional Vehicles, this wild art mobile helps get the point across that Westport makes the best burgers around. This fun and unique form of marketing requires a high level of creativity and commitment to build and operate. Art directors, designers and fine art cross over at these four-wheeled intersections of concept, pop culture and financial 'drive'.

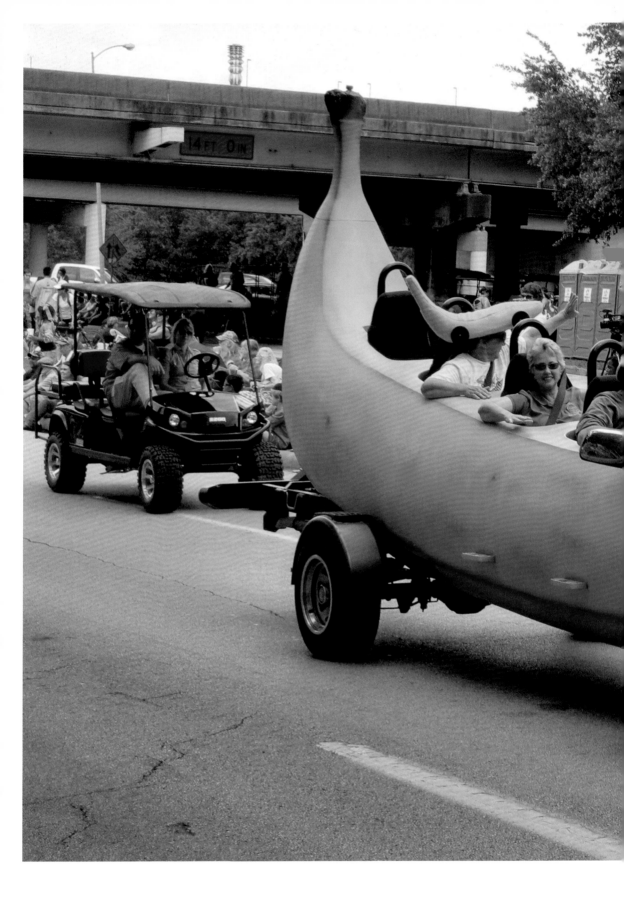

The Houston Art Car Parade offers a large-scale public display of
cars that have been dramatically and crazily altered into exotic hybrid
vehicles. Artists from all over the United States make their cars into
drivable sculptures. These cars, transformed into artworks, have lost
their everyday function and street status, and have turned into a subject

of awe and popular spectacle. The Houston Art Car Parade is sponsored by the Orange Show Centre for Visionary Art, whose motto is 'Celebrating the Artist in Everyone'. This creation, *The Big Banana Car*, was part of the 2012 parade.

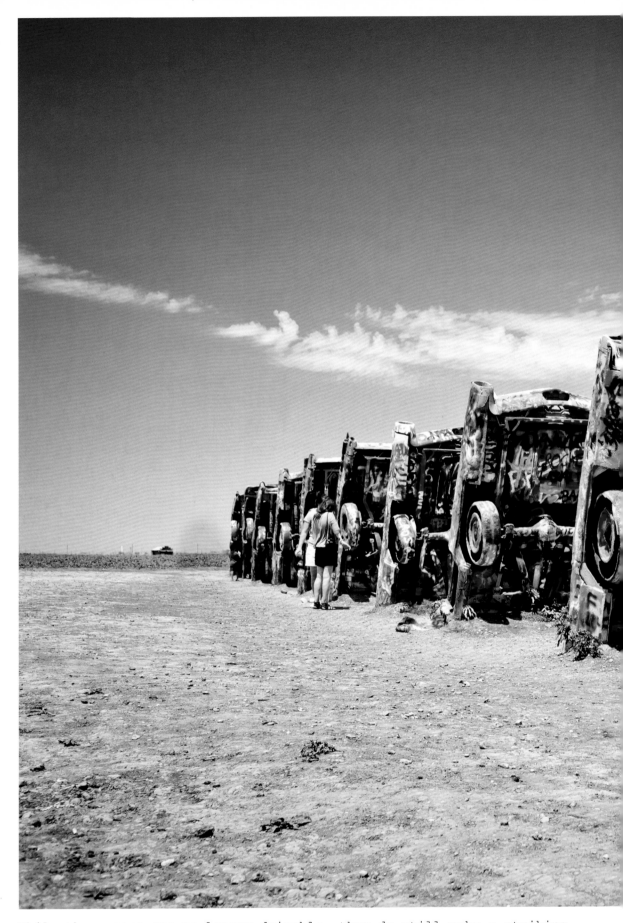

While these cars are no longer drivable, they do still make a striking
piece of static wild street art. This art installation consists of ten
Cadillacs part-buried nose-down in the dirt, and was created in 1974
by a group of artists known as The Ant Farm. Today the site is known as
Cadillac Ranch and is a popular tourist destination.

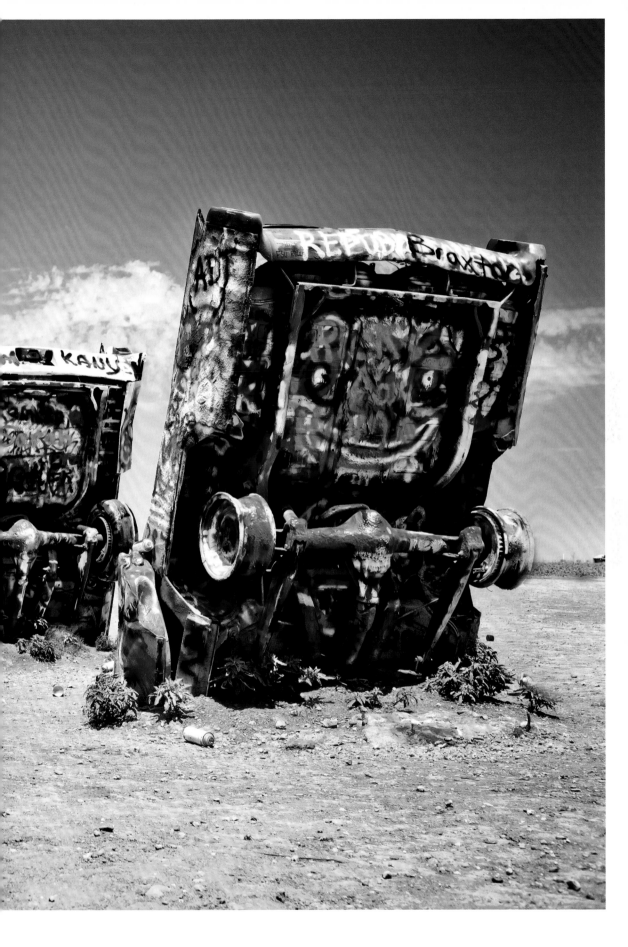

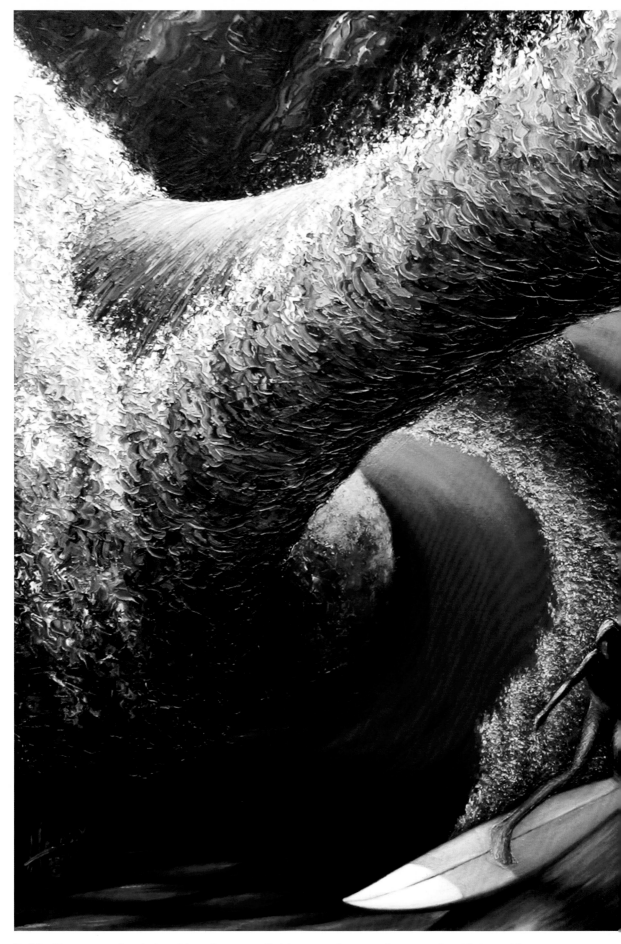

Robb Havassy depicts the drama of the surfer and wave in this oil painting *Midnight Barrel* from 2001. California-native Havassy began his art career at the age of twenty-six when he received a beginner's art

kit. His artistic forays were previously limited to taking photographs
and painting his own surfboards. Havassy is now a highly successful surf
artist and fashion designer.

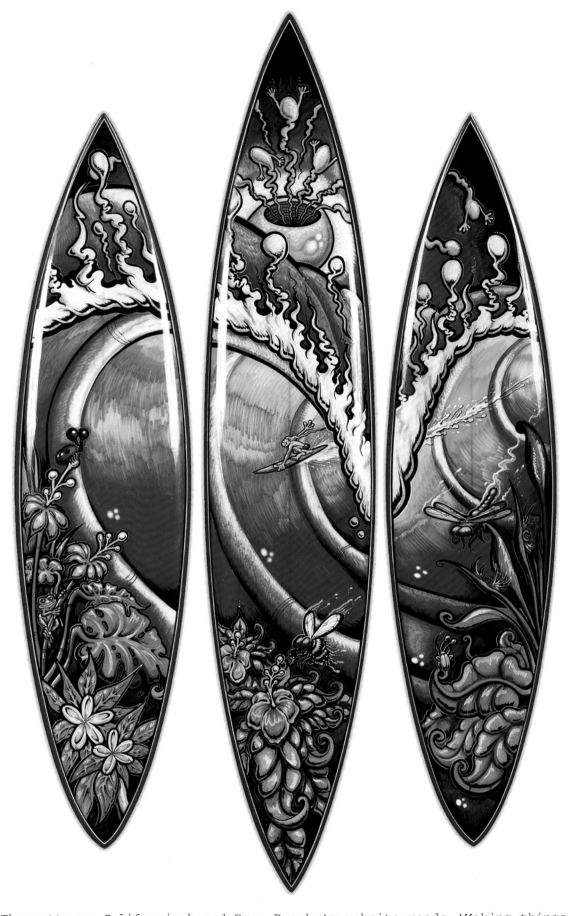

The motto on California-based Drew Brophy's website reads 'Making things look cool since 1971', and explains how he became one of the premier custom surfboard artists. A champion of the most elaborate forms of surfboard art, here he borrows one of the principal structures of early Christian altarpieces: the triptych.

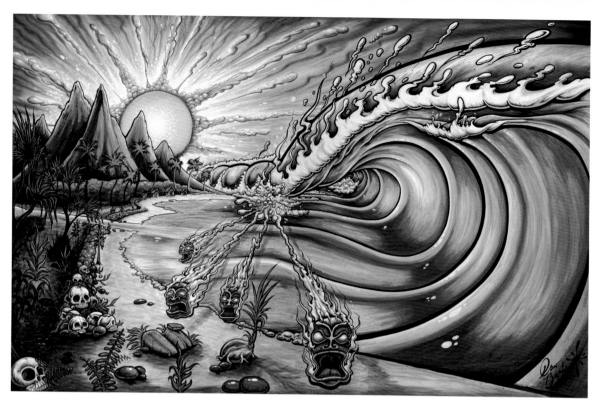

Teahupo'o in Tahiti is a world-famous reef break, and is on every dedicated surfers 'must-surf' list. Waves can reach up to 21 m (70 ft), crashing down on a shallow shoreline. In *Wall of Skulls* Drew Brophy plays on the location's deadly reputation and name, which loosely translated into English means 'to sever the head' or 'place of skulls'. Brophy is a renowned surf lifestyle artist whose original artwork decorates surfboards, t-shirts, skateboards and other products. His style is heavily influenced by psychedelic and visionary art, Tiki culture, and tattoo art.

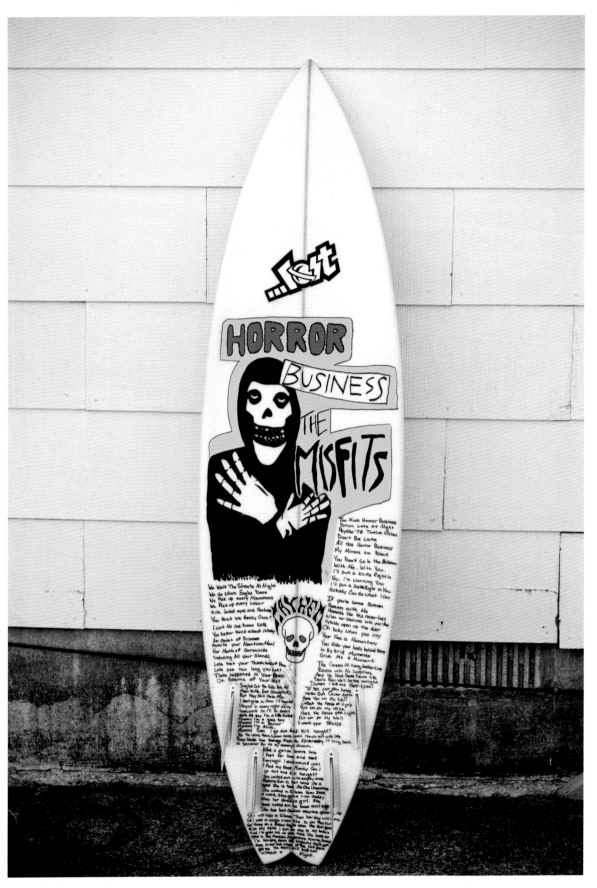

Though there are many professional surfboard artists, some surfers prefer to buy blank boards and personalize them. This board, *Misfits Surfboard* from 2010, professes a punk rock allegiance, featuring a hand-drawn motif by surfer and photographer Trevor Moran. Of this particular board he states: '*Ironically I saved three different people from drowning on this board. Evil words = good Karma.*'

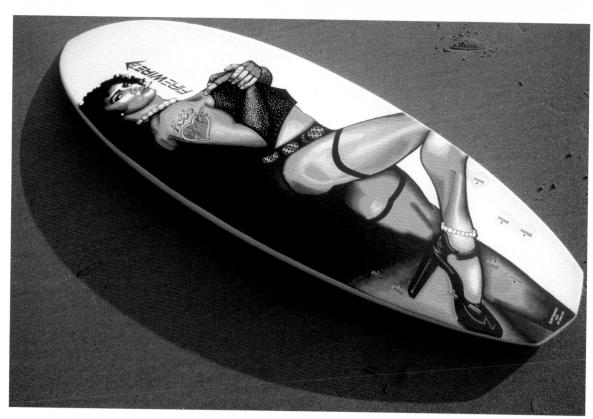

Designed by Patrick Boothman, a wild artist in Wales, this 'transsexual surfboard art' *Franky Firewire* lets the character of Frankenfurter from *The Rocky Horror Picture Show* ride the waves. Besides painting surfboards, Boothman also paints abstracted landscapes and creates photo-collages. From these divergent, creative practices he has found it necessary to create artwork under various pseudonyms, such as Dr Justinian Beau and Mr Herbert Haut, to express and explore these conflicting identities in his practice.

'IN A CULTURE WHERE SURFACES MATTER, SKIN, THE LARGEST ORGAN, IS THE SCRIM ON WHICH WE PROJECT OUR GREATEST FANTASIES AND DEEPEST FEARS ABOUT OUR BODIES. EXPOSE TOO MUCH OF IT, AND CHRISTIAN FUNDAMENTALISTS OR ANTI-PORN FEMINISTS WILL COME AFTER YOU. PIERCE OR BRAND IT AND YOU ASSUME THE UNIFORM OF THE COUNTERCULTURE. NIP AND TUCK IT THROUGH SURGERY AND YOU DRINK FROM THE FOUNTAIN OF YOUTH OR BUY INTO THE BEAUTY MYTH.'

— MARGOT MIFFLIN

The body itself has always provided a support for mark making, in all ages and all continents. From its earliest state *in utero* it is about shape, an organic, living shape, evolving, creating itself and developing from within. Further on in life, the body ceaselessly transforms itself: this transformative process can be heightened, or slowed down: but it cannot stop. The body can thus become the very medium and support of artistic expression. Today, in a multitude of surprising possibilities, wild art abounds within the folds of the flesh through diverse modes: piercing, tattooing, surgical alterations, as well as some less permanent, but equally striking, creations. The body thus becomes a living and breathing sculpture: a live form that can inspire delectation or dismay, awe, horror or envy, aesthetic joy or repulsion.

Wild artistic practices reveal much about changing cultural ideals: statistics confirm and reinforce the impact of tattoos as a popular and prevalent form of art, albeit still largely ignored within the perimeters of the art establishment. Today, half of the American population between the ages of eighteen and twenty-nine have at least one tattoo. Within the last generation, our relationship with our bodies and how we view them has changed drastically. The current generation seems to confirm Michel Foucault's prescient words: '*The body is the inscribed surface of events.*' Tattoos allow a person to present their life history right on their flesh, where it is potentially visible to everyone.

Tattoos are inscribed on one's skin for now and the future, and terminated by one's own death. The tattoo is like a film of pigment, permanently, indelibly etched into one's fragile, mortal skin. They conjure up both the history of mankind, going back to its earliest sources, and one's own, necessarily limited, future. It is possibly *this* paradox that strikes us so intensely when we look at some of these spectacular tattoos, although of course there are now techniques available to remove or erase these cutaneous graphic forms.

Such radical body alterations may seem to us a modern and Western art form, but their far older origins are revealed by the tribal art seen in such practices as neck elongation by the Padaung women of Myanmar (Burma) and traditional Samoan tattoos, which date back over 2,000 years. It would seem that treating the human body as a canvas has a long history.

While tattoos and surgical alterations are permanent, there is a strand of body art that is more transitory, as can be seen in 'living dolls', saline injections or nail art. Although these changes are not necessarily permanent, this does not lessen the fact that the makers or wearers consider it to be their form of artistic expression.

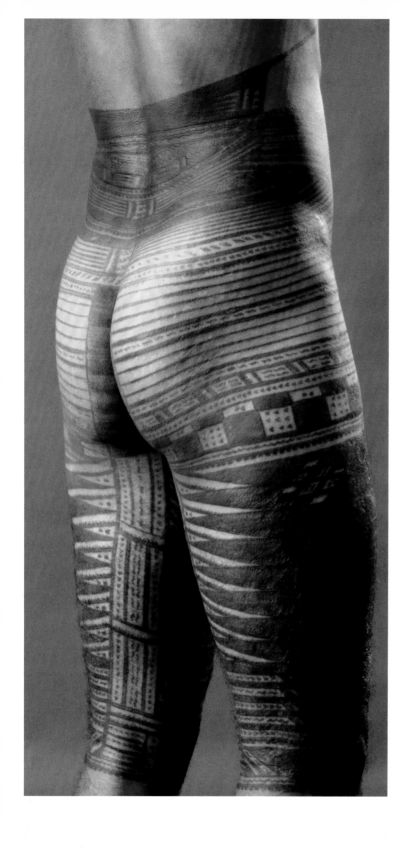

The English word 'tattoo' is derived from the Samoan '*tatau*', a process more than 2,000 years old. This tatau is a long and painful process done with hand tools - nothing like the machine-based procedure of today's Western tattoos. According to Samoan tradition, men suffer the pain of *Pe'a*, the name for a traditional tatau, so that they feel the equivalent discomfort women experience during childbirth. Samoans say: '*Fanau le teine fana fanau, fanau le tama le tatau*' (If a girl is born it must bear the pain of birth, if a boy is born it must bear the pain of tatau).

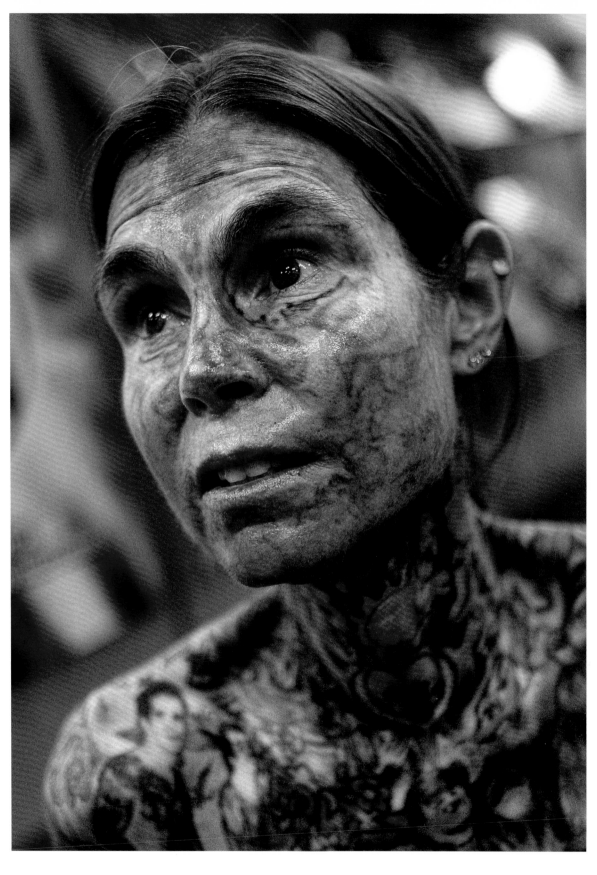

'The Illustrated Lady' Julia Gnuse has covered ninety-five per cent of her body, including her face, with tattoos. Unlike the Samoan man (*left*), she creates tattoos for purely aesthetic reasons; her tattoos can only be fully 'read' by those who share her fascinations.

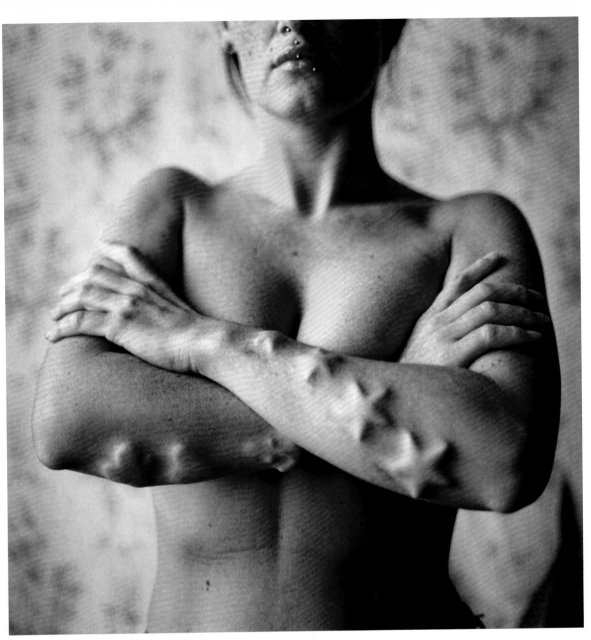

Sub-dermal implants mark a line of stars down this woman's arm, made by implanting shaped pieces of jewellery underneath the skin. Once the shapes have been inserted, the body heals over them, allowing for the raised design to show through. This wild art form is in a sense the symmetrically opposed form to the tattoo: it is built underneath the skin rather than on it. It is inside one's own body.

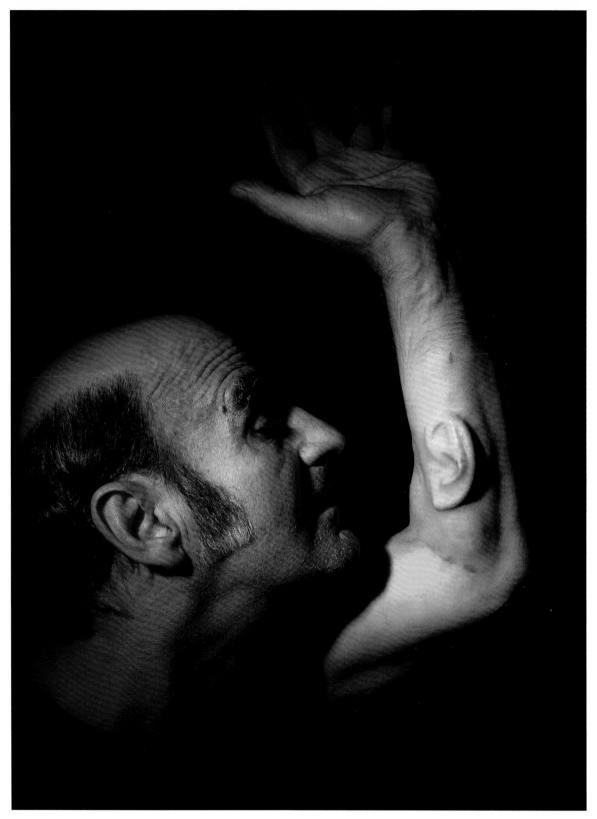

Performance artist Stelarc uses medical processes, technology and robotics to interface with the human body, exploring the limits of what human biotechnology may offer in order to transform one's appearance. Here is his 2007 work *Ear On Arm*, a cell-cultivated ear transplanted onto his own arm. Stelarc says of his motivations and the dangers of his work: '*I've always been envious of dancers and gymnasts because they use their bodies as their medium of expression, coupling experience of the body and expression with the body. Experimenting on yourself must present risks … suspending your body, inserting a sculpture inside your body or engineering an ear onto your arm means the body undergoes dangerous and difficult performances and projects.*'

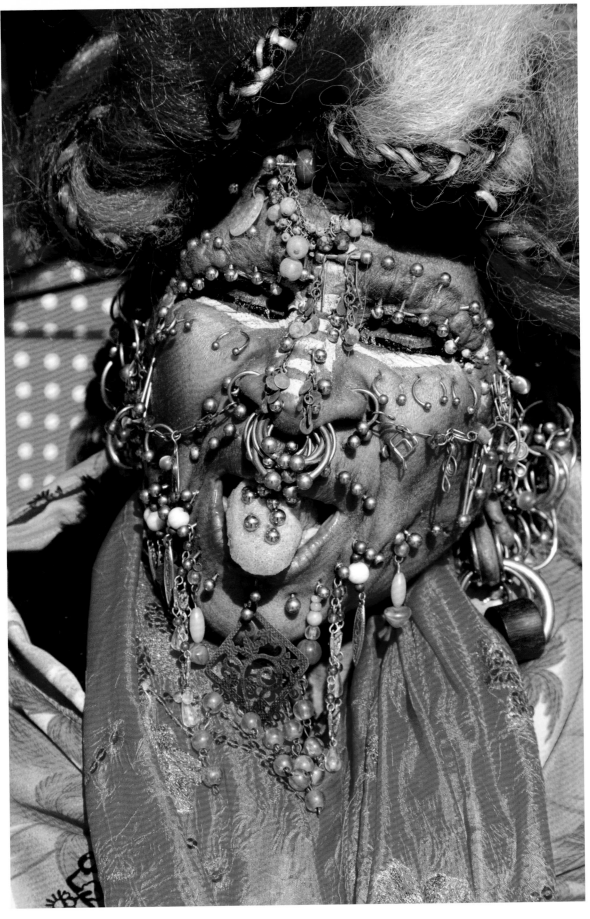

Elaine Davidson, the world's most pierced woman, has so many piercings that her face is barely visible.

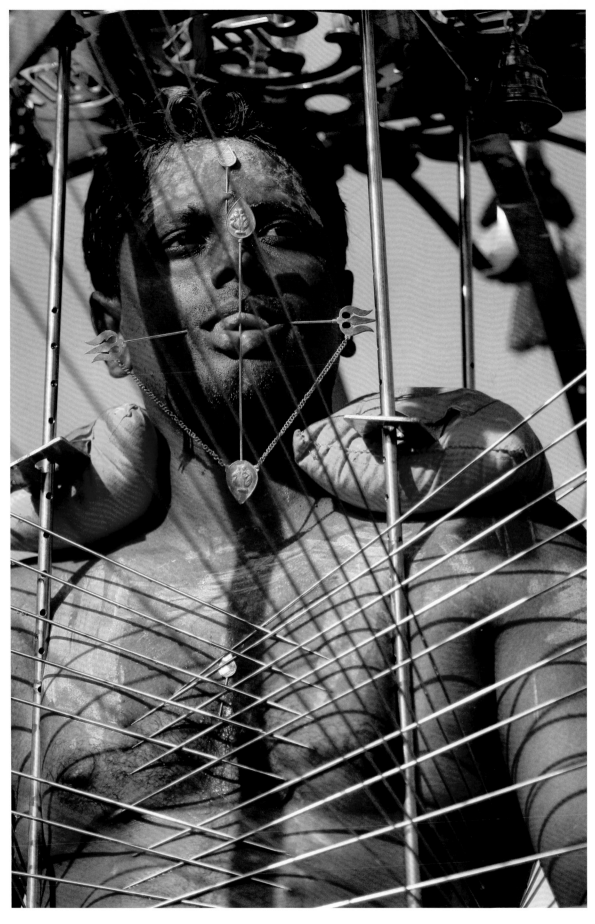

Wild body art is often the product of religious ceremonies, as is the case with this Malaysian man who has undergone mortifications of the flesh as part of the rituals for the Hindu Thaipusan festival in Kuala Lumpur.

Ryoichi 'Keroppy' Maeda is a Japanese photojournalist who has brought the art of underground saline injection into the wild art mainstream. This Japanese sub-culture involves young people injecting saline into their foreheads to temporarily change their appearance. Many apply pressure to a central point during the injections process, creating the appearance of a bagel and earning the term 'bagel heads'. The results only last up to 24 hours as the saline is absorbed into the body.

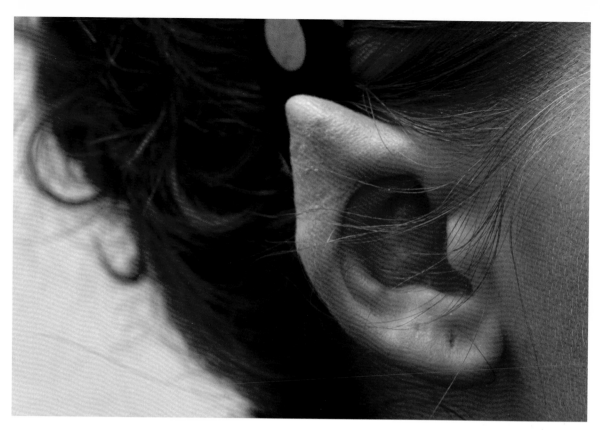

Ear pointing is a form of body modification which creates 'Vulcan'
or elf-like ears. Such body transformations are made possible through
surgical procedures which remove a small wedge of tissue, and then suture
the remaining ear segments together. The resulting ear, after healing,
takes on a pointed shape.

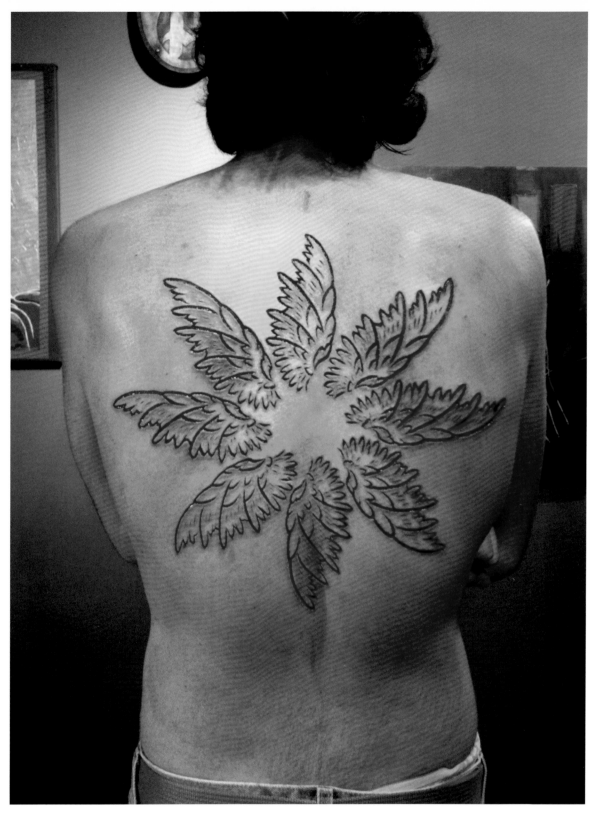

Created by cutting and incising designs into flesh with scalpels, scarification offers another form of body modification. After the cuts heal the design manifests itself through a subtle web of interwoven lines made out of scar tissue. This example of scarification was created by Brian Decker of Pure in Williamsburg, Brooklyn. He has gained the reputation of being one of the best in the business for artistic, yet extreme, body modifications.

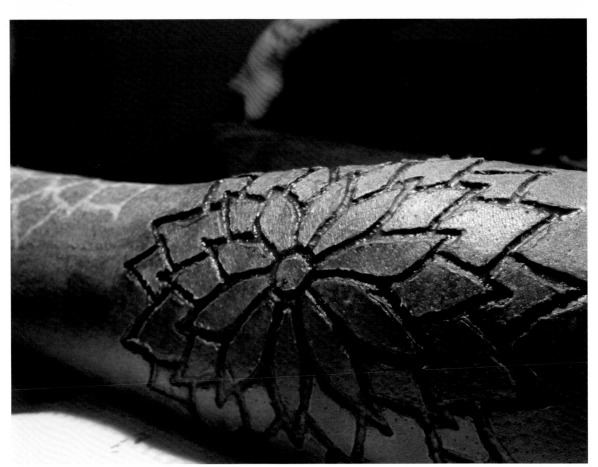

Also the work of Brian Decker, this lotus brand is made over the top of an all-black, tattooed arm. A form of scarification, branding is the process of using heated instruments, usually metallic, to burn the skin for the purpose of the resulting scar that will form after the burn has healed. Traditionally used to mark cattle, in recent years branding has gained increased popularity as a method of human body modification.

Much contemporary Western body art centres around personal expression and the creation of the individual. But in many other cultures the structures of this art form, passed down through generations, are socially given. In this example from Ethiopia, a woman from the Surma (or Suri) tribe in the Omo Valley displays a lip plate. The inital piercing for the plate takes place in the year pefore a Surma woman is married.

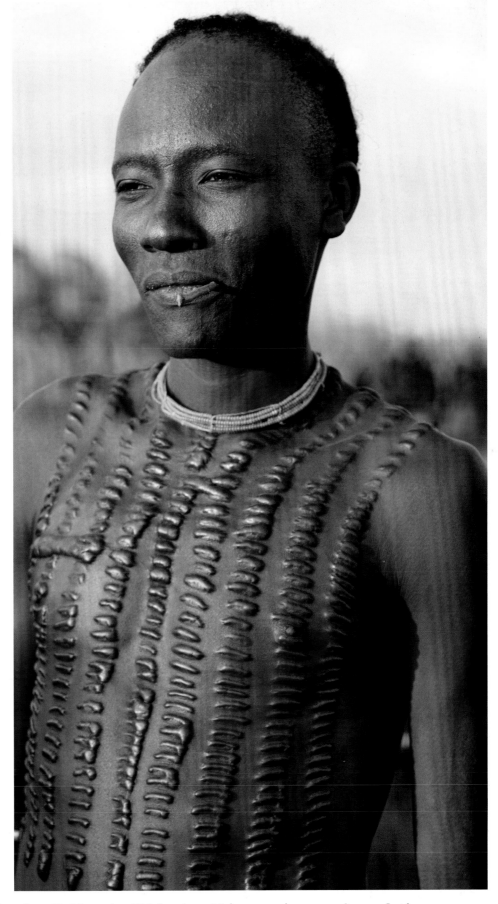

Also from the Omo Valley in Ethiopia, this man is a member of the
Dassanech people. His extensive scarification symbolizes that he has
killed an enemy in battle. After a cut is made, ash is rubbed into the
wounds, causing the scars to darken. The modern scarification practices
shown on the previous pages have close ties to these African examples.

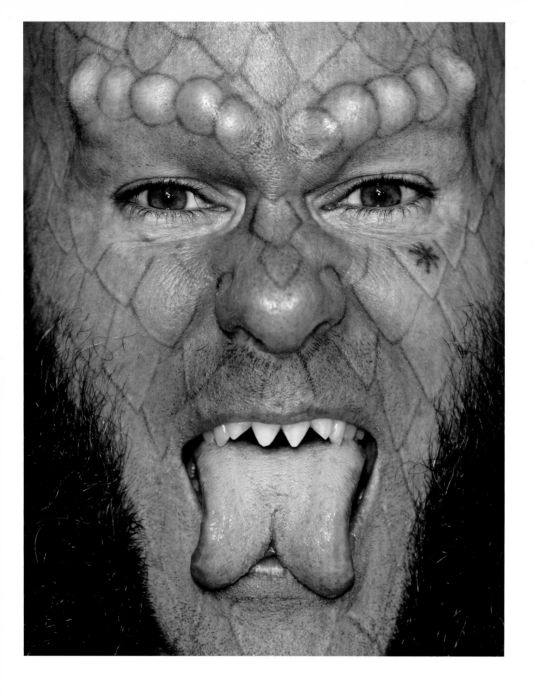

Tongue modification is another form of body art. One such alteration, known as tongue bifurcation, creates a forked tongue resembling that of a snake. Most methods involve using a laser, or undergoing surgery, but some individuals self-modify by inserting nylon bindings into an existing tongue piercing, thereby splitting the tongue. Tongue bifurcation is just one of the body modifications that Erik Sprague has used here to turn himself into 'The Lizardman'.

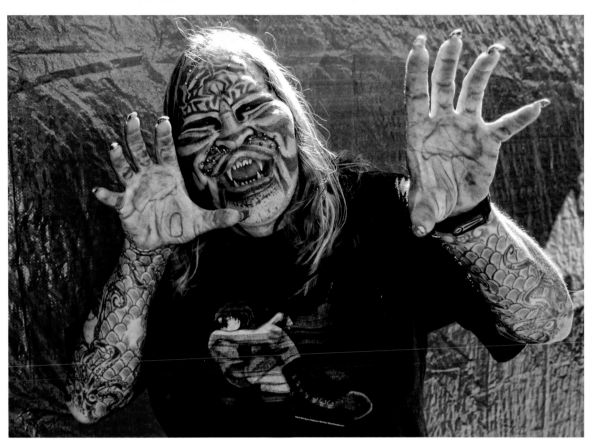

Dennis Avner, known as 'Cat Man', spent hundreds of thousands of dollars on tattoos and plastic surgery to alter his physical self. Avner, a San Diego computer programmer, planned to get fur grafts in order to complete his transformation. Before his death in November 2012 Avner did manage to make an indirect entry into the mainstream art world as the model for one of Marc Quinn's sculpture series.

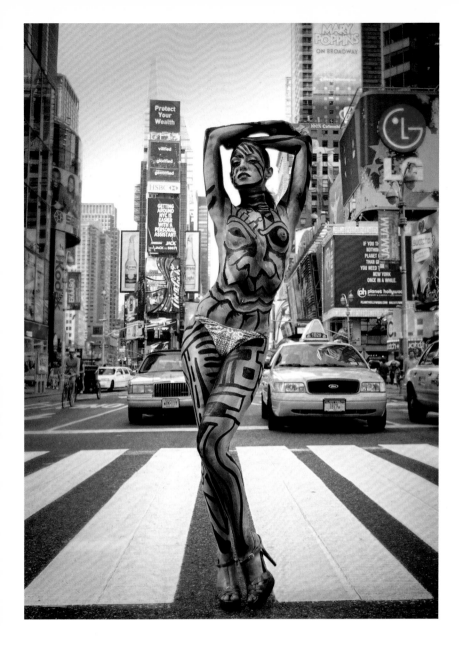

Contemporary artists often experiment with shaped canvases, modifying their compositions in response to an unconventional format. The New York artist Andy Golub adapts a more radical innovation, making his canvas the body of a near-naked woman.

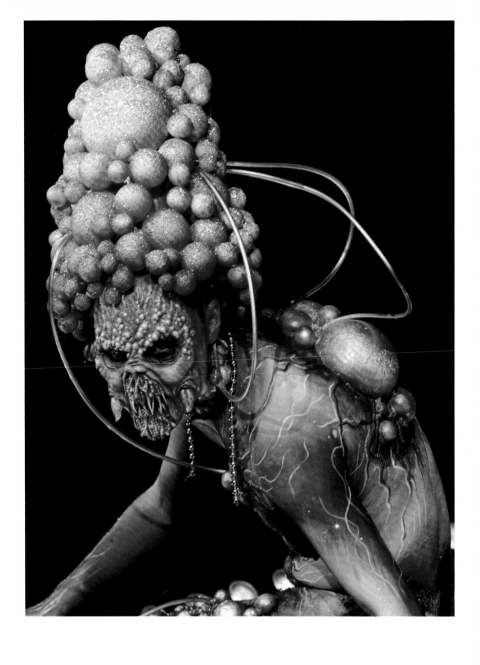

In July 2009 body artists from around the world descended on Auckland,
New Zealand, for a contest. Categories in this wild art show included
hand-painted special effects, world of fluorescent and a Maori myths
and fantasies section. The overall winner was Kelly Zhong-ni Ren, whose
Painted Skin, show here, was modelled by Shou Lin Mitchell.

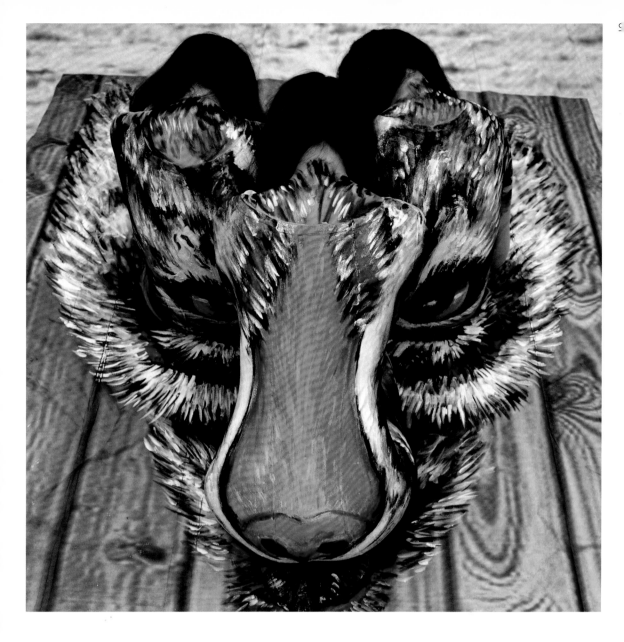

In this work, human canvases combine with an animal subject matter to create a three-dimensional depiction of a tiger face on the backs of three nude models. The work was created in Fuzhou in China's Fujian Province in 2013.

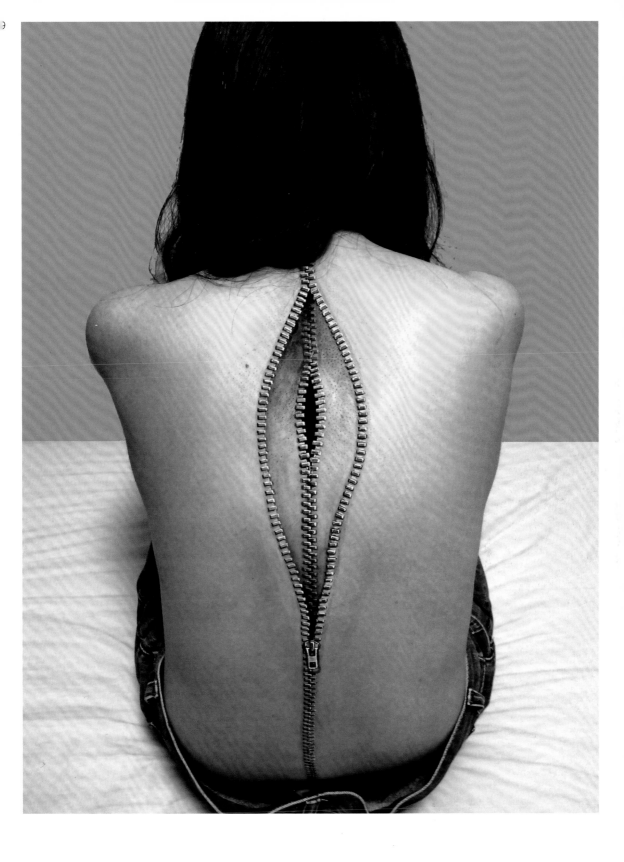

Japanese artist Chooo-San also uses the back of a model as the canvas for her art. She painstakingly applies paint to create realistic effects, such as this 'zip' down the spine of the model.

Cathie Jung has the smallest waist of any living person, measuring approximately 38 cm (15 in). She managed to reach this distorted figure through tight-lacing, the practice of extreme corset wearing day and night. For the past 25 years, she has only taken her corsets off when she bathes. This practice has permanently changed the anatomy of her body.

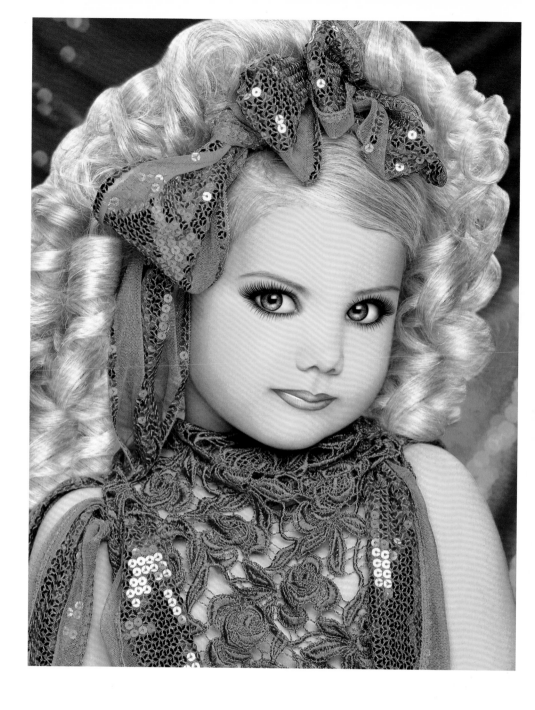

This is not a photograph of a doll: this is a child. Eden Wood is one of the top child beauty pageant contestants in the United States. Only six years old, she is already a veteran of the pageant circuit. Her mother is the real artist here: Mickie Wood has spent thousands of hours and dollars shaping Eden's hair and flesh to resemble a woman's. '*I've spent easily $100,000 in savings and Eden has made back maybe $40,000 or $50,000 in prizes. You gotta know going into this, you're never gonna make the money back. It's an extremely expensive sport, but it's what we love.*' Eden is the star of the reality television show, 'Toddlers and Tiaras', which chronicles the pageant world of toddlers and very young girls.

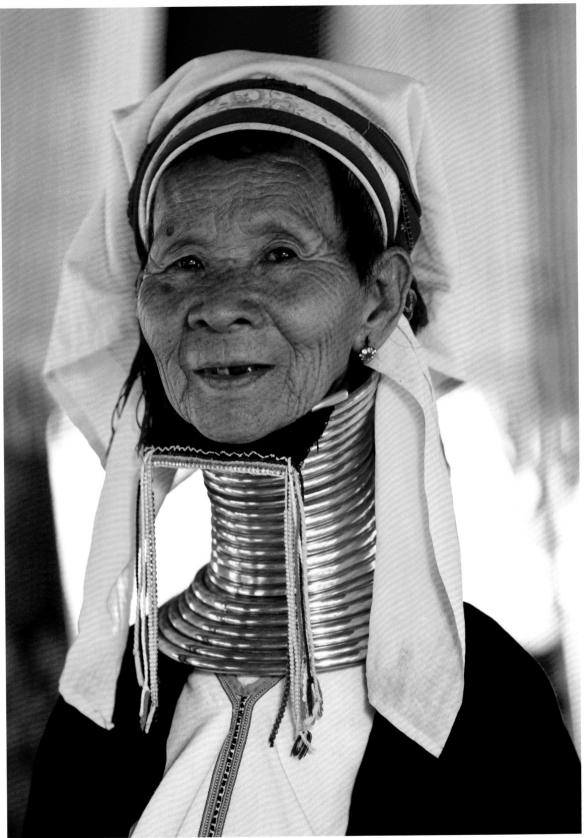

The Padaung people of Myanmar (Burma) value the appearance of long necks. They devised a system of coiled gold neckware, which is first placed on the necks of young girls at around five years of age. While it appears that these coils stretch the neck, they actually deform and press down the clavicle and rib cage, creating a permanent physical change. To achieve this, longer coils gradually replace shorter ones. This older Padaung woman from the village of Myinkaba in Myanmar shows the full extent of the modification.

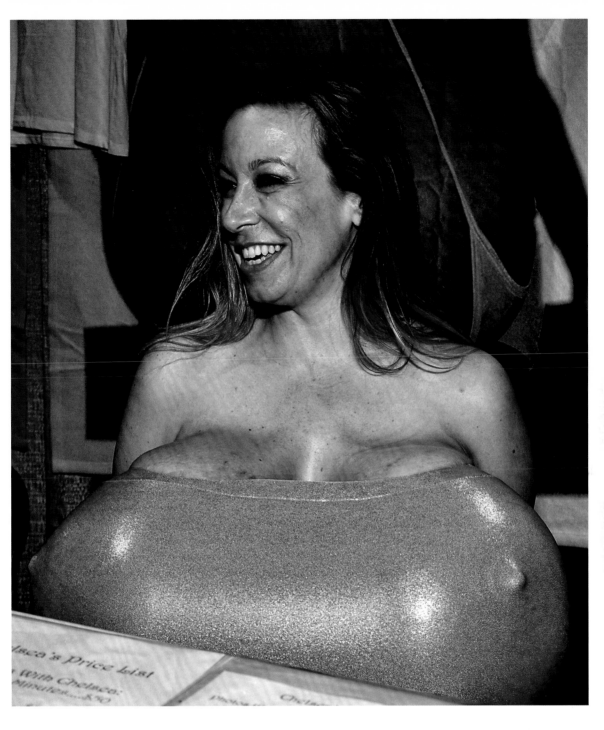

In the West, other parts of the female anataomy are particularly valued. In 2000 Chelsea Charms, an adult industry star, had the world's largest breasts, a size 153XXX; each weighed 11.8 kg (26 lb). Through an augmentation process known as the polypropylene string technique, an implant to the breast irritates the organic breast tissue, causing fluid to collect inside the implants and the breast to consequently 'grow'. The procedure is banned in the European Union and the United States.

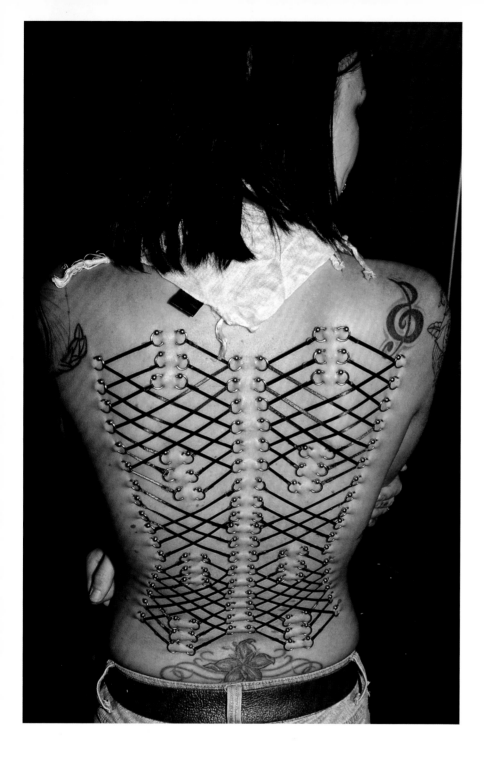

Here is an example of 'corset piercing', where lines of piercings are made so that laces or ribbons can be threaded through to create the appearance of a corset. These are called 'novelty' or 'play' piercings for their purely temporary nature. In general, the piercings last for the duration of one evening, or even only the length of a photoshoot. This example was made by artist Brailey of Fat Zombie Tattoo in Phoenix, Arizona.

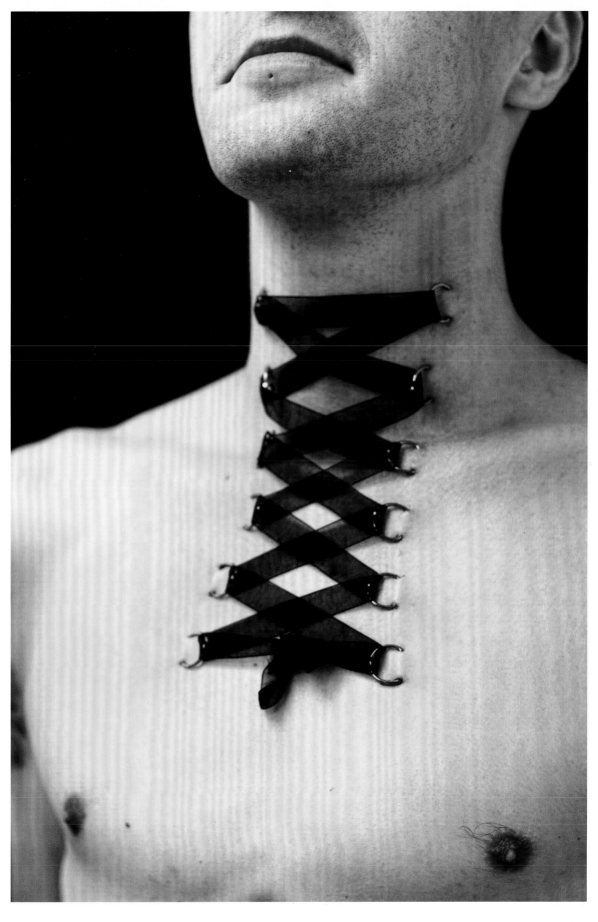

Another example of corset piercing, this 2011 example from British artist Laura Hunt is situated on a man's neck. The 'decoration' can be applied to any area of the body where the skin is loose enough to pinch in order to thread a needle through. This work took around an hour to complete.

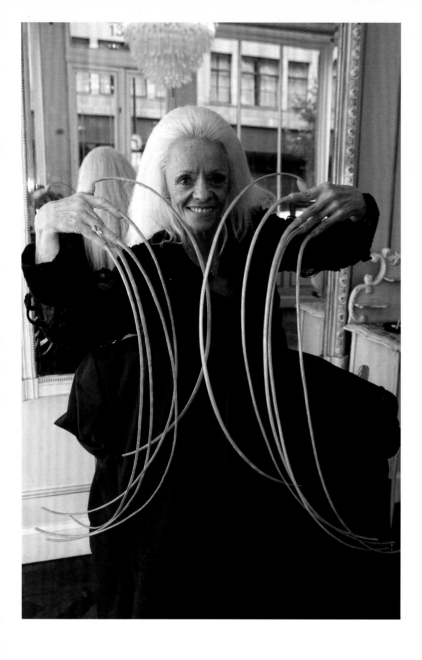

Lee Redmond did not cut her fingernails for thirty years. She grew and carefully manicured each nail to a total combined length of around 7.6 m (24 ft 9 in), which won her a Guinness World Record in 2006. Having nails this long restricted the movement of the body and made everyday tasks difficult, a sacrifice she was willing to make for the sake of aesthetics.

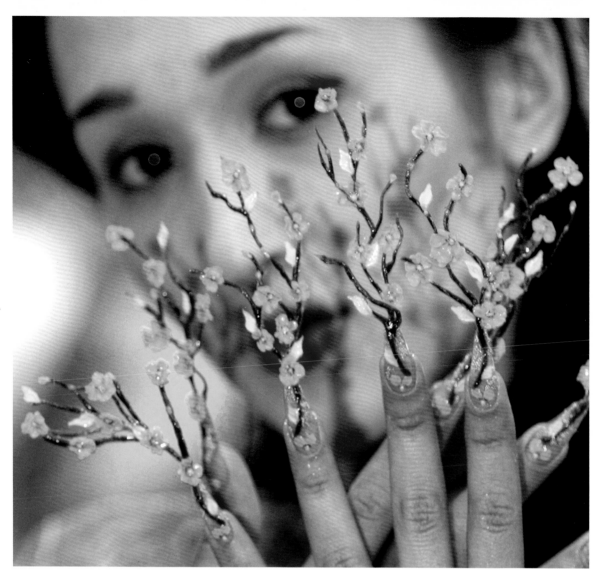

This model, who demonstrates another way to utilise fingernails as body art, participated in a nail design contest in Kiev (2004).

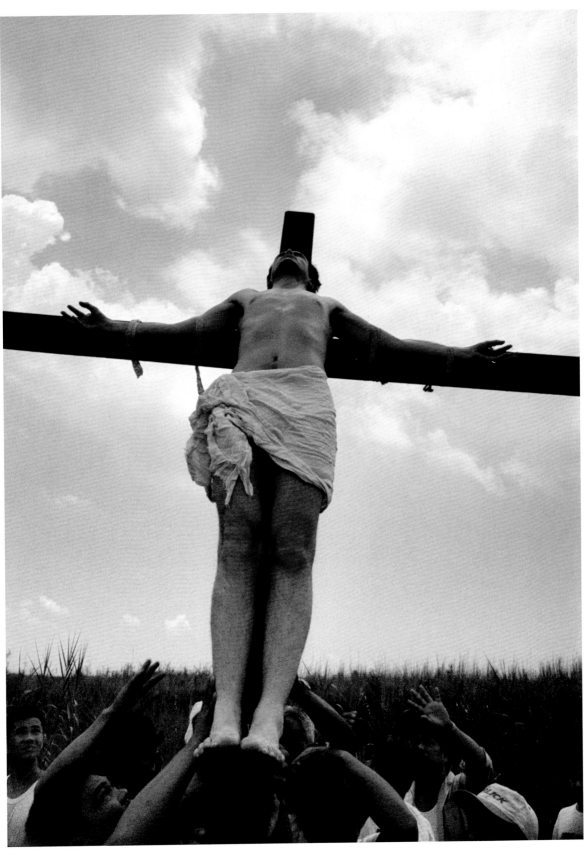

When London-based artist Sebastian Horsley (1962–2010) had himself cruci-
fied in 2000, some felt that he had pushed the boundaries of his perfor-
mance art too far to be acceptable within the art world. Although claimed
to be research for intended crucifix paintings, these documentary photo-
graphs are the subject of the majority of internet searches for Horsley's
art. In 2011 Horsley's subsequent paintings formed part of an exhibition
in London to raise money and awareness for mental illness and related
creative therapies.

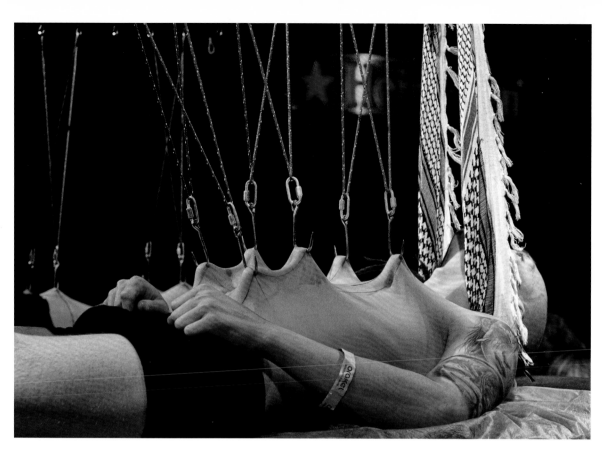

In what could be seen as an extention of piercing, the process of ritual
suspension involves hoisting a person into space using a series of hook
piercings inserted just under the skin. Ritual suspension has become
a rite of passage in some subcultures, and weddings have even been
performed while the happy couple hangs, suspended in air. This example
comes from the Altered States Crew at a festival in Poland in 2011.

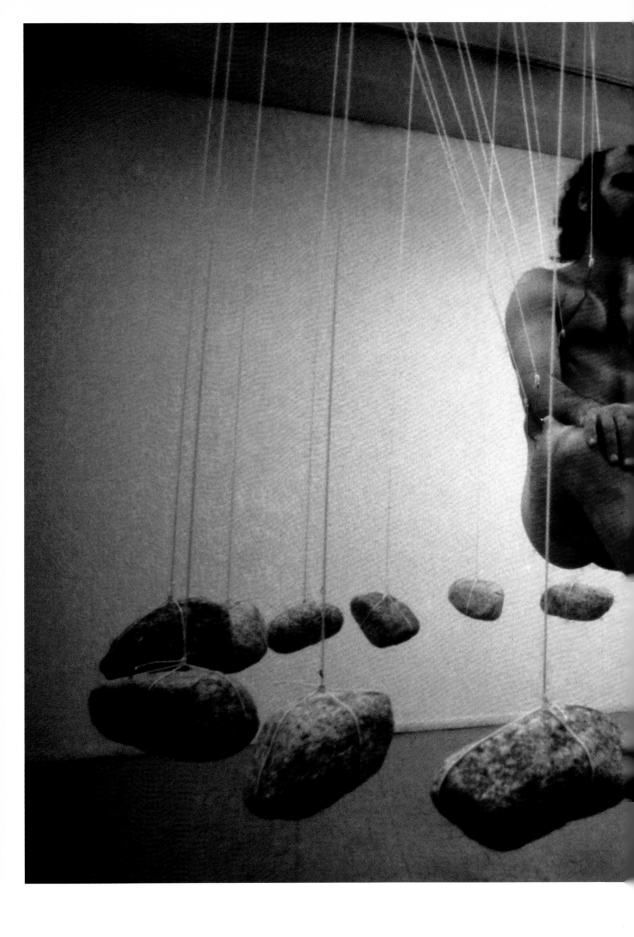

Stelarc (*see also page 85*) is also known for his flesh hook suspension rituals, such as this one, *Rock Suspension* (Tokyo, 1980), from the very early days of his career as a performance artist.

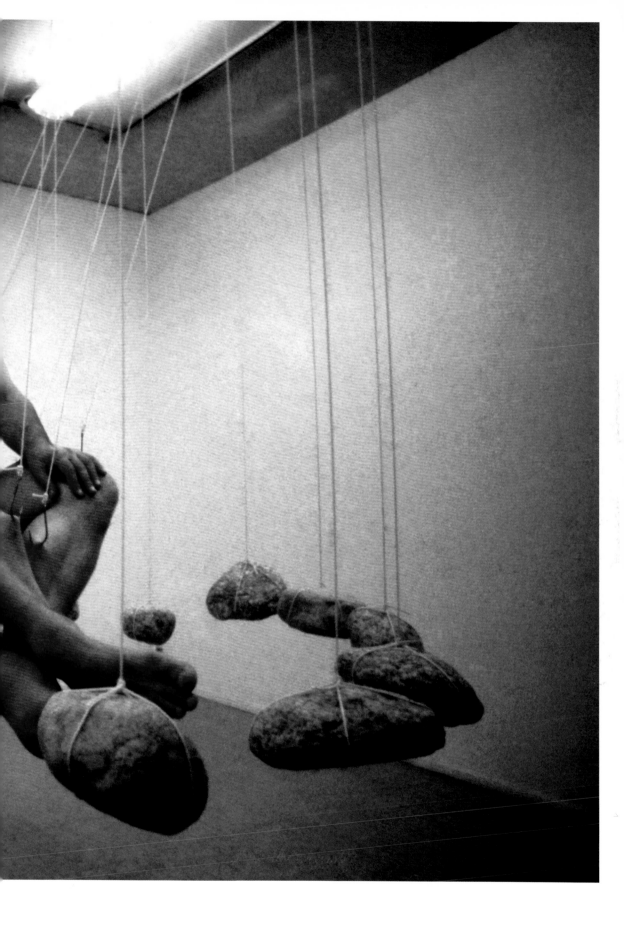

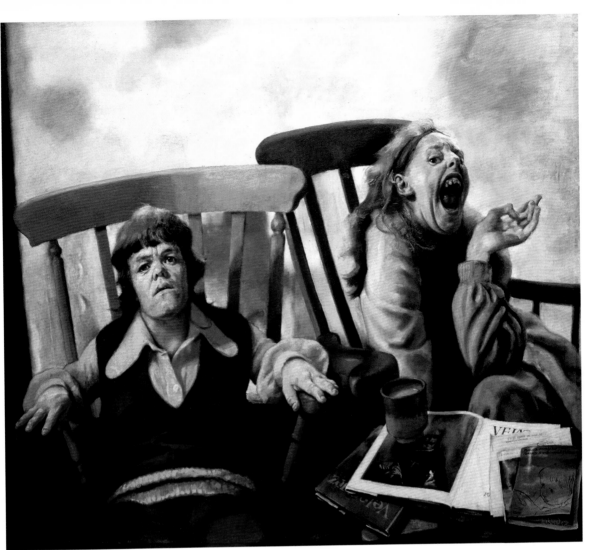

Wild art that is inspired by the human form does not always have to use the body itself as a canvas. An exceedingly talented and prolific academic figurative painter, the British artist Robert Lenkiewicz (1941–2002) never found favour in the established art world, yet his work enjoyed popularity within a wider context. Many of his paintings dealt with social issues, depicting vagrants, tramps and the mentally handicapped. A truly wild artist, Lenkiewicz had affairs with countless women, fathered eleven children and died penniless. In 2008 his painting collection and library were auctioned for £2.1 million.

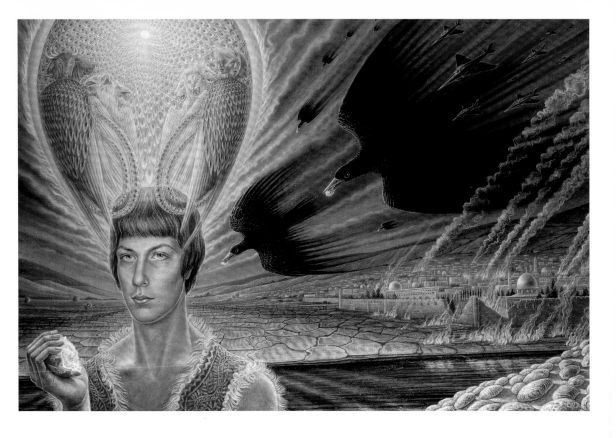

Brigid Marlin is another visionary artist whose works combine mysticism, symbolism and surrealism. This painting, *Ezekiel's Vision*, pictures the heavenly vision of the prophet along with a view of the earth: cities on fire, menacing blackbirds and modern forces of destruction. The American-born, UK-based artist founded what is now known as the Society for Art of the Imagination, a group of wild artists who do not adhere to the 'rules' of contemporary art, but follow their own unique spiritual and visionary paths.

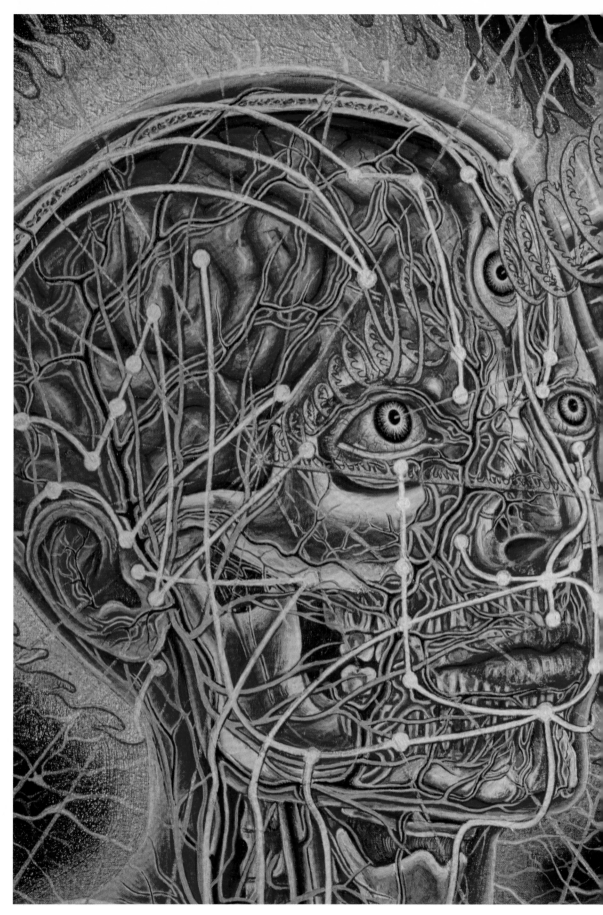

Alex Grey arrived at his unique aesthetic (showing the human body's
anatomical layers along with pressure points and emanating radiating
lines of chakras and auras) while tripping on LSD. Bearing the influences
of Eastern religions and New Age tenets, the Ohio-born artist's works
are spiritual meditations that appeal to a broad range of art lovers

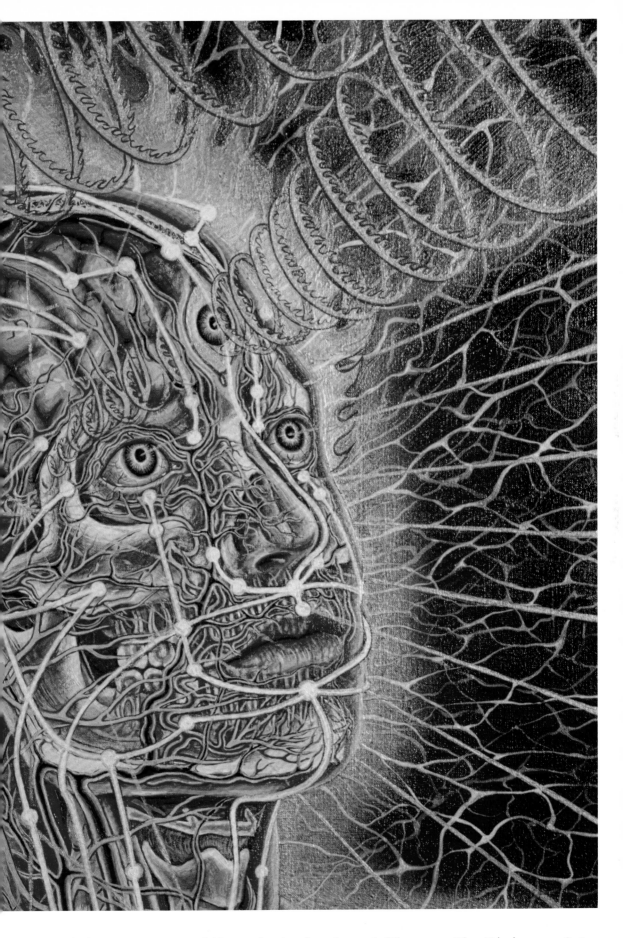

and spiritual seekers alike. His book, *Sacred Mirrors: The Visionary Art of Alex Grey*, has sold over 100,000 copies. Grey's work is on permanent display in a highly distinct art space, The Chapel of Sacred Mirrors in New York state.

'IN MY BOOK, EVERYTHING AND EVERYONE SPEAKS –
EVEN FISHES DO. WHAT THEY HAVE TO SAY ADDRESSES
ALL OF US, EACH ONE OF US … I USE ANIMALS TO
INSTRUCT HUMAN BEINGS.'
– JEAN DE LA FONTAINE

Animals and pets offer extensions of human creativity in that they are often coiffed as objects of aesthetic contemplation, as, for instance, in the grooming competitions where dog coats are shaped into a living, sculptural display; or when people use specially designed bike baskets to hold their dogs while they cycle together. Either we love these things, particularly because they're so cute and cuddly, or we don't, considering them populist and lowbrow culture. Indeed, where many of those in the mainstream art world will look at such works and say 'ewwww!', many others outside it will decidedly say 'ahhhh!'. Again, as will be seen throughout this book, this binary system of oppositions – going from the eulogization of some artists to the demonization or vilification of others – does not make much sense at all when art is considered in a wider sense. Likes and dislikes cannot stop us from seeing that there are clear analogies between art forms that are idealized by the mainstream art world and others that linger in its peripheries and gutters.

Whether treating animals as models of representation, or indeed (as we saw with body art) as a platform or medium for aesthetic interventions, or, even more interestingly, turning to them as potential artists themselves, wild artists enlarge the boundaries of the art world in ways that affect how we (may be willing to) understand art. Indeed, art made

by animals is a subject of increased fascination. In 2001 nearly 42,000 people visited the exhibition 'When Elephants Paint' at the Sydney Museum of Contemporary Art – a virtually unprecedented phenomenon. As Stefan St-Laurent, the curator of a 2009 exhibition of art made by animals at Galerie SAW Gallery, Ottowa, comments, not acknowledging that work produced by animals can be considered as art has restricted our interactions with them:

'*The reluctance of so many researchers and art historians to entertain the notion that animals have subjectivities, or an aesthetic sense, has led us on the wrong path. With growing evidence of animals' complex cognitive skills and emotional depth, will we ever see radical changes in the ways humans treat animals? Can animals fully realize their creative potential in captivity or through training?*'

This chapter will present three forms of wild art: animals as artists, human artists depicting animals and animals themselves becoming the artistic medium. In the latter form, we see quantities of animal 'parents' who turn their animals into aesthetic forms in ways that appear spectacular, eccentric and impossible to ignore.

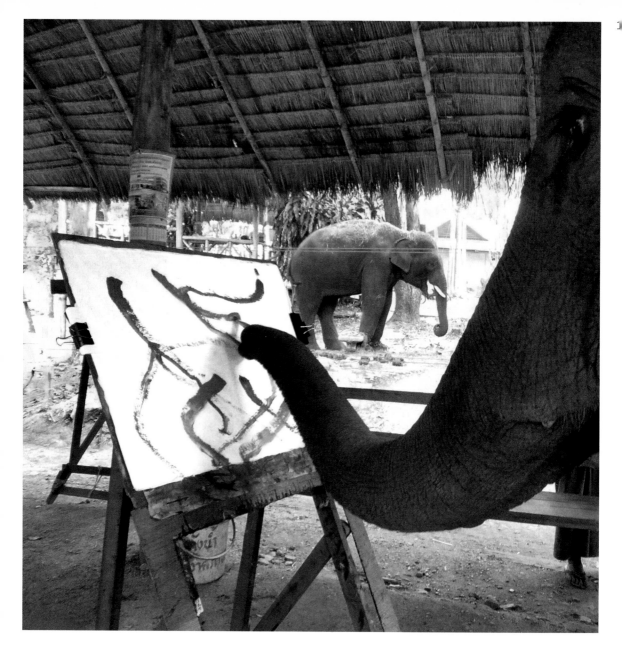

Elephant painting in Thailand began in 1998 when Richard Lair invited the conceptual art partnership of Vitaly Komar and Alexander Melamid to teach selected elephants at the Thai Elephant Conservation Centre (TECC) to paint. Elephants had done this before in over twenty zoos and circuses around the world, but this was the first such occurrence in Thailand. The work of this artistic partnership soon came to prominent media attention worldwide.

A similar elephant art project, known as The Elephant Art Gallery TEAG, was initiated by British citizen in Thailand Henry Quick, shortly after Lair's project got off the ground. The first TEAG elephant art was shown alongside human art at HQ Art Gallery in Chiang Mai in early 2000. The elephants are not cued in any way during their painting sessions.

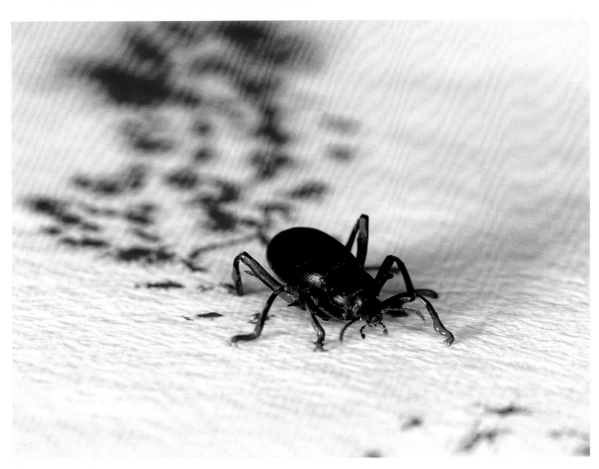

Bugs, too, make art. Californian entomologist Steven Kutcher uses insects
as living paintbrushes to generate his 'participational' paintings: part
bug/part human. Kutcher delicately loads the bug's legs, be it a fly,
cockroach or other creature, and sets it loose on a prepared canvas.
Using non-toxic materials, the bugs scamper around until the paint is
gone, having created their 'masterpiece' while remaining unharmed.

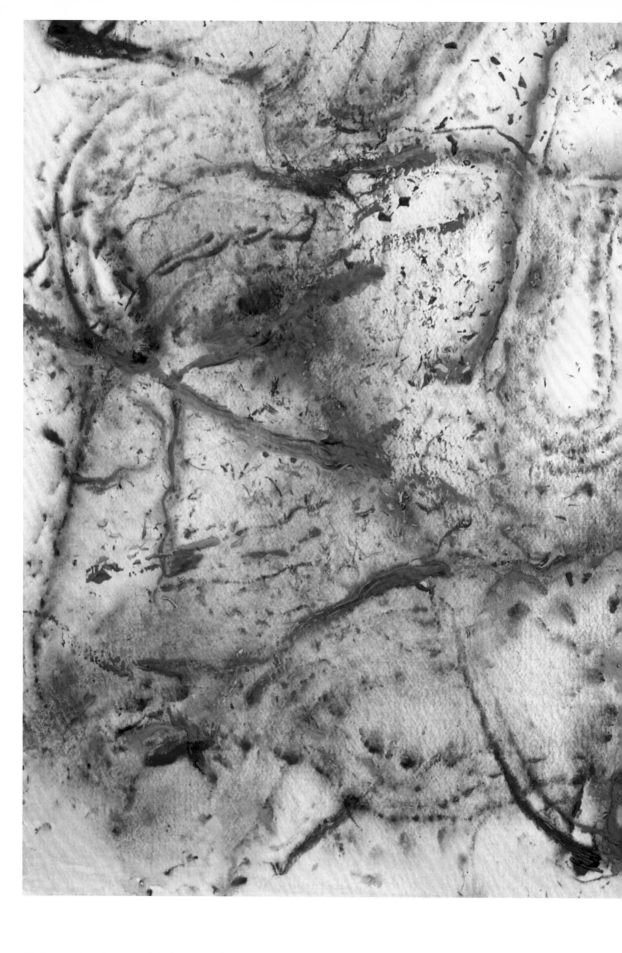

This painting, which at first glance resembles surrealist fantasy images of nature, is in fact an 'action picture' created not by a human hand but a very active bug.

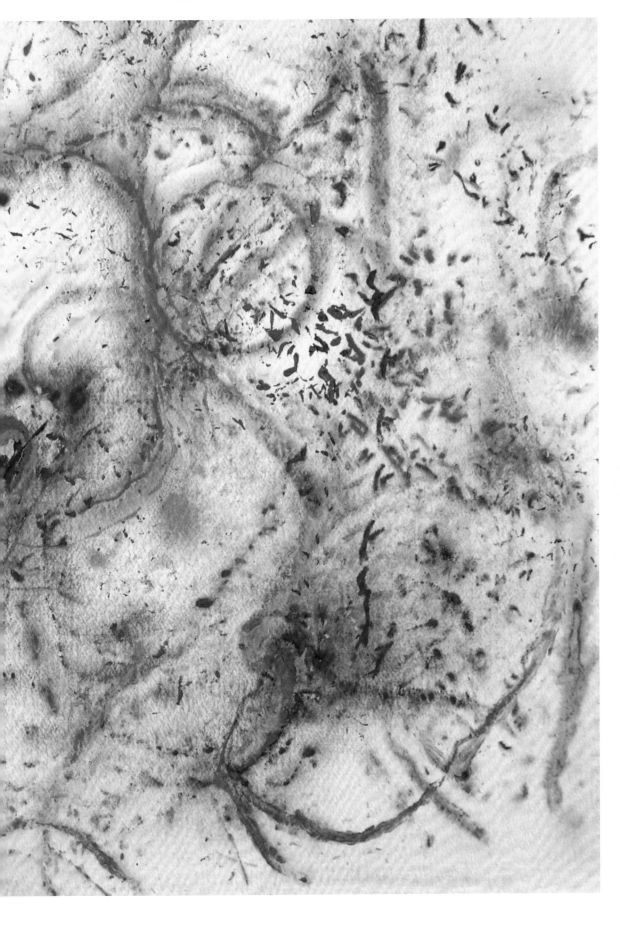

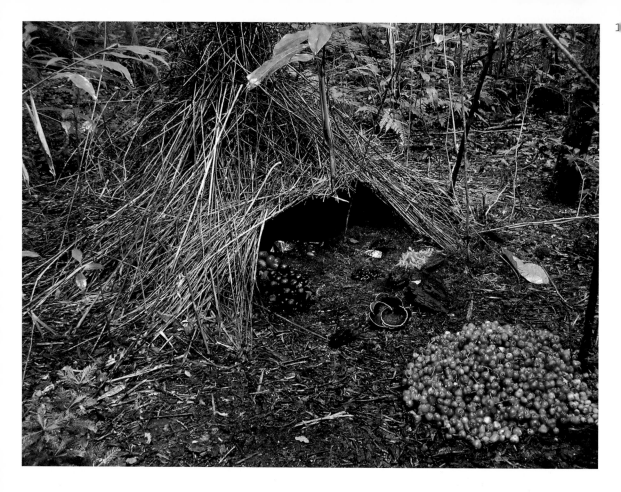

Do animals have an aesthetic sense? Is it arrogant of humans to claim
that no species other than our own is able to experience something like
an aesthetic sense? We do know that animals respond to aesthetic stimuli,
and in certain cases actually make art for other animals. The case of
the Vogelkop bowerbird in New Guinea speaks volumes: male bowerbirds
make elaborate constructions of sticks and decorative objects to attract
a mate.

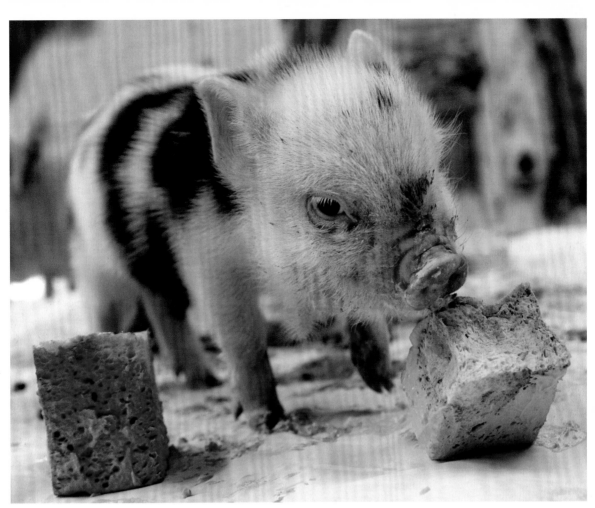

Among throngs of unacknowledged artist-animals are Del Boy and Rodney, the painting miniature piglets from Devon, England, known collectively as 'Trotters Independent Painters'. Is an artist-animal capable of enjoying the aesthetic product of his work? Whatever the answer, the piglets and their art production pose serious questions about the definition of art.

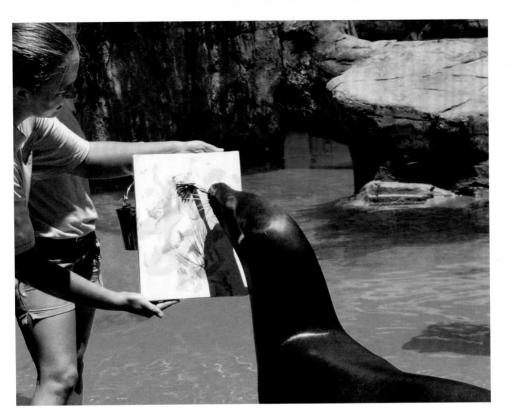

Sea lions are able to paint by holding a brush in their mouths, and zoos and refuge homes have been created to bring attention and resources to this astonishing phenomenon. Here, Sushi paints a picture in her New Orleans Audubon Zoo home. The painting was exhibited and auctioned in a fundraising event to help give animals like Sushi a permanent home.

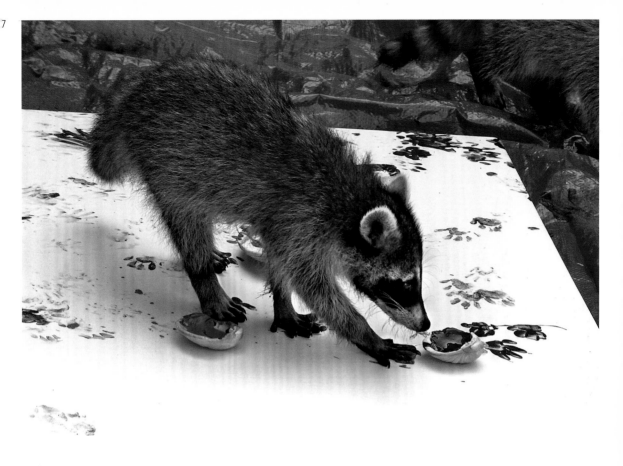

In Kansas, a raccoon utilizes shells as paint pots and fingers and toes as paintbrushes as it paints its way across a prepared canvas. A part of the move to bring funding to zoos and animal habitats, this furry artist represented Hutchinson Zoo in a 2008 auction of animal art.

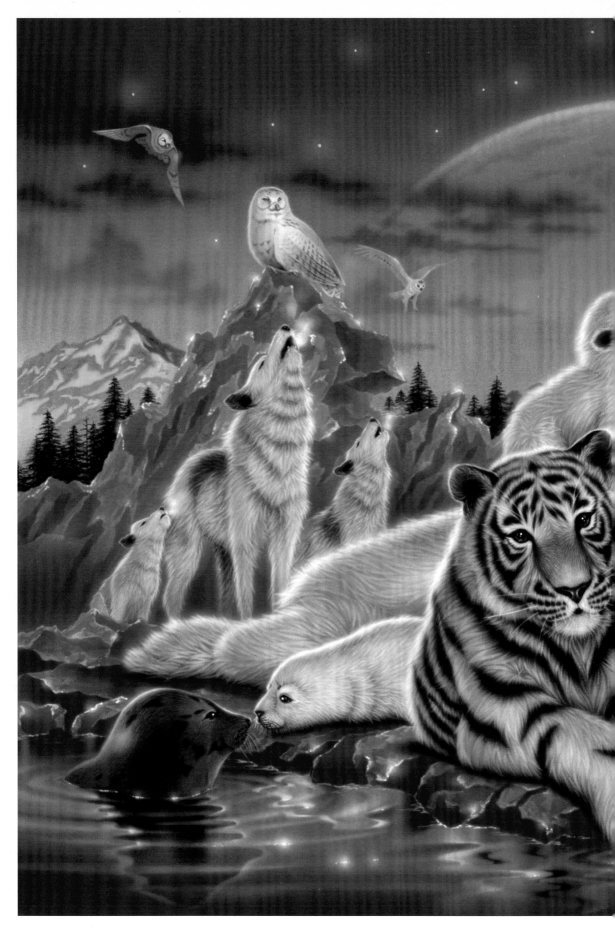

Animals often feature as subjects in fantasy wild art. Japanese artist
Kentaro Nishino paints fantastical and idealized scenes of nature,
featuring outlandish colours rendered in acrylics and airbrush. Depictions
of wildlife, particularly white tigers and wolves in striking blue arctic

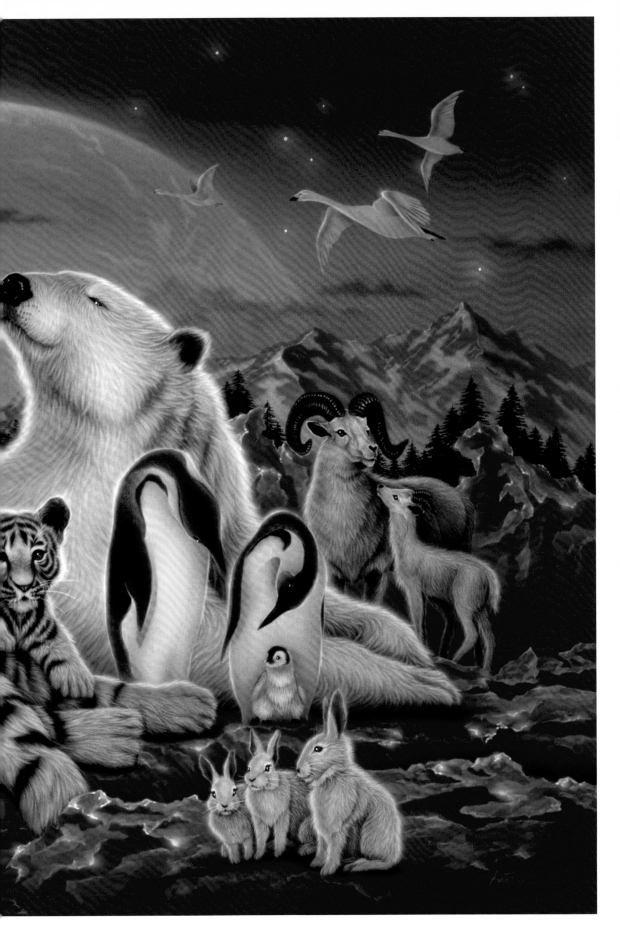

landscapes are a mainstay of 'kitsch' – or what is now more fondly known as 'spectacle' art. Nishino's *Family* from 2009 develops this tradition of wild art in a striking way.

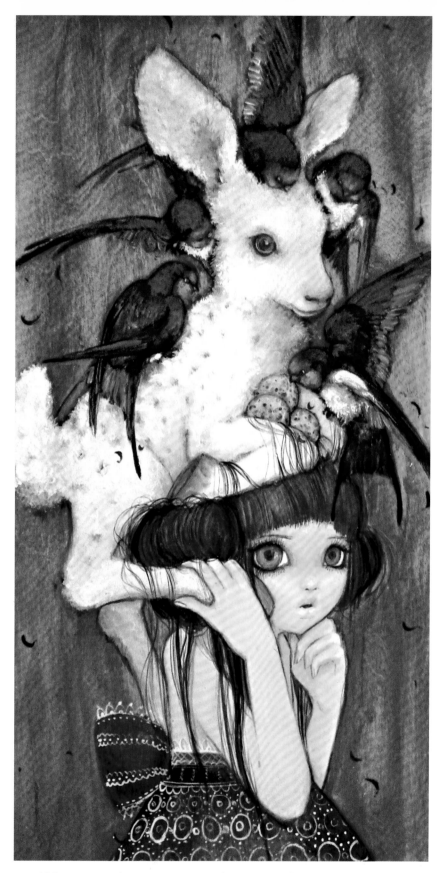

Camilla d'Errico's strangely seductive 'Helmet Girls' series often features bizarre headdresses composed of live animals. Her young heroines seem to struggle and cry under the weight of their own heads. Here is her *Bambi's Egg Child*, painted in 2008 using oil and acrylics on wood. Other artists such as Margaret Keane, as well as Japanese comics and animation, influence her style. D'Errico has illustrated and designed a variety of comics, graphic novels and books, stationery, toys and handbags, among other products.

Canadian fantasy artist Den Beauvais, aka 'The Imaginator', has won many awards for his book covers and comics. After some early study in an Ontario commercial art school, he developed his skills as a self-taught illustrator.

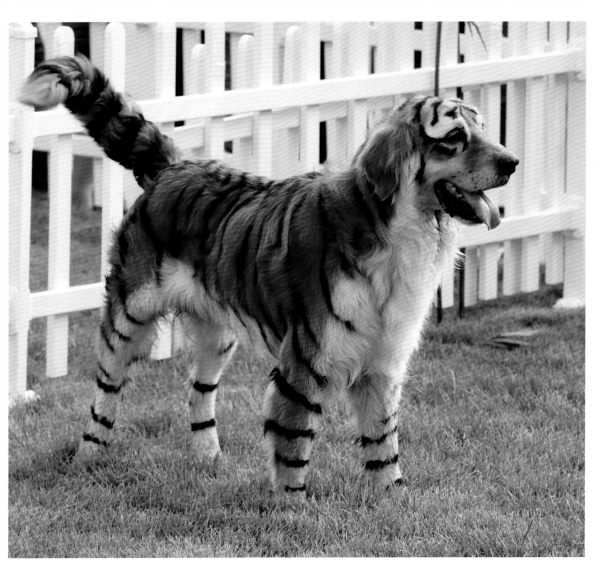

Of course, animals themselves can sometimes become the art. As dog owner-
ship grows in China, painting pet dogs as depictions of other animals has
become fashionable. This example of a dog painted to look like a tiger
comes from Zhengzhou, Henan Province of China in 2010.

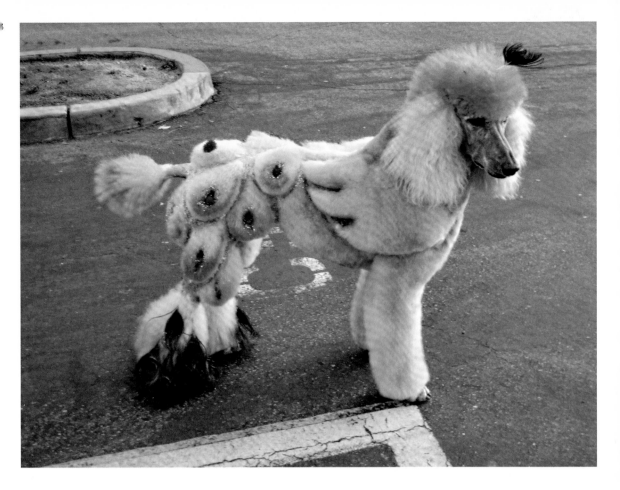

As dogs are turned into living sculptures, so a variety of shows have become highly competitive platforms to showcase each artist's work. Here, award-winning groomer Sandra Hartness has transformed her dog Cindy into a peacock.

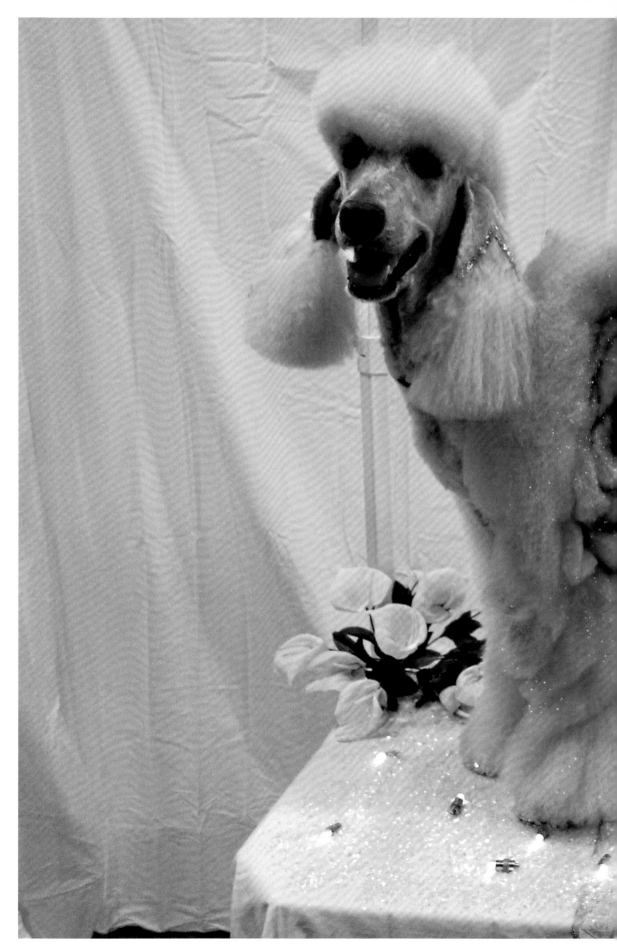

Angela Kumpe, who steadfastly remains outside the established art world, 'prepares' dogs. Recently, her exquisite works have helped her become the groomer-to-beat at artistic grooming contests. This design, *Grieving*

Angel, is on seven-year-old poodle Missy and was completed after Kumpe's mother died. The design includes a sleeping woman and delicately shaped flowers, all made using non-toxic, semi-permanent dyes and pens.

It's not just members of the animal kingdom that can be used to produce living art. This artwork was composed using petri dishes painted with living bioluminescent bacteria: all of the light shown was produced by the bacterial colonies. The piece, measuring approximately 2.7 x 1.5 m (9 x 5 ft), was installed in December 2002 at the O'Malley Library, Manhattan College in New York. The work was part of an exhibition that aimed to bring art and science closer together.

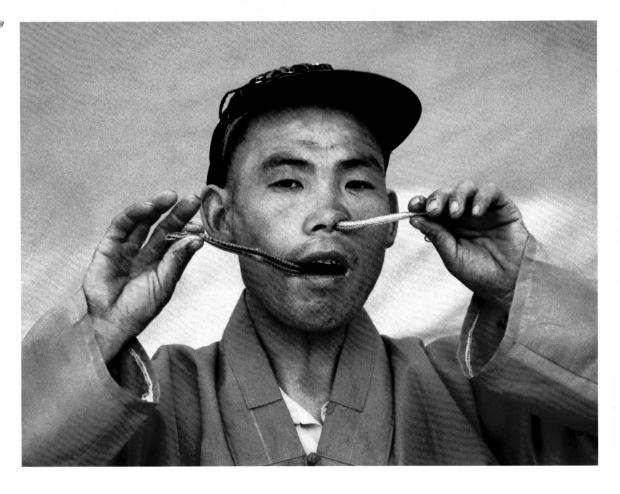

This snake has become wild performance art, having been inserted into a man's mouth and nostrils as part of a celebration marking the Chinese Lunar New Year outside the Beijing Temple in 1999.

A naturalist and artist, Sarina Brewer 'recycles the natural into the unnatural, breathing new life into the animals she resurrects'. Her wild art is made of recycled animal components. Strongly opposed to killing animals to make art, she creates fantasy creatures that look a bit scary, yet strangely fascinating, as is the case with this piece, *Mother's Little Helper Monkey* from 2005.

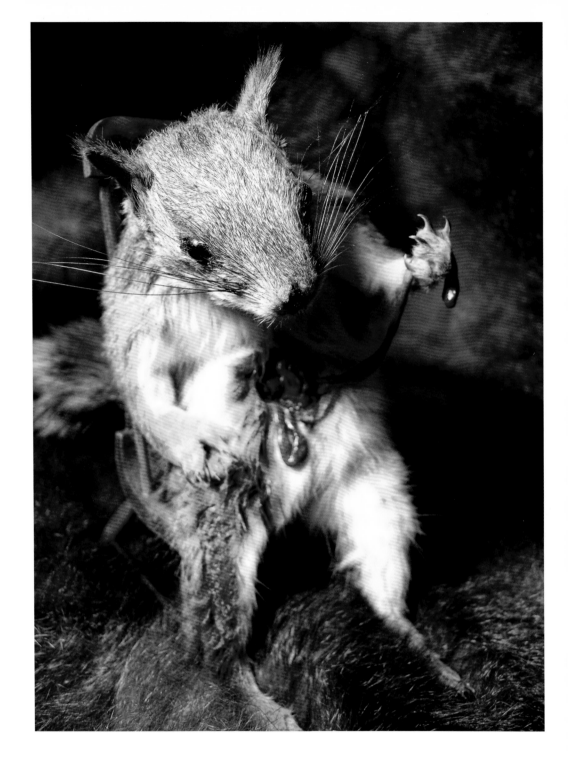

This is taxidermy with a difference! A co-founder of the Minnesota Association of Rogue Taxidermists, Robert Marbury makes wild art from animals that have met their end in a variety of ways, including roadkill, discarded livestock, animals that have been destroyed as pests and those that have died of natural causes.

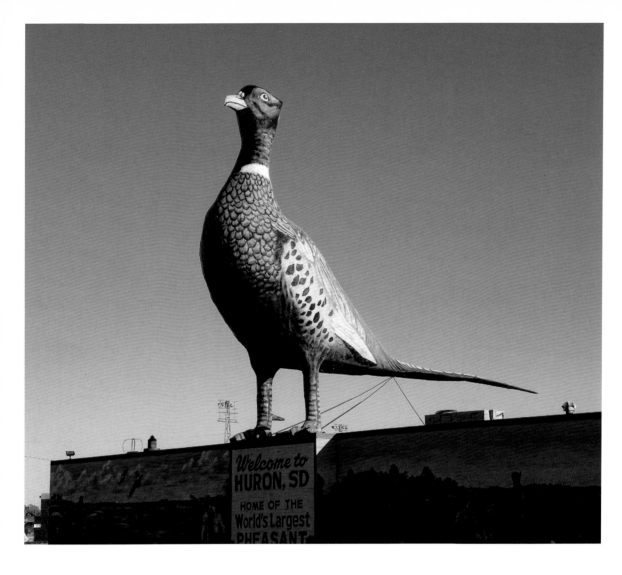

Spanning 12 m (40 ft) and reaching 8.5 m (28 ft) in the air, the world's largest pheasant dominates a building in the heart of pheasant-hunting country in Huron, South Dakota. The artist R. F. Jacobs was commissioned in 1959 to create the sculpture, and it stands as a proud landmark in the small town. The original idea for the work comes from a local legend, wherein a giant pheasant roamed the plains, appearing to hunters but was never killed. One day a young boy had the bird in his sights, but mesmerized by the magnificent being, did not shoot. The pheasant, realizing what had happened, thanked the boy and the town by blessing future hunting seasons.

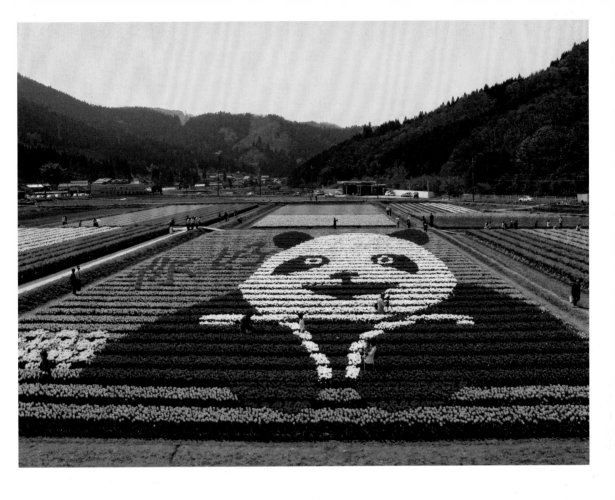

A fallow field in Hatayama, Japan, is used for an annual Tanto Tulip Festival, held each April. This design of a panda was made from 10,000 flowers in 2008.

The Giraffe Childcare Centre in a suburb of Paris certainly stands out!
The incorporation of a giant yellow giraffe into the design is meant to
appeal especially to children, and you have to walk through its legs to
enter the building.

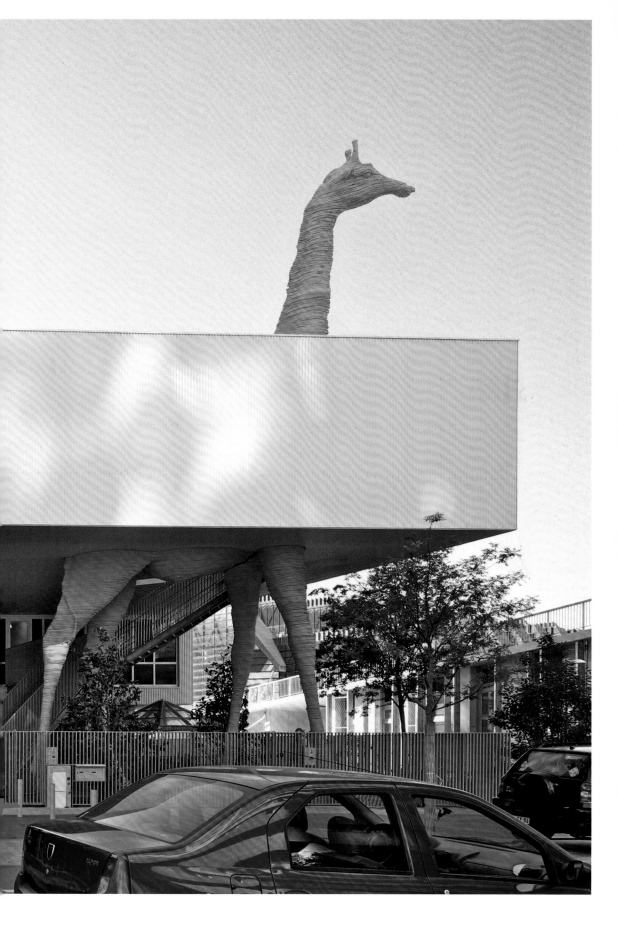

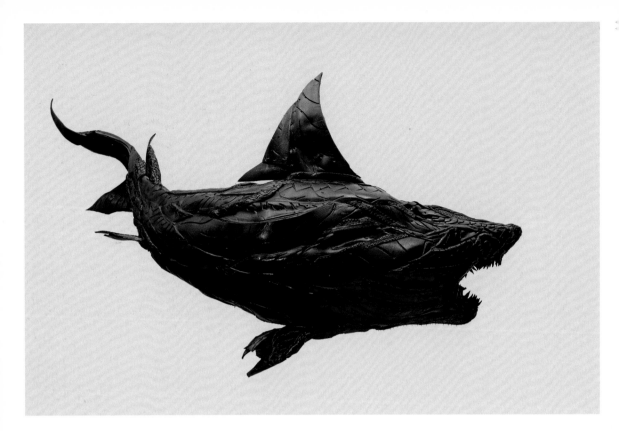

Korean artist Ji Yong Ho creates a wide range of animals out of man-made materials, in particular tyre treads. *Shark 13*, made in 2011 and measuring 240 x 130 x 110 cm (94 x 51 x 43 in) is made from used tyres and synthetic resins.

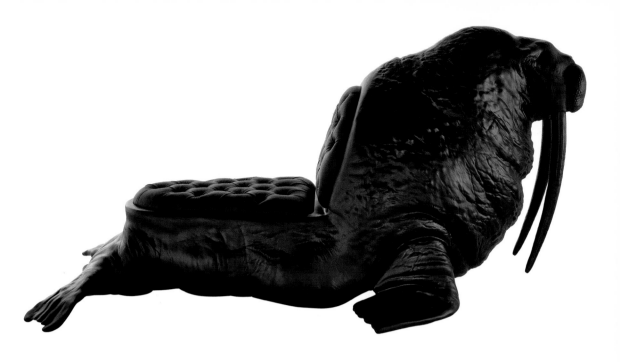

Maximo Riera's collection of chairs inspired by animals are crafted in his studio in Cadiz, Spain. His work includes rhinos, elephants, whales and octopuses. These are wild animals that you can put in your living room - to sit on.

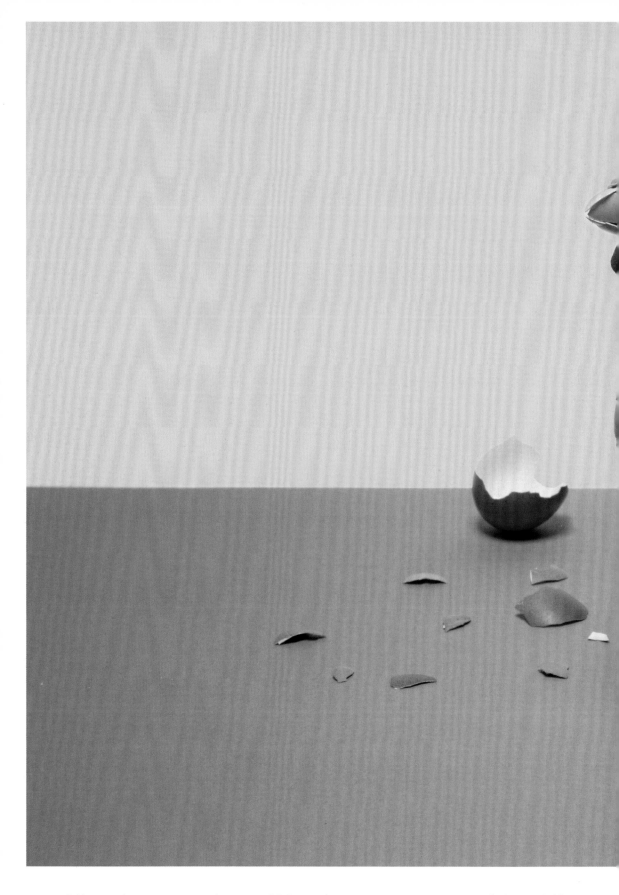

Just like mainstream artists, wild artists can present us with a philo-
sophical conundrum. Kyle Bean's *What Came First?* is a sculpture of a
chicken made from eggshells. As Bean explains: '*My new project is a funny
take on the well-known saying. I thought it would be a nice ironic twist
to actually make a chicken from eggs. It has taken a couple of failed
attempts and I have eaten quite a few poached eggs and omelettes in the
last couple of weeks, but I have finally finished the sculpture.*'

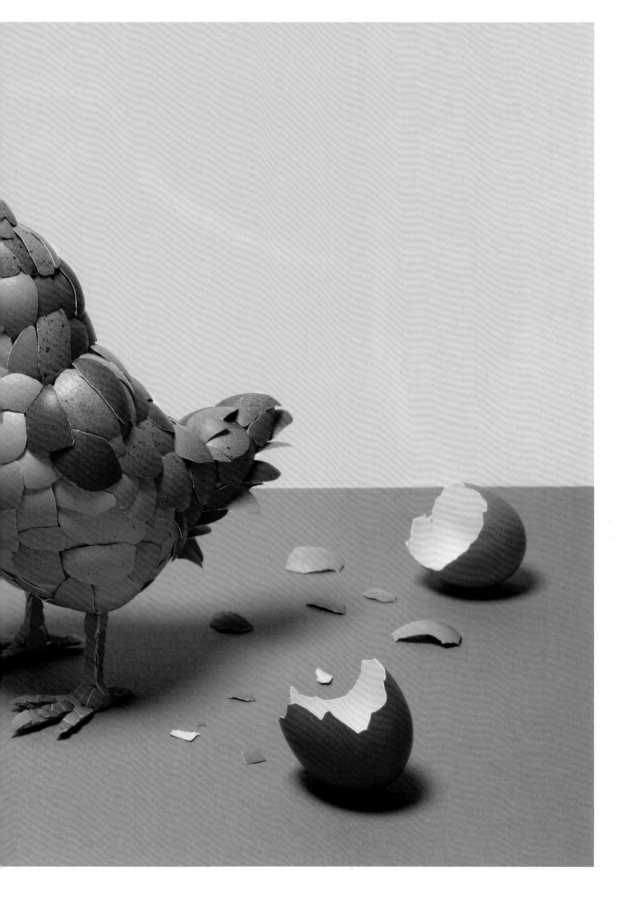

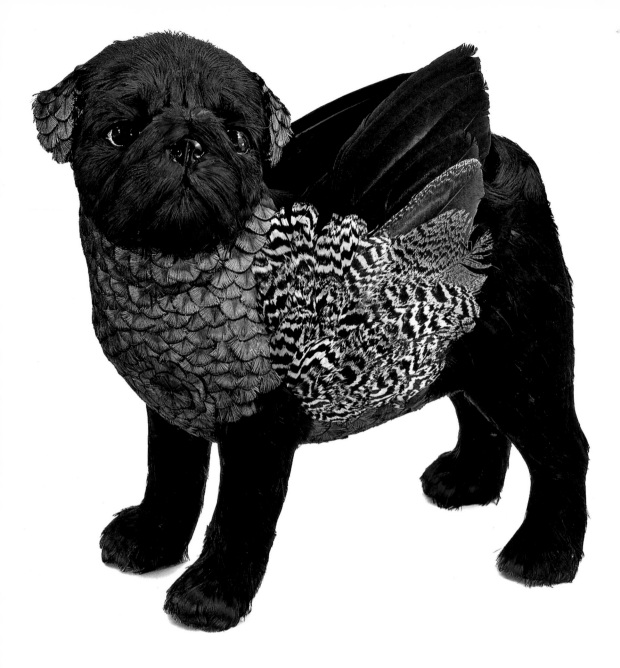

'*Feathers are my paint,*' states Emily Valentine, who uses them to create
mythical beasts. This creation, which forms one half of her 2008 work
Pair of Pugcocks, was made primarily using feathers, and each dog meas-
ures 28 x 35 x 18 cm (11 x 14 x 7 in). Like many wild artists, her art
makes a political statement: '*In my work, I wish to discuss how attitudes
to wearing birds' parts have changed. Is this just because of fashion, or
has society become more caring of animals? I wish to stimulate the viewer
with the uncomfortable nature of the feather, to question our callous
treatment of animals and birds, and ask how we subconsciously classify
animals – pet or pest, valued or worthless, beautiful or plain, and why.*'

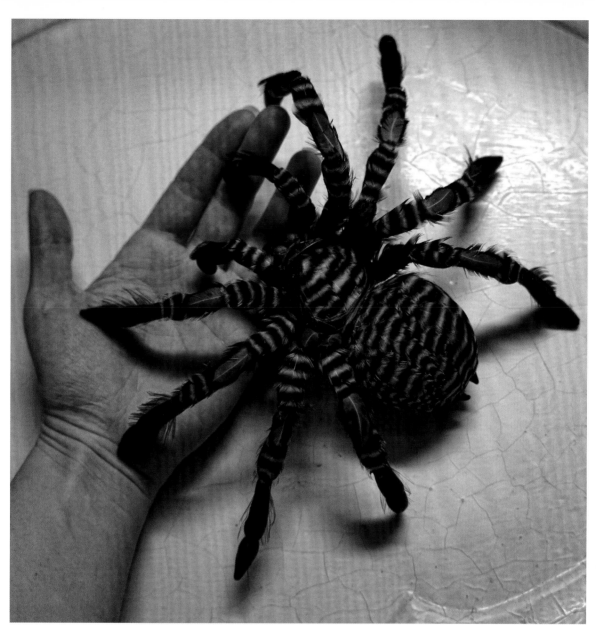

The artist Escaron used feathers, along with wire, tin foil, acrylic paint and glue to create this realistic spider in her work *Arachnid*. Just as art world artists depict animals using pigments, so can a wild artist use bird feathers to represent a spider that looks real enough to bite.

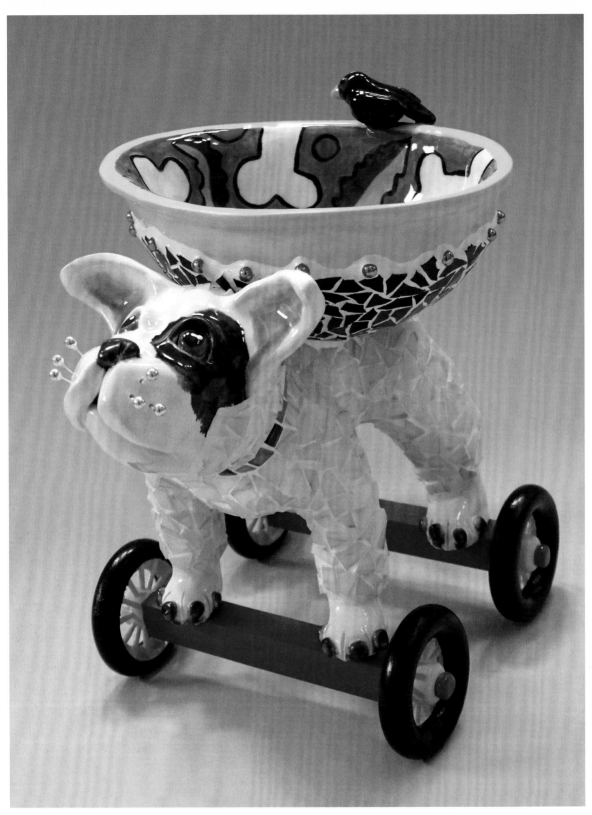

Riley is a ceramic dog, handmade by animal-inspired, California-based artist Suzanne Noll. Working with ceramics, stained glass and mosaic materials, Noll creates a variety of objects in addition to sculptures, including clocks and urns for pet ashes. The urns offer an aesthetic testament to the dedication with which animal lovers will care for their beloved animals, dead or alive: they even buy art for them, before and after death.

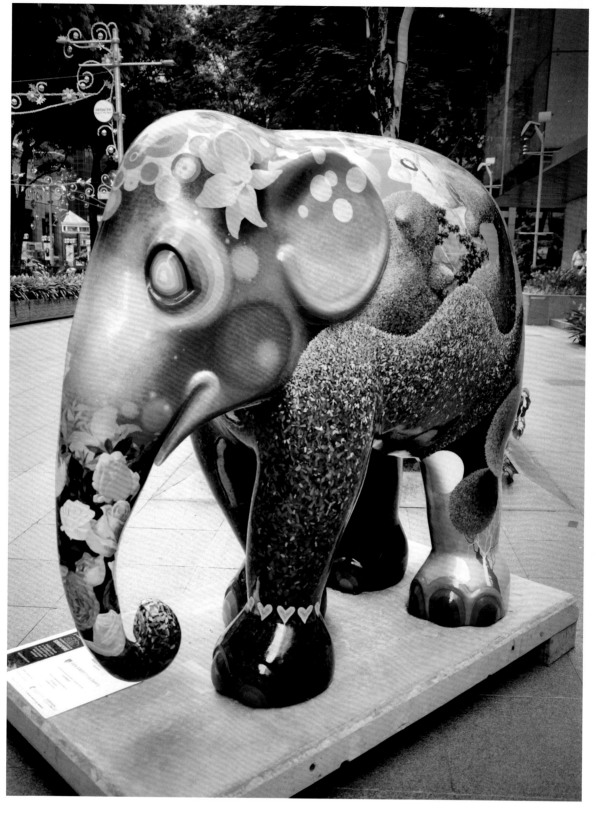

This bright elephant sculpture from Singapore was one of 160 that were painted by international artists as part of the 'Elephant Parade Decoration'. They were distributed throughout the city in 2011 to promote public awareness of elephant conservation.

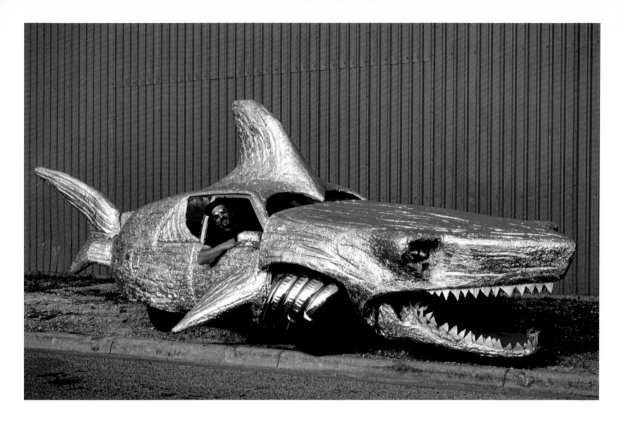

Designer Tom Kennedy created *Ripper the Friendly Shark Car*. Constructed from a 1982 Nissan Sentra, it has been transformed into one of the ocean's most feared creatures. One can imagine that climbing inside this evocative beast might illicit macabre feelings: either the sense of being digested inside the belly of the beast or the desire to eat up unsuspecting pedestrians. Inside, blue fluorescent light illuminates fish dangling from the car's ceiling. It has appeared at many parades and events, including several Burning Man festivals.

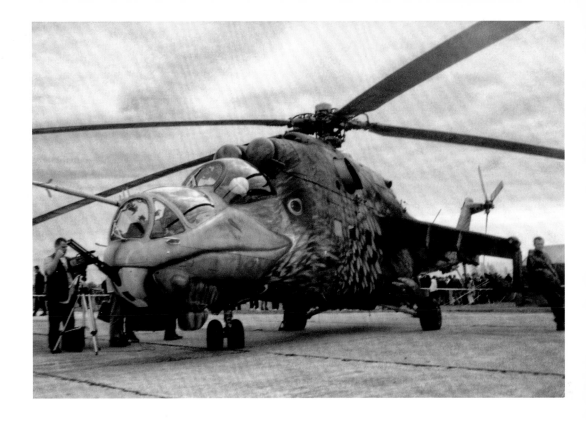

This spellbinding painted aircraft is an Mi-24 Hind helicopter (known as *Tweety*) which belongs to the Hungarian Air Force. Painted and intended as an air-show exhibition piece, this is truly a stunning example of art in odd places. The symbolic meaning between the fierce reputation of the eagle, a preeminent hunter, fits perfectly with the perception the aircraft crew would want to project. In battle, this would appear as a fearsome piece of propaganda and a great use of art to frighten enemies, and follows the legacy of the Viking ships made to look like threatening monsters. The art of war decoration, whether on the body or weapons, is something that has been practised for hundreds of years.

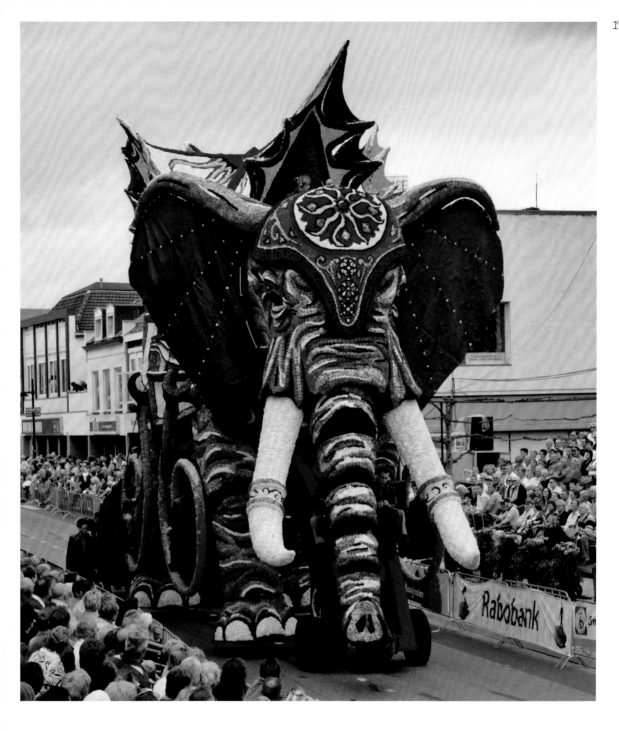

Bloemencorso Zundert is a huge flower parade held annually in the Netherlands, featuring magnificent floats sculpted from organic matter. Neighbourhood associations design and build the floats, which can include dahlia blooms numbering almost 500,000, each grown in neighbourhood community gardens. This elephant was the winning float from 2007; it was called 'MCE'(Manually Controlled Elephant) and was built in the hamlet of Stuivezand. Its designers were Bart Goetschalckx, Ben Vriends and Jeroen Boot.

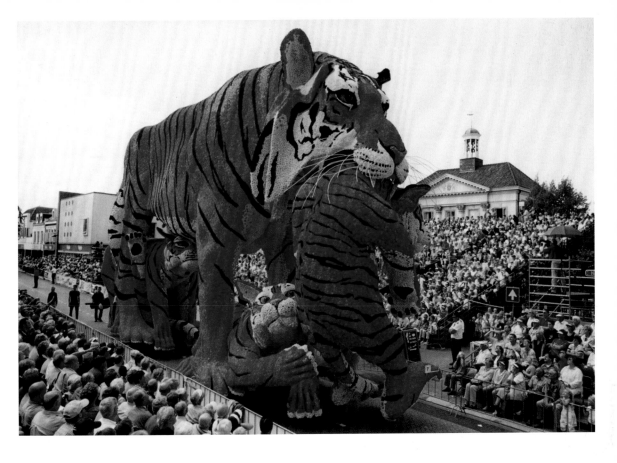

This tiger was the winning float from the 2002 Bloemencorso Zundert. It was called *Moeder's Kroost* ('mother's offspring') and was built in the hamlet of Klein-Zundertse Heikant. Its three designers were Aart-Jan Borrias, Erik van Elsacker and Rene Jochems, and it is still considered by many to be the most beautiful float ever built for the parade.

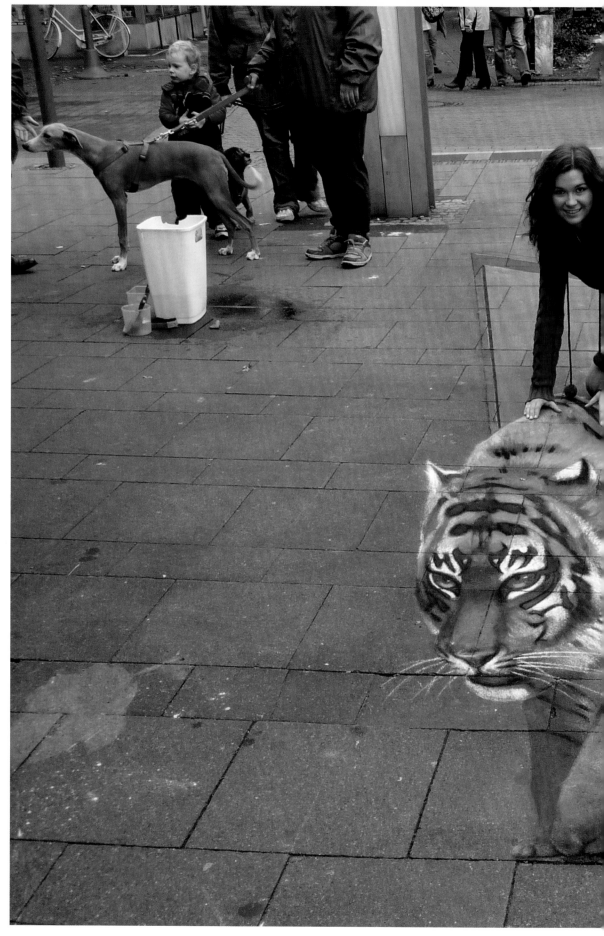

German street artist Nikolaj Arndt creates awesome three-dimensional
animal art. Here we see a real woman pretending to ride on his *trompe
l'oeil* image of a tiger in Geldern, Germany, in 2010.

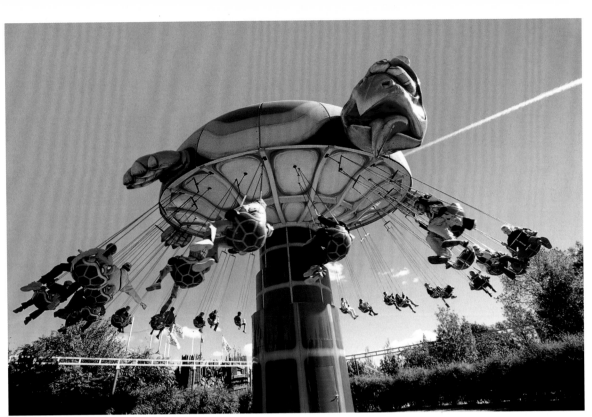

The Danish amusement park Bon Bon Land uses vulgar and unrefined visual motifs to surprise and delight visitors. The concept of the park came to fruition when Michael Spangsberg, a confection maker, decided to open the park so that visitors (for whom access to his actual factory was restricted) could gain access to his wonderful and delicious world. His confectionary creations, involving animals and other objects, form the basis for the rides and amusements. This ride is called Skildpadden.

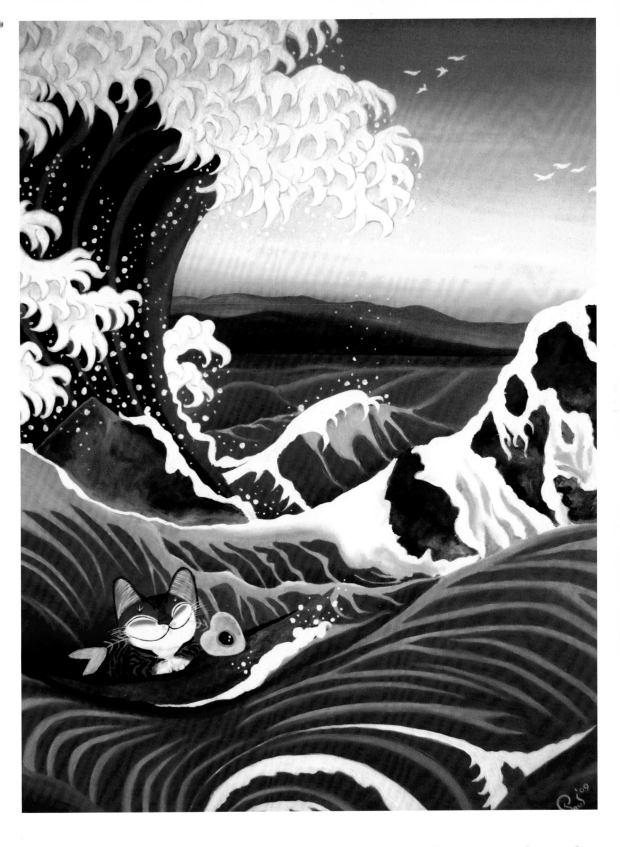

Paul Koh is a wild artist whose paintings such as this one, *Catch Me If You Can*, feature cats. As he explains: '*This is an exploration of the classic paintings I love. It's a way of immersing myself via the cat into the adventures of these masterpieces. How else can you sail the great wave in Hokusai's painting, pose in Botero's still life, or appear between Mondrian's lines? It's about entering into a dialogue with these classic paintings and making them accessible to viewers from another perspective. It is akin to Warhol creating art out of an ordinary soup can. By introducing the cat, a door is opened and the audience is invited to participate in the painting.*'

When artists such as Leonardo or Correggio depicted the mythical story of *Leda and the Swan*, their paintings were accepted into the art world. However, in more recent years this same subject has become a source of controversy for contemporary wild artist Derek Santini. His work *Goddess of Love* shows a swan engaging in a sexual act with a woman. The work is

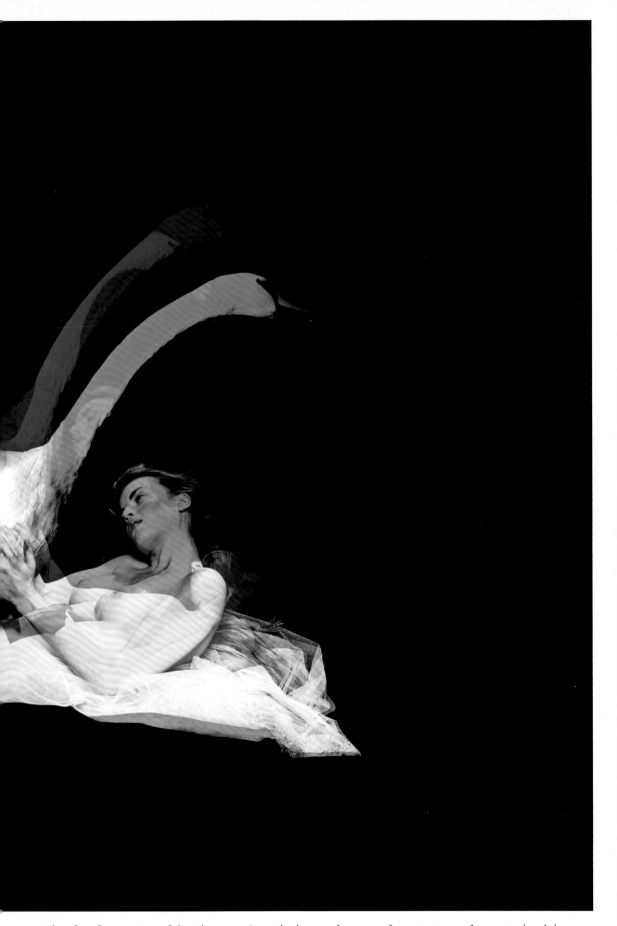

particularly naturalistic as Santini used a real woman and swan in his photograph, and also created a lenticular effect, so that the image seems to move as the viewer passes it. The police demanded that it be removed from a gallery window in London in 2012, after concerns were raised that it promoted bestiality.

In Taste

'THE TRUE COOK IS THE PERFECT BLEND, THE ONLY PERFECT BLEND, OF ARTIST AND PHILOSOPHER. HE KNOWS HIS WORTH: HE HOLDS IN HIS PALM THE HAPPINESS OF MANKIND, THE WELFARE OF GENERATIONS YET UNBORN.'
– NORMAN DOUGLAS

Paintings and sculptures are usually made to be seen. By contrast, wild food art is a feast for the eyes *and* the taste buds. Combining two senses, gustatory and visual, the culinary art examples shown here ask that we judge whether their look matches their taste. All these examples of art attempt to reconcile the two different meanings of taste: aesthetic and gastronomic.

The artists in this chapter turn ingestible ingredients into art materials. There are a considerable number of venues where one can admire, and consume, culinary art, but of course even with the use of artificial preservatives it can be difficult for such works to last long, as either disintegration or the human appetitie destrong them – a challenge for even the most dedicated conservator.

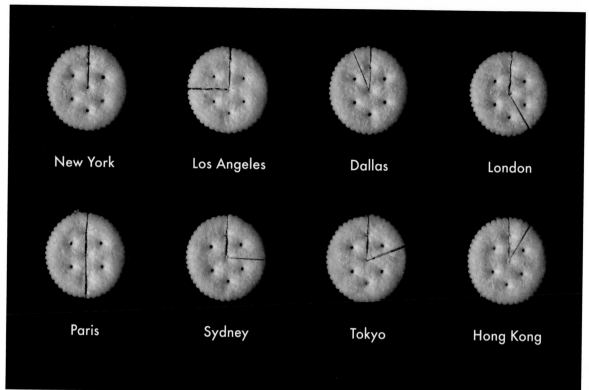

New York Los Angeles Dallas London

Paris Sydney Tokyo Hong Kong

Among other media, artist Kevin Van Aelst creates various artworks from foodie beginnings, including a Mondrian-looking slice of bread and a Krispy Kreme donut highlighting cellular separation. In *Local Times* we can use these cracker clocks to keep up with the rest of the world.

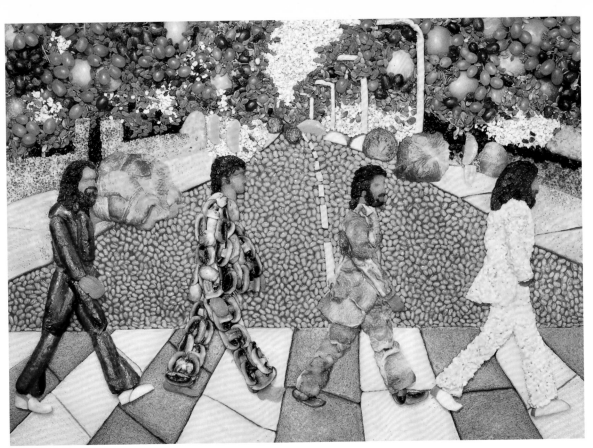

Food sculptor Paul Baker used a full English breakfast of sausages, bacon, scrambled egg, tomatoes, croissants, crumpets and hash browns to create this tribute to the cover of the Beatles' *Abbey Road* album. The character of Paul McCartney has been created entirely from mushrooms, reflecting his well-known vegetarianism.

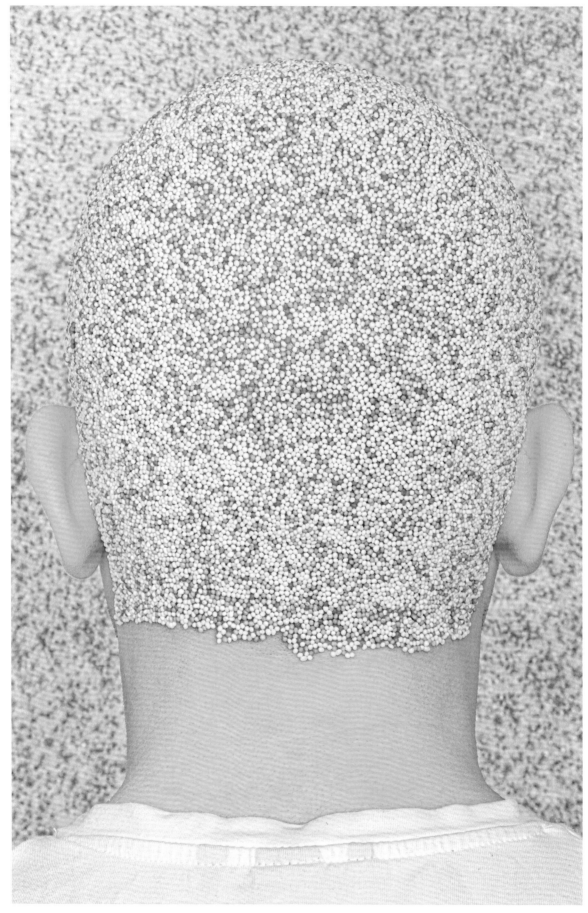

When Philip Levine went bald, he began to use his head as a canvas. Photographer Daniel Regan and body artist Kat Sinclair have created hundreds of designs which are featured on his head, many of which were included in his exhibition 'Headism'.

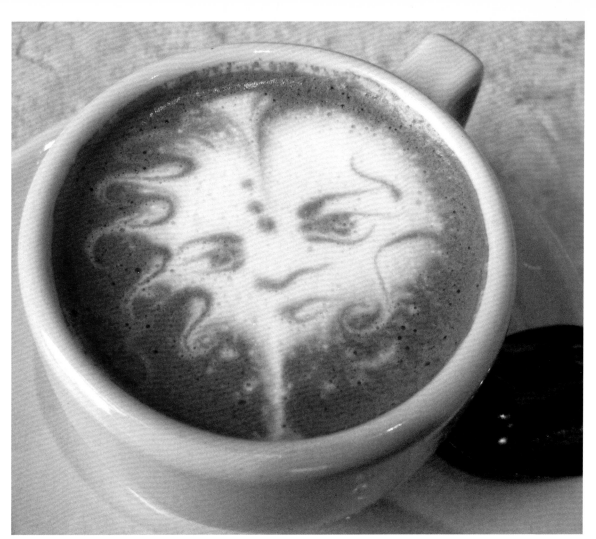

Here is an example of what are referred to as 'latte etchings'. They are
created by pouring steamed milk into a shot of espresso so as to create a
pattern or image on the surface of the drink. The barista/artist Joerael
Julian Elliott who created this one works at Dubsea Coffee in White
Center, Washington D.C. The design possibilities appear endless, the only
constraint is the surprisingly complex skills required in order to create
these new art forms.

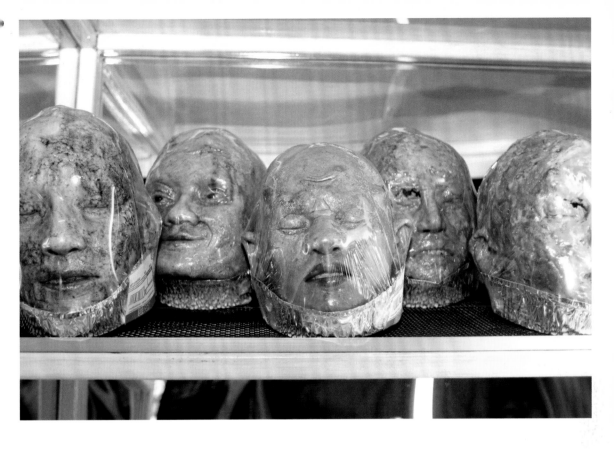

Kittiwat Unarrom creates hyper-realistic body parts baked out of
tantalizing bread, raisins, cashew nuts and chocolate at a bakery in
Ratchaburi, Thailand. Unarrom studied art, having been raised in a
butcher's family surrounded by meat. Blending these two worlds has led to
some shocking results. The impact his work has on his audience (and their
stomachs) is comparable with those encountered in many a contemporary art
museum: for example, Marc Quinn's *Self*, made out of the artist's blood.

Norma 'Duffy' Lyon (1929–2011) was an Iowa-based artist who sculpted butter, as in this rendering of *The Last Supper*, showing the artist herself at the head of the table. A regular fixture at the Iowa State Fair, she also created private commissions for celebrities and politi-

cians. Lyon used to run a dairy farm with her husband in Toledo, Iowa,
which provided the initial context for her highly skilled experiments
with creating creamy artworks.

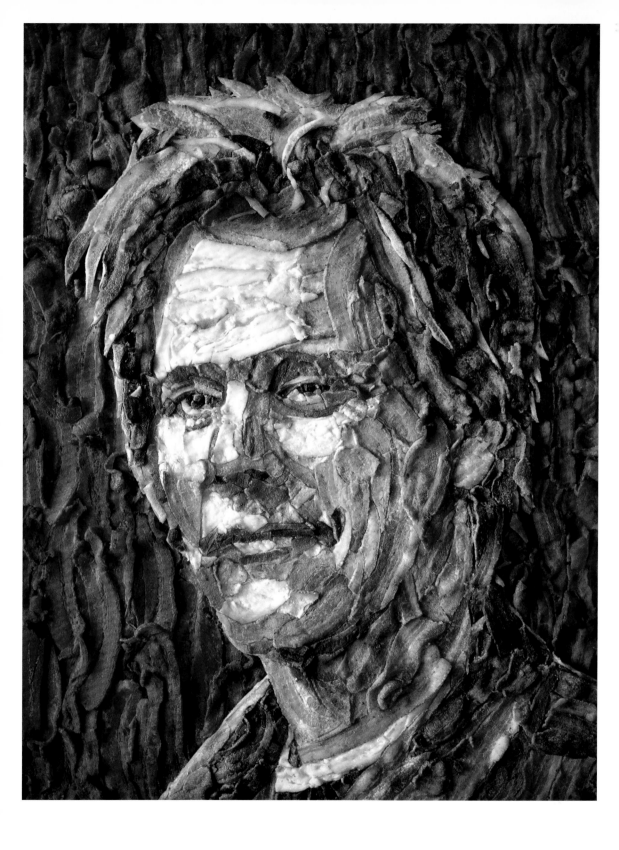

Mosaic artist Jason Mecier is known for fashioning uncanny portraits of
famous people from junk. Now he has made a tasty addition to his collec-
tion with a portrait of Kevin Bacon made from 6.8 kg (15 lb) of bacon.
Mecier, from San Francisco, has previously made Barack Obama from beef
jerky and Harry Potter from licorice.

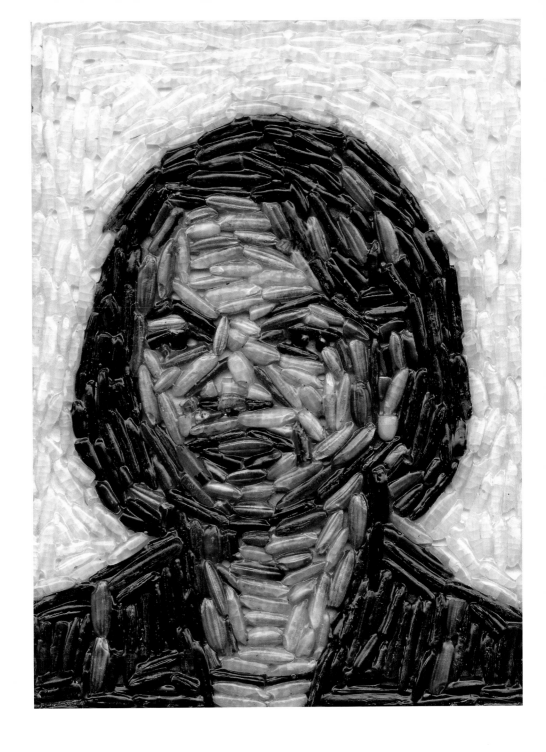

Here, Jason Mecier uses various types of rice in order to make a mini-portrait (7.6 x 10.1 cm, 3 x 4 in) of former US secretary of State Condoleezza Rice. As with his Kevin Bacon portrait, the choice of material provides a visual pun on this powerful woman's name.

Jack Daws makes politically challenging artworks, and his 2003 work *Twin Towers* is no exception. It is a replica construction of the World Trade Centre towers built out of McDonald's French fries, cemented with Heinz ketchup and photographed by Richard Nichol. Through this peculiar – though politically charged – choice of medium, his work challenges the viewer to question some of the national values attached to the American identity at the turn of the twenty-first century.

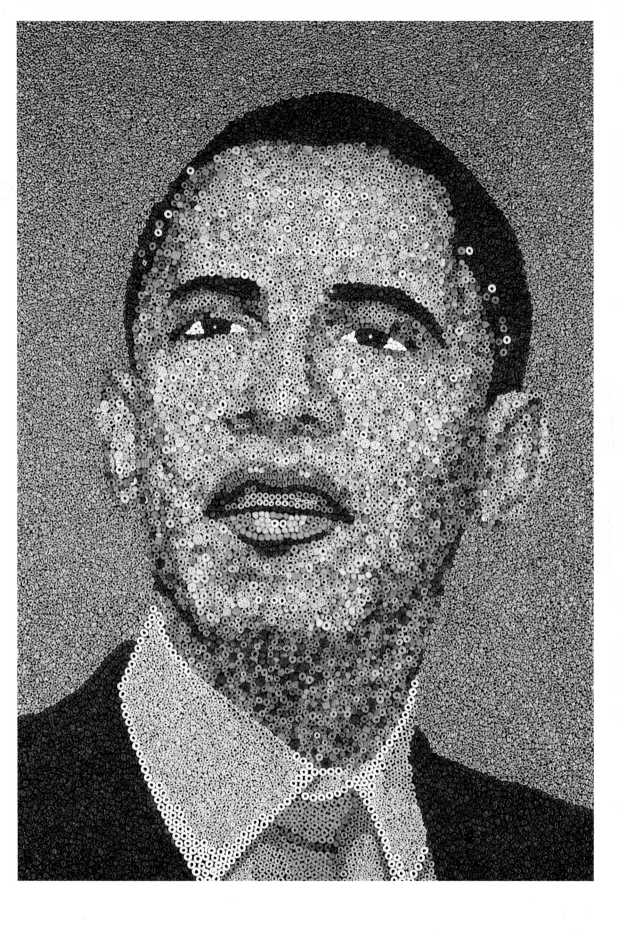

This is a portrait of US President Barack Obama made out of breakfast cereal. The artists, Hank Willis Thomas and Ryan Alexiev, say this mosaic represents what a healthy, balanced democracy should consist of. This work is called *Breakfast of Champion*.

Andrew Solomone created this portrait of Bill Cosby comprising different coloured jelly shots in honour of the actor's birthday. Patrons (over 21s only) were invited to partake from Cosby's head at the Buoy Gallery in Kittery, Maine.

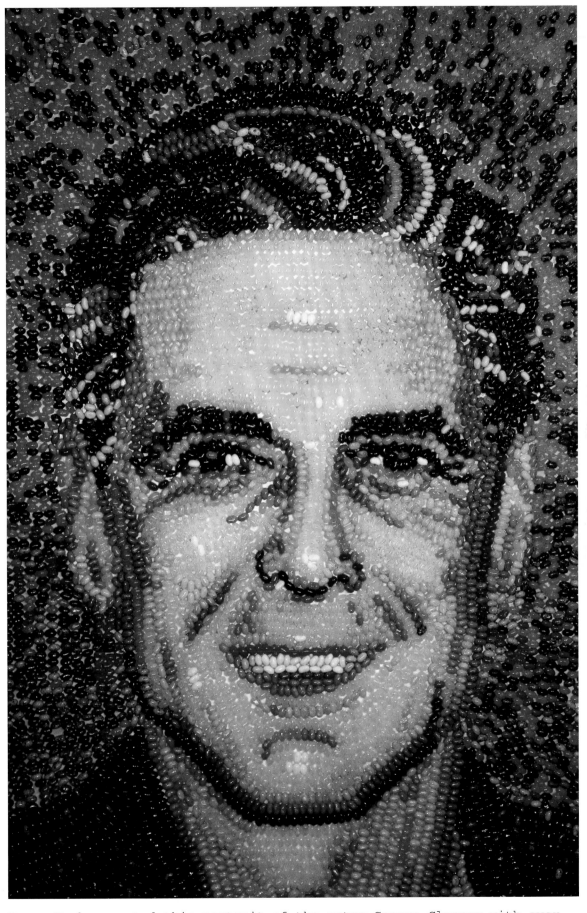

Roger Rocha created this portrait of the actor George Clooney with over 10,000 jelly beans, a commission he received from the Jelly Belly Gourmet Beans Company in 2008. The portrait, displayed at the company's suite at Beverly Hills' Luxe Hotel, was donated to raise money for a charitable cause supported by Clooney.

YaYa Chou used 2,500 jelly sweets to create this decorative light fitting.

In Thailand there is a tradition of fruit carving dating back to the fourteenth century, originating in the court of King Phra Ruang. Thai chefs are expected not only to make food that tastes good but that is also aesthetically beautiful.

As a part of a campaign against food waste, the Russian artist Dimitri Tsykalov uses fruits and vegetables to carve skull sculptures: nothing is wasted. This work, *Skull III*, is from 2008.

Lebanese artist Ginou Choueiri's ongoing project, *Potato Portraits*, is rooted in, well, root vegetables. Potatoes are the raw canvas upon which she carves portraits of famous people and friends and family. Choueiri explains: '*I chose the potato to portray human faces because of the many striking parallels. Not only is their skin porous like ours, but their skin texture and colour is very similar, and like us, they come in different sizes, shapes and forms. Potatoes grow, live, and then decay, mirroring the ephemeral existence and fragility of our own human nature.*'

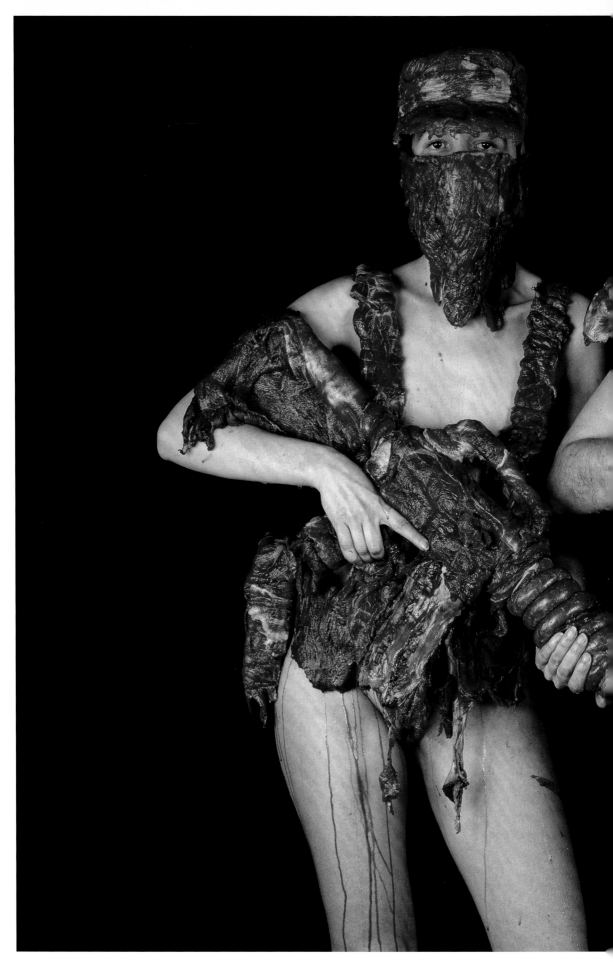
Dimitri Tsykalov is also responsible for these military uniforms and guns made from meat. The bloodiness of the meat makes a powerful statement

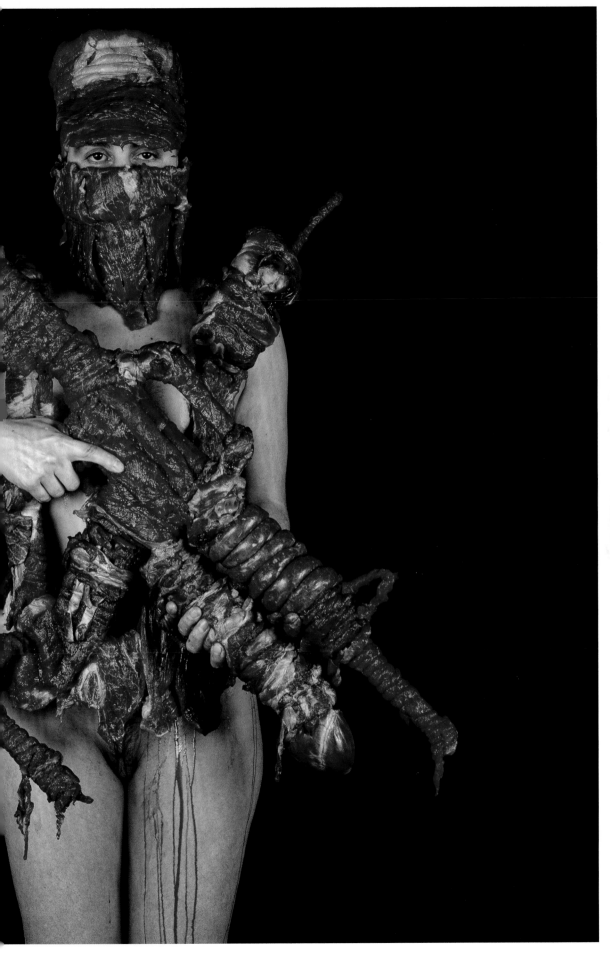

on the violent nature of guns, reflecting the blood lust of his depicted soldiers - or simply the daily realities faced by gun-hogging nations.

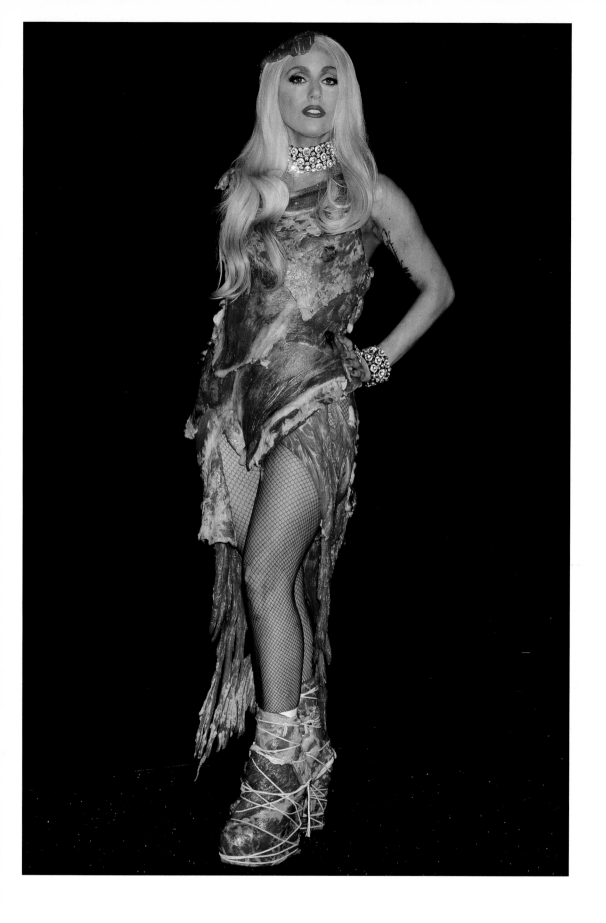

Worn by Lady Gaga to the 2010 MTV Video Music Awards, this meat dress was designed by Franc Fernandez. In giving advice about creating a meat dress of your own Fernandez says, 'Go to your butcher, *get some good cuts and start sewing*,' noting that, just as with cooking, it is important to choose the right cuts of meat.

By contrast, this playful *Cuts of Meat* dress was made by Rhode Island-based designer Kelly Eident and divides the human body into meat cuts such as 'rump', 'sirloin' and 'rack'. The dress is modelled by Eident herself in this image.

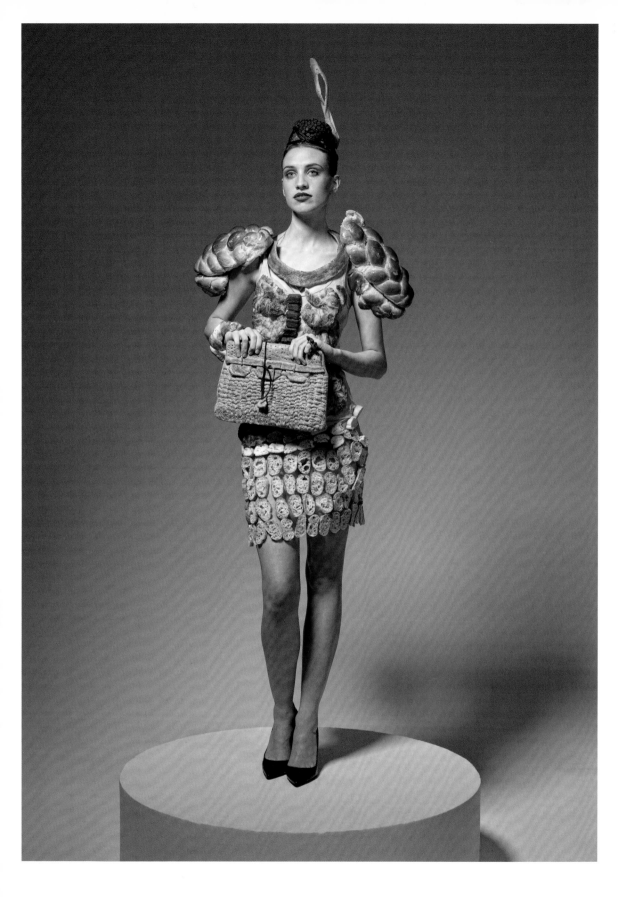

SOTU fashion team, comprising designer Ami Goodheart and fine art photographer Ted Sabarese, created a fashion spread called *Hunger Pains* where models wear outfits made out of food depicting their personal cravings. The photograph represents the food craving for bread and pastries. The challah shoulder pads look large and out of place on the female model's thin frame.

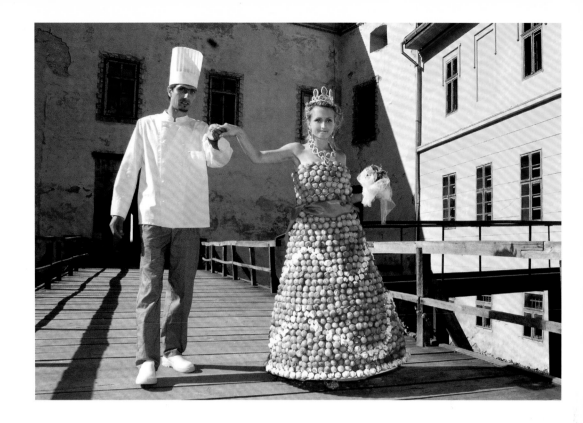

Ukrainian pastry chef Valentyn Shtefano made a wedding dress inspired by the croquembouche, a cone-shaped celebration cake made out of profiteroles. This creation for his new bride, Viktoriya, was made completely out of the delicate cream puffs and weighed about 9 kg (20 lb). It took the baker two months to make. His wife is clearly supportive of her new husband's career, as demonstrated by her willingness to wear his baked goods.

Stephanie Kilgast creates incredible fake food sculptures that would
pose no issues over reducing your portion sizes. Made from polymer clay
and sculpted using pins and toothpicks, her work is either snapped up
by collectors or transformed into jewellery. These cupcake earrings are
about the size of a small thumbnail.

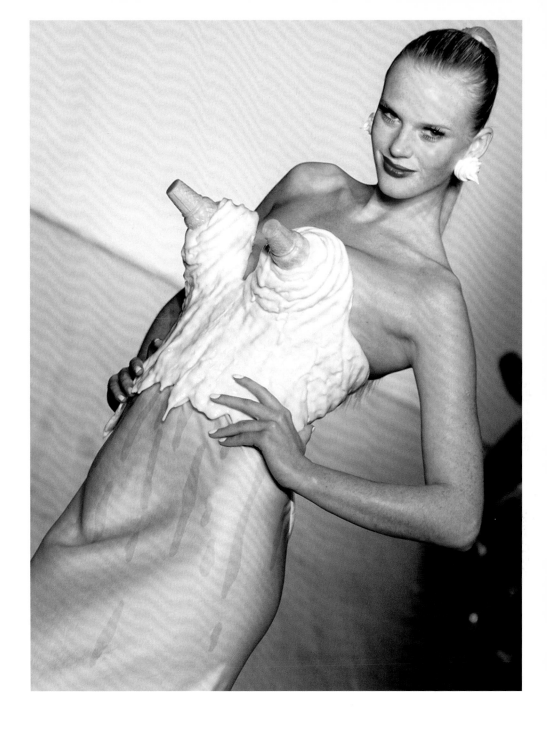

In 2006 New York Fashion Week was in for a delicious surprise when funny-man designer Jeremy Scott unveiled his *Food Fight* collection.

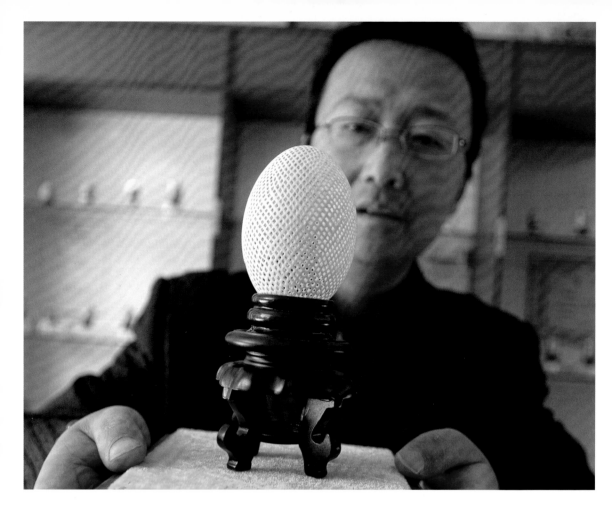

Sculptor Li Zheng Rong has created this intricate artwork by carving more than 2,000 diamond-shaped holes into a hollowed-out white goose egg using special technology.

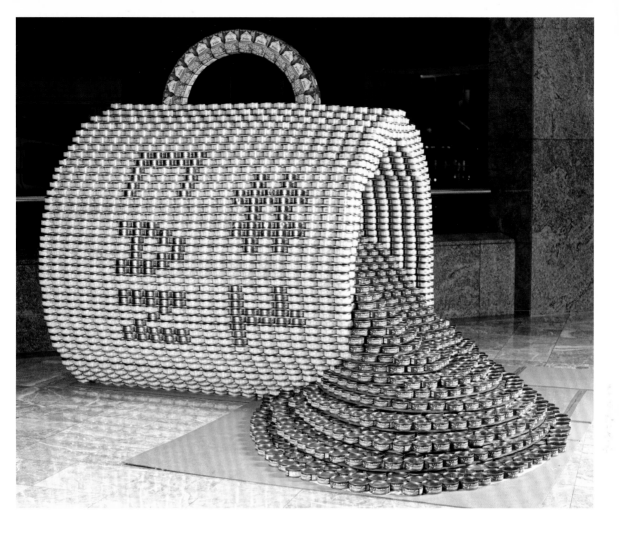

'Canstruction' is a charity competition in the United States where archi-
tects, engineers, contractors and students compete to design and build
giant sculptures made entirely from full cans of food. Once a winner has
been declared, the works are displayed to the public before being disman-
tled and the tins of food donated to charity. This work was entitled *Cups
Can Only Spill*.

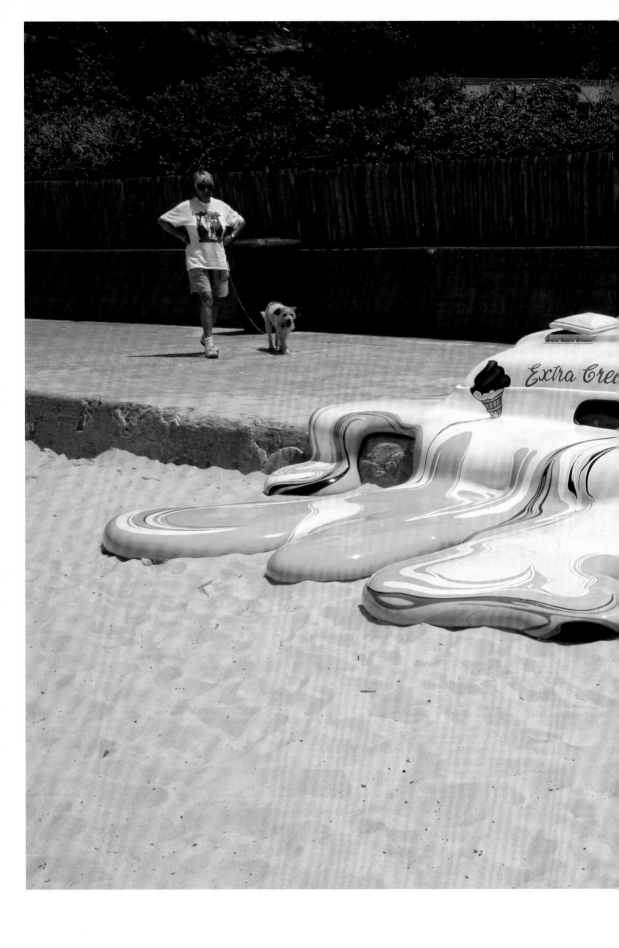

Hot With The Chance Of Late Storm is the name of this ice cream truck sculpture by The Glue Society for the 2006 'Sculpture by the Sea' festival in Sydney, Australia.

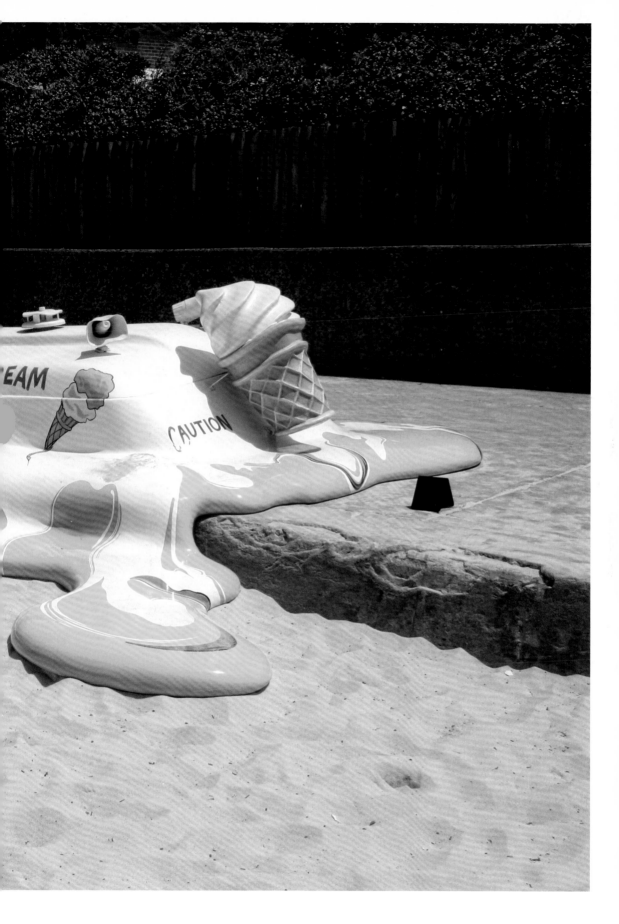

Gayle's chocolates have created something delicious (if perhaps not very durable) in these chocolate shoes, which are decorated with edible glitter dust to create a realistic effect.

Created to promote the ice-cream brand Magnum, this is a chocolate rendering of Baptiste Giabiconi in a scene also made entirely from chocolate. Standing alongside is fashion designer Karl Lagerfeld who directed commercials for the brand which starred Giabiconi, his muse and travelling companion.

Every February the Menton Lemon Festival on the French Riviera celebrates all things fruity and zesty. For several weeks these fascinating and elaborate constructions, layered with tons of lemons and oranges, are a source of fun and citrus-flavoured creativity. This work featured in the 2012 festival.

This marvellous 91 kg (200 lb) octopus cake was made by Karen Portaleo of Highland Bakery in Atlanta, Georgia. It comprises yellow cake, butter-cream and fondant, the eyes are chocolate and the colour is airbrushed

food colouring. We're sure it's delicious, but maybe it's best not to get too close!

'THE DESIRE TO GRASP AND BE UNITED WITH ANOTHER HUMAN IS SO FUNDAMENTAL A PART OF OUR NATURE THAT OUR JUDGEMENT OF WHAT IS KNOWN AS "PURE FORM" IS INEVITABLY INFLUENCED BY IT, AND ONE OF THE DIFFICULTIES OF THE NUDE AS A SUBJECT FOR ART IS THAT THESE INSTINCTS CANNOT BE HIDDEN.'
– SIR KENNETH CLARK

Images in this chapter illustrate an aspect of art creativity that dangerously flirts with all kinds of taboos. Here, we have deliberately wanted to retain the blurry lines between images produced for and by the mainstream art world, and others produced by authors who have no position within that world. Interestingly enough, we will find that these types of concerns and their social, ethical and political implications (or questions posed by many of these works) are very similar. While the tradition in Western Christian cultures inhibited the development of erotic art, the situation was very different in ancient Greece and Rome, as well as ancient China, Japan and India.

No culture lets itself be characterized under any simple categories: what secular people like will not necessarily appeal to more pious individuals, and a wide variety of tastes fall between these two extremes. The modern era has often been characterized by its alleged permissive 'let it be' attitude. Paradoxically, it has also retained, indeed sometimes developed, layers of taboos of different kinds. The focus of this chapter is to look at how art can activate, resist or give way to these taboos.

With its gradual release on prior artistic restraints, together with the ability for nearly anyone to create images through access to a camera, the modern era radically transformed the situation it inherited. The nude body became a subject of exploration for all, whereas in the past it was the preserve of male academic artists. However, alongside this, new distinctions were established in terms of acceptability, between mainstream art world images and the flow of wild art images. Erotic themes were acceptable; pornography was not.

Thanks to Marcel Duchamp's *Fountain* (1917), toilets – those humble, prosaic and everyday functional fixtures – have now become a familiar point of reference within the mainstream art world. Interestingly enough, the toilet also occupies a prominent place in wild art. Toilet seats can be painted and even sculpted, but are also indispensable points of pilgrimage. At one point or another, every day, or night, for all of us, these special sites have garnered captive audiences. They continuously elicit extraordinary stimuli for artistic expressions of all types.

Indeed, everyone uses toilets, but they normally remain private, and almost always are separated according to gender. Thus, perhaps, a certain anxiety about these places arises. For reasons that psychoanalysis has explored, we resist knowing that elegant people, like everyone else, piss. As the commonplace phrase 'toilet humour' indicates, bodily functions are often great sources of amusement, but they fundamentally register with lowlife culture. The types of language associated with going to the toilet, or found etched on the walls of many toilets, offer a case in point. Genteel people speak of going to powder their nose. Hearing in a respectable restaurant 'I am going to take a piss' immediately signals that the person who uttered the sentence doesn't belong.

Some of our wild art examples are graffiti found in restrooms. Others consist of toilets transformed into sculptures. Some contemporary artists within and outside the mainstream art world are concerned with social commentary. Others just want to amuse us. In Korea, as our examples show, toilets have been used as the basis of wild architecture. In fact, studying how art and toilets interface through different cultures has taught us a great deal about how people understand or project themselves.

Pornography, which doesn't usually find a place within the art world, offers an important source of wild art imagery. Adam Harvey, a designer based in New York, had the idea to turn pornogrpahic email spam into art. This image of a nude woman has been digitally created using an algorithm that takes subject lines from Harvey's email inbox and maps them into erotic forms, which mirror the explicit content of the emails. 'I started with the idea that spam was becoming such an object of hate, and I thought maybe it could be made into something more enjoyable. I played with it for a while and thought that the best way to display it was with porn as the vehicle. It's kind of like the idea of taking shit and turning it to gold.'

This 1974 work, *Gas Mask*, is by Tanya Mars and is taken from her collection 'Codpieces: Phallic Paraphernalia'. Mars is a feminist video and performance artist from Toronto. While following in a long tradition of the human form rendered in black-and-white photography, the focus here is less on the male (who is regarded as a model rather than the subject) than the accessory attached to him. The work subverts the viewer's undoubted initial interest in the body and directs it to the utilitarian nature of the object.

말뚝박기
Horse riding

Jeju Loveland is an outdoor erotic sculpture park on Jeju Island in South Korea. The island had served for many years as a popular honeymoon spot for Korean couples, many the results of arranged marriages. Then, in 2002 art students from Seoul's Hongik University started adding sexy sculp-

tures to the island for an adult theme park. The park opened in 2004 and features 140 erotic sculptures in various sexual positions ranging from the titillating to the downright hilarious, from suggestive to explicitly instructional.

Molly Crabapple is a New York-based illustrator, burlesque dancer, art-school dropout and the founder of Dr Sketchy's Anti-Art School, a cabaret and 'alternative drawing salon' that now boasts groups in 120 cities worldwide. Her paintings explore themes of artifice and sex, starring sarcastic corseted ladies, men-pigs and bewigged aristocrats, all in fanciful stage settings.

Japanese rope-bondage artist and performer Hajime Kinoko takes the fetish of *shibari*, or artful bondage, to excessive heights. Hajime has performed his elaborate stagings of rope bondage worldwide, often using unusual materials and black lights to create tableaux that are as aesthetically striking as they are erotically fascinating. Here, he has tied model Ageha Asagi in a massive and intricate coil of red rope, thus disturbingly interweaving themes of sex and violence, erotic allure and menstrual blood.

'The Queen of Burlesque' Dita Von Teese, an American actress, model, author and costume designer, has been instrumental in popularizing the 'New Burlesque' movement. Her extravagant dance routines feature an elaborate and lengthy striptease involving various props and spectacular stage settings, most famously an oversized martini glass. Von Teese is inspired by the archetypal glamour of film noir, Golden-Era Hollywood and classic pin-up girls. Here she is performing in a giant champagne glass at an event in 2007.

Kisses! by the female Dutch designer Meike van Schijndel is a urinal that takes the form of open red lips. Bathroom art of the highest standard, these receptacles would have turned the restrooms into a veritable 'cistern chapel'. When these urinals were presented at a trade fair in 2002, some people praised their inventiveness, while others claimed that they were degrading to women.

These astounding and magnificent Victorian-era public bathrooms are in
the sea resort of Rothesay on the Isle of Bute in Scotland. Built to last
in 1899, they were saved from demolition almost a hundred years later and
restored to their former splendour. These incredible and sedate public
lavatories offer a return to a past era through the magnificence of their
features, including decorative ceramic tiles and mosaics arranged in
exquisite patterns that mirror the surrounding architecture. They are
a stunning example of the care and attention to detail that went into
Victorian public service design over a hundred years ago.

'ABC No Rio' is a centre for art and community resistance and activism.
Housed in a condemned, old, graffiti-covered townhouse on Manhattan's
Lower East Side. Its first-floor toilet, named *The Throne's Lament*, has
become a legend in its own lifetime. Generations of artists, punks, slam
poets, food collectives, printmakers and many other ABC users have added
drawings, text and makeshift collage to the toilet walls. It is liter-
ally a repository for art! We hope that this toilet will be preserved for
future generations.

Marco Evaristti created this bold, red toilet painting in Chamonix in 2007, as part of his Mont Rouge or Pink State Project aiming to raise awareness of environmental degradation. After the toilet was made, Evaristti completed the work by emptying his bladder into it. Aside from the scatological associations, what we see here is a beautiful 'drawing' in the ice.

Taboo wild art is also present in some forms of performance art. *Bowel Movement* is a satirical ballet and dance spectacle created by choreographer Jamie Benson and fashion designer Andrae Gonzalo, which was performed as part of the Triskellion Arts 3rd Annual Comedy in Dance Festival in Brooklyn, New York, in 2012. The ballet's story centres on a refined lady battling her darkest fear, her own excrement.

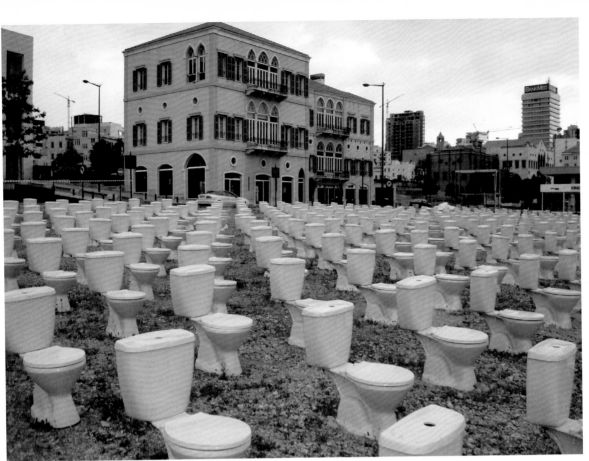

In this piece, Lebanese artist Nada Sehnaoui laid out 600 white toilets arranged in a similar fashion to war graves. One Lebanese wartime survival tactic involved hiding in the toilet to avoid daily random shelling and gun battles. Sehnaoui's work commemorates war, memory and suffering, and here uses the toilets to beg the question 'Haven't fifteen years of hiding in the toilets been enough?' While there can be a lot of humour inherent in toilet art, it is possible, as we see here, to utilize these ubiquitous objects for contemplative and quiet remembrance.

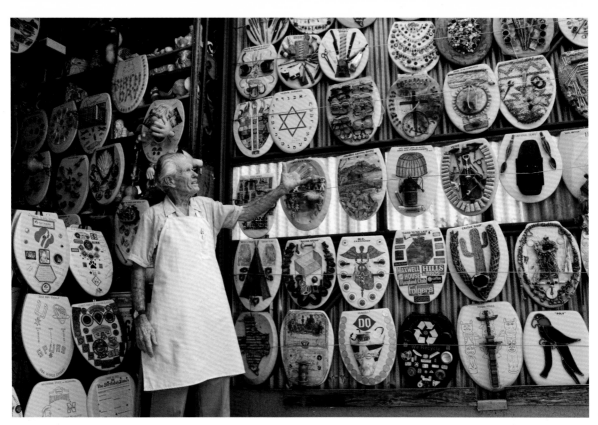

Barney Smith has been painting, engraving and collecting toilet seats
for over 30 years; his collection now includes well over 1,000 examples.
Every seat is a piece of art and crosses several distinctions, falling
between folk art, outsider art (a term invented by the museum system to
describe art outside the boundaries of official culture but which has now
been subsumed into it) and craft, among other forms. Ultimately, all such
categories are irrelevant. Every seat in the collection is catalogued for
posterity. Smith only works with pressed wood toilet seats at his museum
in San Antonio, Texas. Of his potty passion, he comments: '*[I] was a
master plumber before I retired, so I was comfortable with the medium.*'

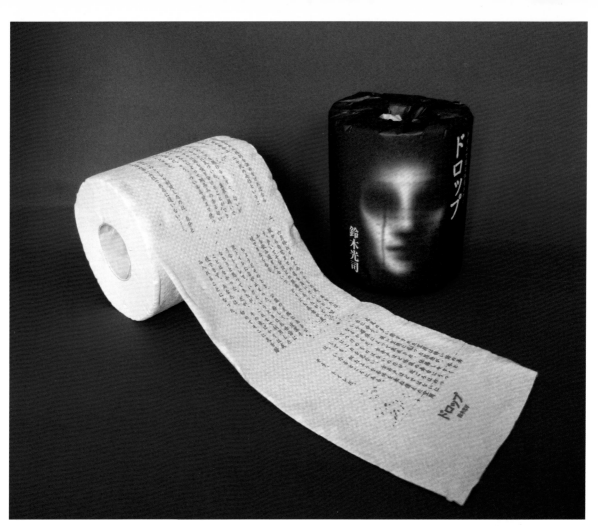

This unusual toilet paper from Tokyo (2009) has a horror story printed onto it. The nine-chapter novella *Drop* by author Koji Suzuki is appropriately set in a public bathroom and tells the story of a spirit that inhabits a toilet bowl.

Talk about recycling! Anastassia Elias is a French artist who, among other projects, creates artwork out of toilet paper rolls for her 'Rouleaux' series. Subjects include many aspects of daily life, from underground workers to sports and wild animals. Painstakingly produced, Elias's work is an inventive and unusual way to express creativity out of everyday utilitarian items. And, of course, she enjoys an endless supply of material.

This dress made from toilet paper is one of eight such works created by leading Canadian designers to raise awareness of breast cancer.

This wonderful toilet-shaped house shows the scale and ambition of some
wild artists. It was built in 2007 by Seoul-based Sim Jae-Duck, allegedly
born in a bathroom and now the president of the World Toilet Association.
The fact that he is nicknamed 'Mr Toilet' in South Korea will surprise
no one. The aim of his organisation is to highlight the global need for
better sanitation. That he chose to do this through art, design and
architecture in his own house is remarkable. It is situated in Jae-Duck's
native city of Suweon, 40 km (25 miles) south of Seoul.

This stunning, ceramic waterfall was created for the Pottery and Porcelain Festival in Foshan, in South China's Gunagdong Province. Over 4.6 m (15 ft) tall and 91 m (300 ft) long, Chinese artist Shu Yong made the work out of 10,000 bathroom accessories, such as toilets and sinks, often donated by the companies who made them. While this is definitely art on the go, the idea was mainly to raise awareness of recycling. This is a huge sculpture by any standards and we certainly hope the supporting wall held up to the immense weight of the (water) pressure!

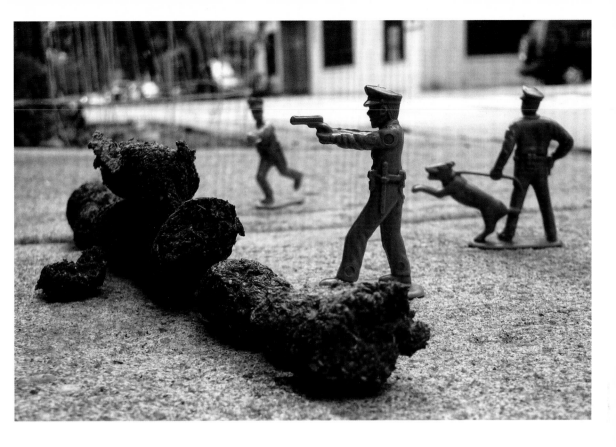

The Sprinkle Brigade is a group of guys who believe in 'urban beauti-
fication'. Their motto is 'just leave it, we got it' and they decorate
doggie evacuations throughout New York City, photographing their work as
they go. In a dog-friendly city where most owners are conscientious about
cleaning up after their pooches, it is interesting and surprising that
the Sprinkle Brigade finds enough raw material for their ongoing street
art interventions.

'WE'RE GOING TO MAKE A LOT MORE JUNK, AND THERE'S GOING TO BE A LOT MORE JUNK ART. I THINK PEOPLE ARE GOING TO HAVE A LOT TO SAY ABOUT IT, AND MORE PEOPLE NEED TO THINK ABOUT IT.'
– JEREMY MAYER

Great works of fine art are luxury goods, which we guard carefully and preserve. Rubbish is what we discard. Yet it is also quite possible for rubbish and waste to serve as material for art, both within the mainstream art world and as wild art. David Carrier was teaching art history in Hangzhou, China, and after he presented Arthur Danto's account of Warhol's *Brillo Box* (1964) a student killed some flies and asked if they also were a work of art. That student understood the intricate conceit and complexities of art today.

'Junk artists' use the most humble materials as the raw matter for their art. What we see here is, again, a sample of an extremely wide range of wild artists who pick up rubbish from the street, and turn this detritus, alchemically, into the most elaborate forms of art. Christianity tells us that the grand shall be made humble, and the lowly rise up to enter the kingdom of heaven. Art outside the system reveals a parallel truth to this idea. The most ordinary materials can be used as valid vehicles for art, just as the most precious stuffs can be. Some artists within the art system, like Marcel Duchamp, Andy Warhol and Vic Muniz, to name but a few, have pursued this idea. We, however, are most interested in the myriad figures outside the galleries and museums, demonstrating wild art's considerably broader and richer nexus of possibilities.

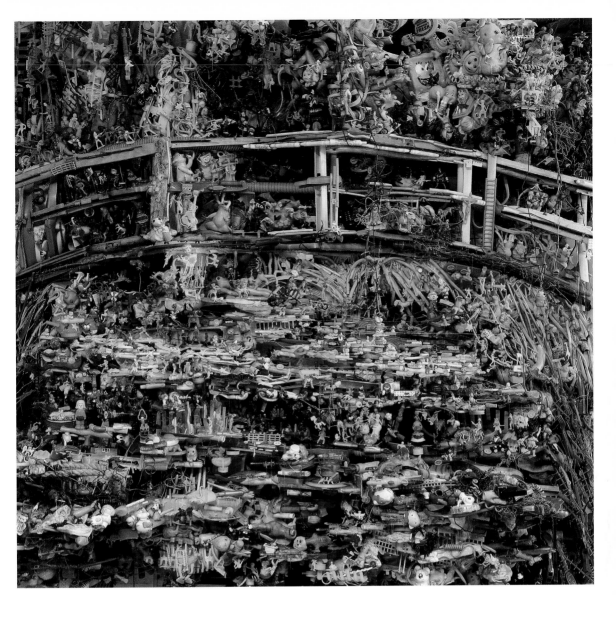

Rhode Island-based Tom Deininger combines composition, colour and form to create extremely detailed versions of famous artworks and various other cultural icons and motifs. Here we see his 2006 work *Stroking Monet* – a reproduction of Monet's famous Japanese Bridge over his waterlily pond. As with many artists who recycle discarded products into wondrous artworks, Deininger raises questions about consumption and waste versus beauty.

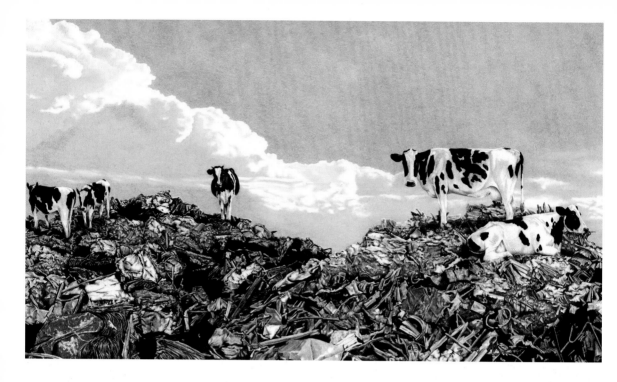

In another example of wild art making comment on current social issues, this coloured drawing depicts cows outside of their native countryside and instead being forced to graze on rubbish piles. *Cows On Garbage 2* (2004) is Don Simon's imaginative depiction of what is not, we hope, the farm of the near future.

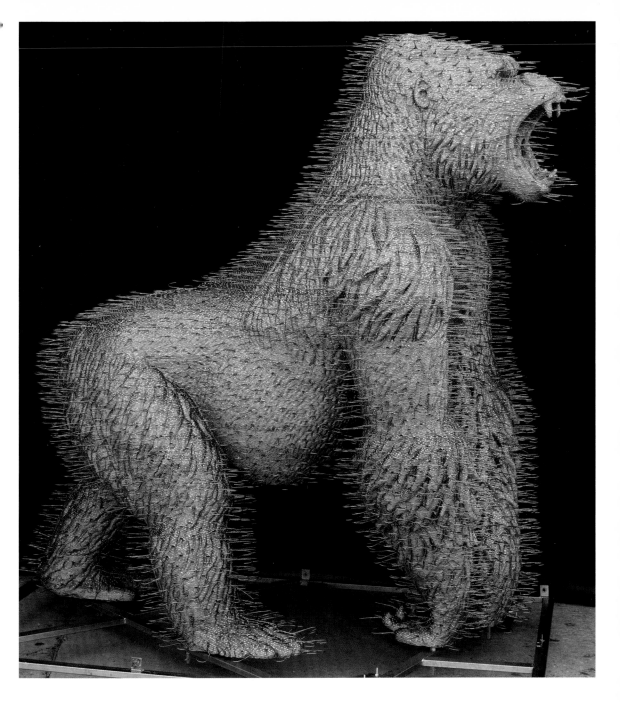

Scottish sculptor and installation artist David Mach makes sculptures from coat hangers, magazines and matchsticks. This gorilla, entitled *Silver Skin* (2011), is constructed from 3,000 coat hangers, and is larger than life at over 2 metres (6.5 ft) tall. Mach says: '*I don't make work out of bronze. I'm doing it with this unlikely, naff material because coat hangers are something you don't give a second thought to.*'

'Shoe trees' are a familiar American roadside attraction, places where people deposit their unwanted shoes. They are said to have originated when a quarrelling couple tossed their shoes onto a tree on their wedding

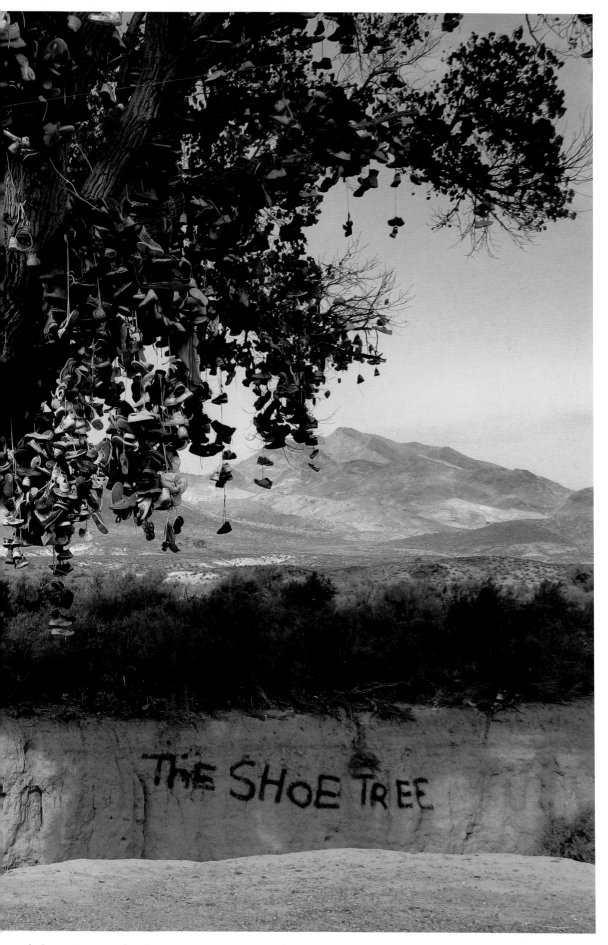

night. Located along US Route 50 in Nevada about 201 km (125 miles) east of Reno, this shoe tree was once the world's largest, but was recently destroyed by vandals.

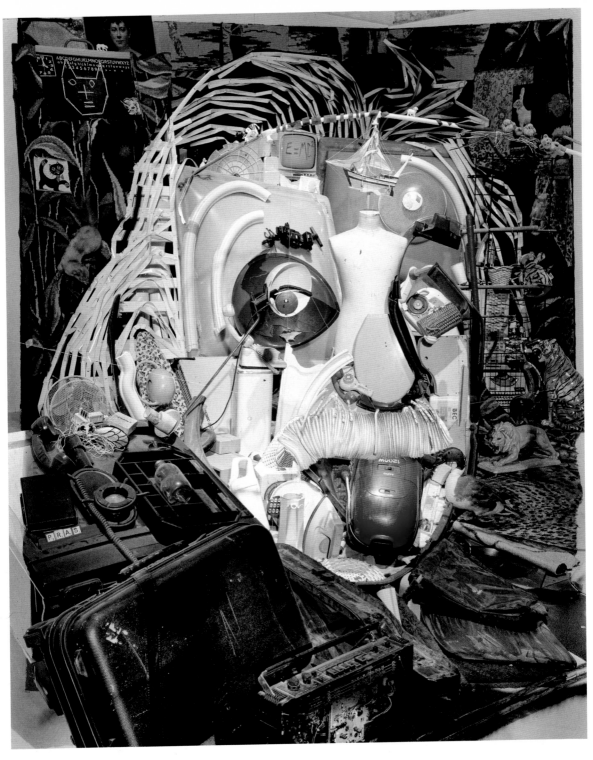

Born in southwest France in 1952, Bernard Pras makes incredible works out of all manner of found objects and rubbish. He often re-interprets iconic images of famous people or mythological creatures, from Mao to Medusa. He has even tackled some of art history's most enduring pictures, from Munch's *Scream* to a Van Gogh self-portrait. In this work from 2000 he has appropriated the famous photograph of Einstein, with his tongue playfully stuck out.

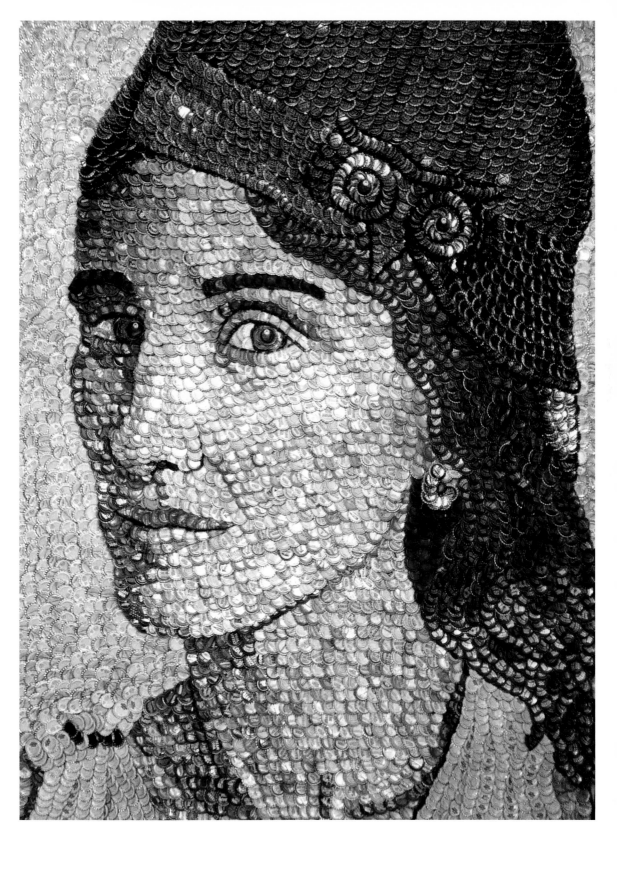

Using vintage bottle caps, South Carolina artist Molly B. Right makes images of famous faces, such as this depiction of the Greek goddess Athena.

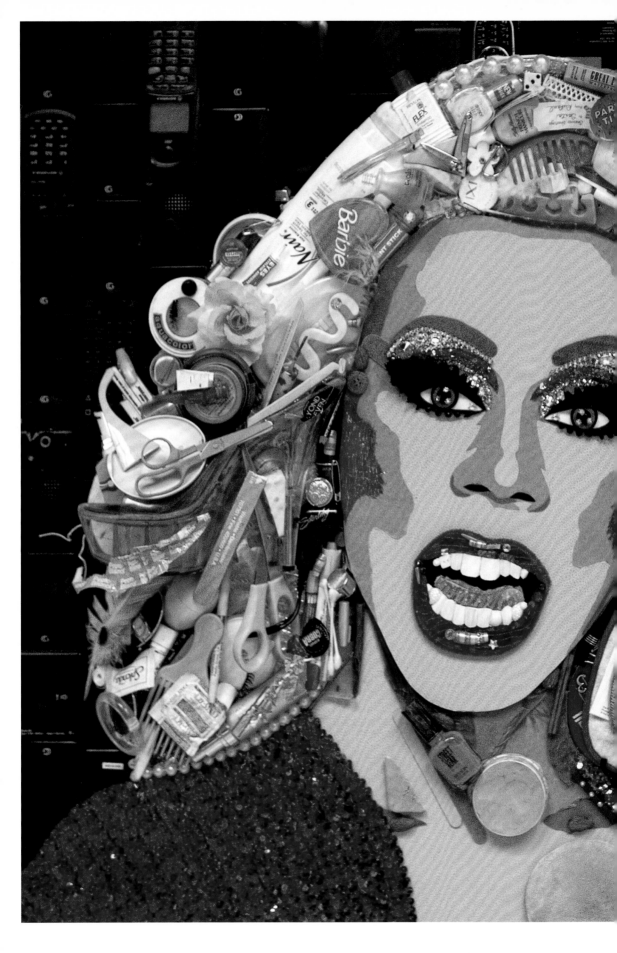

San Francisco-based artist Jason Mecier works in mosaic with many forms
of food, rubbish and found items (*see also pages 172–3*). This is his
2008 portrait of the glamorous drag supermodel RuPaul. Forming part of a

mosaic portrait series of celebrities made out of rubbish, RuPaul's hair
is made from many of the products associated with him, from hairbrushes
to nail files.

CDSea by Bruce Munro was constructed from 600,000 unwanted and donated compact discs, laid out in a field near a small village in south-west England in June 2010 by 140 volunteers. An undulating path bisected the great mass of reflective CDs, which glinted and shimmered in the sun like a peaceful ocean. Munro is a lighting designer, known for his *Field of Light* gardens composed of hundreds of light bulbs perched on fibre-optic stems. Much of his connection to, and love of, light springs from his experiences of the dazzling sun and reflections of Australia, where he lived for eight years before returning to his native England.

Danish artist Gugger Petter weaves rolled-up newspapers to create large-scale composite portraits and street scenes. '*Holding a profound respect for this material, I have never regarded it as "recycled" or "trash"*,' the artist explains. She has worked with this material for over twenty years and this is her *Female Head/Madonna*. After finishing one of her newspaper works, she paints it with varnish to protect it from deterioration. It's not only the newspaper's form and colours that she admires, it's the function as well: '*My works not only hold a date, they also represent an historic documentation of our lives. This information may not be of importance to the viewer, but for me each piece becomes a diary.*'

New York-based artist Howard Lerner takes visual cues from our earliest civilizations and, using discarded materials, creates magnificent sculptures exploring Judeo-Christian themes. While Lerner cites Picasso as an influence, his evocative, highly personal works are also informed by his own spiritual development. *Adam's Rocket*, measuring 33.5 x 17 x 15 m (110 x 57 x 49 ft), is made from mixed media including wood, metal, tin and clay.

Rammellzee (1960-2010) was an eccentric New York City rapper, graffiti writer, performance artist, sculptor and theorist – a 'wild Renaissance man'. Derived from sources such as subway graffiti writing, illuminated manuscripts, science fiction, hip-hop freestyling, Japanese monster movies and the teachings of the Nation of Islam splinter group the Five Percenters, Rammellzee's complex theory of 'Gothic Futurism' drove his artistic output, made from found materials. He nearly always appeared masked or in costume at his gallery shows and onstage performances. Pictured here is his most elaborate outfit, *Gash-o-lear* (1989-98), which features a missile launcher, pyrotechnic displays, keyboard guns and a built-in sound system.

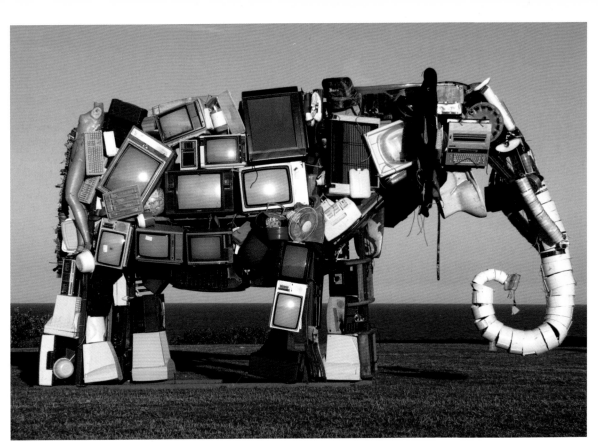

This giant elephant was created out of recycled waste in Sydney, Australia (2004). It formed a part of an annual temporary sculpture park, 'Sculpture by the Sea' at Bondi Beach, where more than a hundred sculptures are on display each year (*see also pages 192-3*).

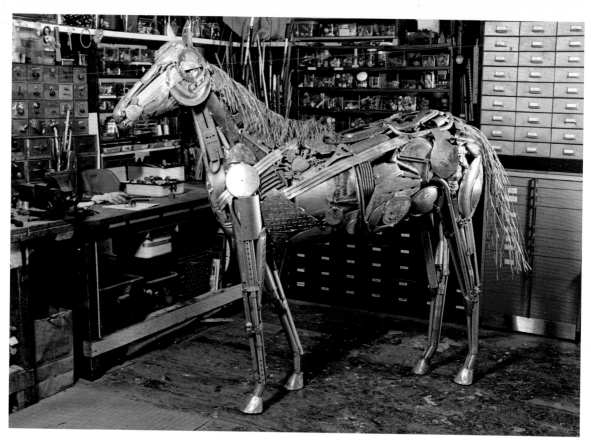

For more than fifty years Leo Sewell has assembled sculpture from junk
materials. He employs metal, plastic and wood objects, which are assem-
bled using bolts, nails and screws or, in the case of the larger outdoor
sculptures, welded. This horse is *Hi Ho Silver* (2003).

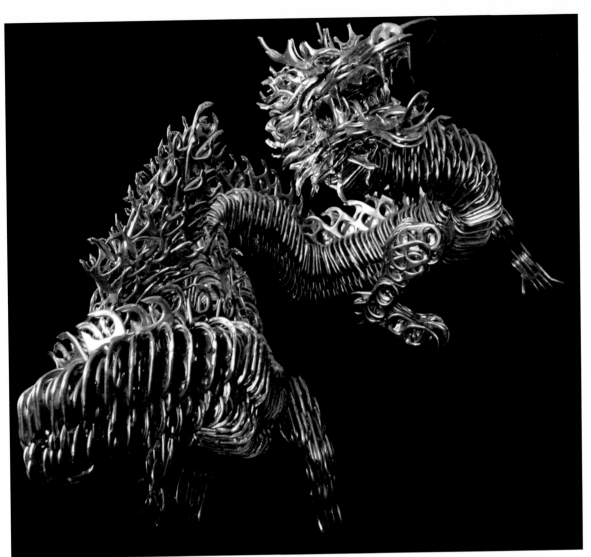

Koji Shimoi and his friends supped on cans of beer until they had enough leftover ring pulls to make this dragon – about a thousand cans. They soldered the pieces together, cutting ring pulls to make the spines running down the dragon's back.

This dog sculpture by Sayaka Ganz is made from discarded plastic cutlery tied onto a wire frame, and comprises approximately 500 pieces.

This is *Cano's Castle* in Colorado, built by Donald Cano Espinoza, a Native American and Vietnam veteran. The structure is made from beer cans, hub caps and other scrap materials, and was created by Espinoza in thanks for his life being spared in Vietnam.

Like cathedral spires, the *Watts Towers* can be seen arching into the sky for miles around. Created by Simon Rodia, an Italian immigrant and construction worker, the *Watts Towers* were constructed between 1921 and 1954, with the tallest tower measuring over 30 m (99 ft) high. They were made from reinforced concrete and scrap reinforced steel, and decorated with a mosaic of discarded materials, including shells, bottle caps, broken glass and tiles, which Rodia collected and salvaged from work-sites, railway tracks and a nearby pottery factory. When asked why he built the towers, Rodia simply replied '*I wanted to do something big, and I did it.*'

Dr Evermor's Forevertron, located in Sumpter, Wisconsin, is the largest scrap-metal sculpture in the world, standing at 15 m (50 ft) high, 37 m (120 ft) long and weighing 300 tons. Tom Every, a demolition expert and collector of antique machinery, built this structure in the 1980s, under

the auspices of a fictional character named Dr Evermor. Every maintains that Dr Evermor was a Victorian inventor who created the Forevertron as a machine to launch himself *'into the heavens on a magnetic lightning force beam'*.

Some wild artists make use of trash materials derived from near-obsolete technologies. Faith Pearson looks to the future with this science-fiction spaceship corridor made from old ink cartridges.

Nothing is less elegant, we customarily think, than rubbish. But Diane Kurzyna, also known as 'Ruby Re-Usable', employs 'recycled, reused, discarded, unwanted, unloved, lost and found, pre- and post-consumer waste materials', as seen here in her 2006 sculpture *Bag Lady*, located in Washington state on the west coast of the United States. Her motto is '*MAKE ART NOT WASTE!*' Her father worked in the junk business, so Kurzyna has had a lifelong interest in recycling.

It was an interest in ecology and the damage that mankind are wreaking on natural habitats that led Mary Ellen Croteau to develop her own mode of artistic expression. Her *Bag Coral* of 2010 used crocheted plastic bags to represent the coral reefs that are all too rapidly being destroyed by the accumulation of discarded rubbish.

Swedish architecture student Robert Janson makes artworks from recycled carrier bags, creating large and fragile installations. From these discarded and ugly materials he produces unexpectedly beautiful forms. In this collaboration with several other artists he has created *Plastic Bag Installation*.

Jolanta Šmidtienė's work *Emerald Christmas Tree* was made from LED lights, a metal frame and 32,000 recycled Sprite bottle in Kaunas, Lithuania, in 2011. While plastic bottles are banal manufactured commodities, a Christmas tree is a product of nature. There is something marvellous in

this transfiguration, as Šmidtienė explains: '*Green colour represents peace, nature and ecology. Ecology is expensive, and only conscious Europeans understand that ecology costs money. We are lucky, because we didn't have to spend the budget money.*'

This sculpture measures 5 m (16 ft) and was made from used motorbike and car parts by the Switzerland-based Recycle Art Team. It took three people a total of two months to complete the artwork, known as *Gladiator*.

Joshua Allen Harris utilizes the particular traits of New York City streets to bring his art to life. Using the city's discarded plastic bags, Harris fashioned a series of soft animal sculptures in 2008. He then attached them to the grates on the sidewalk above subway platforms. When the trains moved in and out of the station, air rushed up through the grate, inflating the animal sculpture. Harris documented his sculptures in action by making videos.

The Japanese artist Haroshi is a passionate skater and, hesitant to throw away cracked skateboard decks, he began to make wooden mosaics from the compressed boards. His art practice has expanded to large-scale sculptures, such as this 2011 hammerhead shark, measuring approximately

1.5 m (5 ft) and made entirely from the discards of his skate practice. Interestingly, the layering method that Haroshi uses to create sculpture from these processed products is exactly the same as that used to create traditional wooden Japanese sculptures of the Buddha.

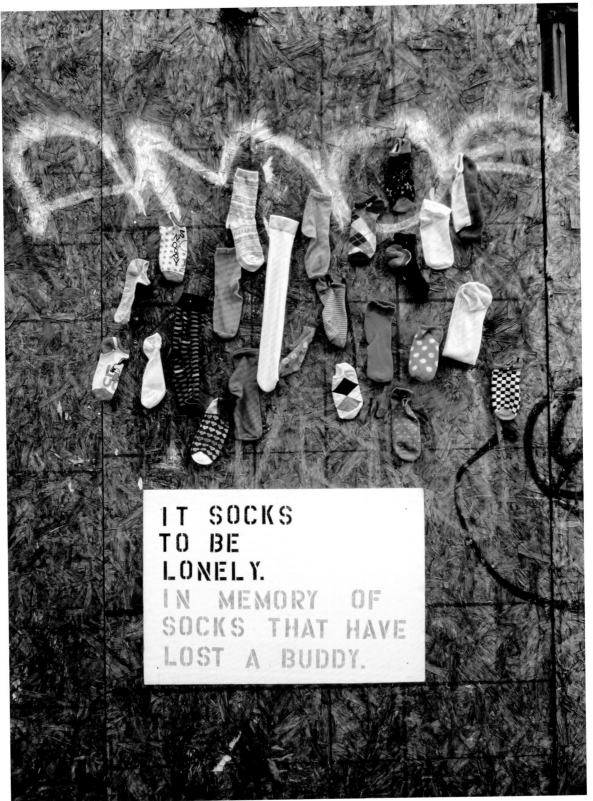

Who does not have a problem losing socks? A daily frustration inspired this witty piece of art. It is an anonymous artwork, unlike signature- or New York-style graffiti, and as such exists not to bolster the ego of its maker, but to interact with its viewers, even if only to make them smile.

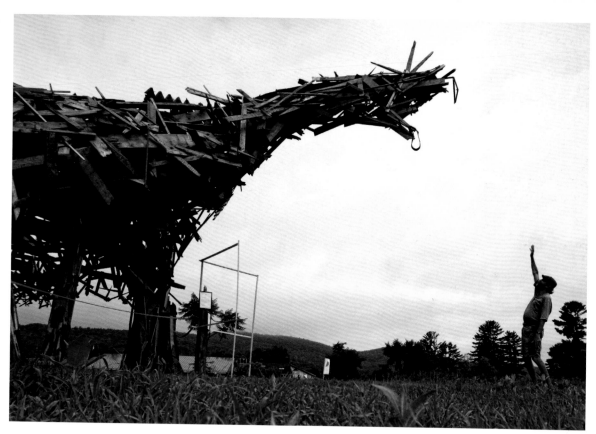

The *Vermontasaurus* measures 7.6 x 37 m (25 x 122 ft) and is made of scrap lumber. It is located in Vermont and is a folk art representation of a dinosaur made by retired teacher and experimental balloon pilot Brian Boland (shown in the picture alongside the work), together with a crew of volunteers. They built this sculpture using lumber obtained from a collapsed portion of Boland's private museum and hot air balloon manufacturing facility. There was debate about whether it was art or, rather, a structure that required a permit; finally the local development board approved its certification as a sculpture.

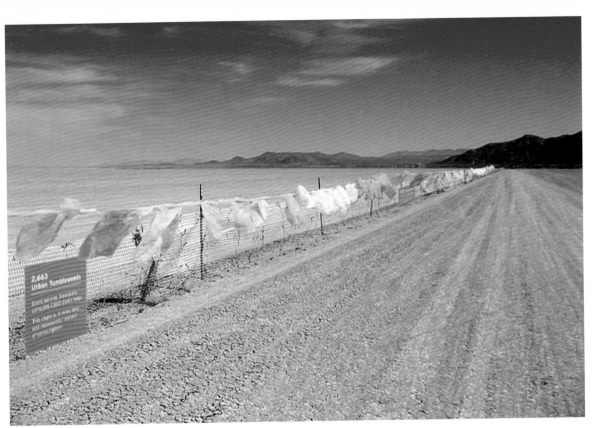

In the United States, 2,663 plastic bags are used every second, and this work by the design firm MSLK shows how when strung together as a chain this number of bags stretches half a mile (0.8 km). In cities around the world, such plastic bags are frequently found caught in trees and fluttering around street corners and are often referred to as 'urban tumbleweeds', giving this 2008 piece, *Urban Tumbleweed Project*, its name. The work makes a powerful environmental statement.

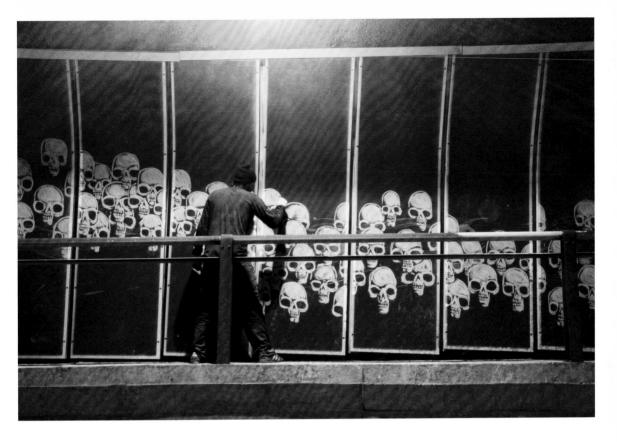

Alexandre Orion performed 'reverse graffiti' in this tunnel in São Paulo, by scraping the dirt and grime off the wall for his 2006 work *Ossario*. The tunnel was transformed into a powerful statement about the detriment of pollution, and its deathly potential was signified through the abundance of skulls. The only way the city could remove the 'graffiti' was by washing the entire tunnel, thereby creating a positive change in the urban environment.

This installation, *B.e.e.s.*, which consists of 400 coffee cups altered to look like a swarm of bees, was commissioned for the Rand Merchant Bank building in Sandton, Johannesburg, in 2011. It is the work of Such

Initiative (which comprises artists Hannelie Coetzee and Usha Seejarim) with the intention to remind office workers that they are individuals who are part of a great collective, or 'swarm'.

This striking and graceful fish sculpture on Botafogo Beach, Rio de Janeiro, Brazil, is made from plastic bottles. It aims to promote recycling, portraying exactly the kind of wildlife that is put at risk through human litter and pollution.

Kris Kuksi creates sculptures from tiny plastic figurines that he buys on eBay. They are the result of his lifelong fascination with the grotesque and the macabre. Each of his sculptures, he says, testifies to '*the multifaceted nature of perception*' in a '*struggle to understand, and bend, the limits of mortality*'. He is pictured here in his studio in 2008 with one of his works.

An artist-duo from São Paulo, Urban Trash Art recycles all sorts of discarded materials to create wild artistic pieces. This is *Fenix Arara Azul*, part of the Whippersnapper Gallery Summer Projects 2011 held in Toronto, Canada. The artists' website contains a beautifully concise description of their goal (translated here from the original Portuguese):

Space for artists is the street
the raw waste
the source of inspiration, improvisation
occupation of public spaces
ephemeral art coming out of garbage
recreation of that which is unusable.

Considerable academic literature is devoted to the relationship between music and mainstream art. By transforming trashed CDs into beautiful bird sculptures, such as *Baby Spoonbill* (2012), Sean Avery demonstrates that wild art, too, can contribute to this discussion. How, we wonder, does it change your experience of his art to know its source?

With an interest in science fiction and mythology, Gabriel Dishaw created this fantasy creature *Lecturing Bird* in 2011 from an array of materials, including typewriter parts, aeroplane wire and pieces of computers and photocopiers. As he explains on his website: '*I take the items people no longer have use for and that would normally end up in a landfill and in turn create something new and upcycled. My mission is to create dialogue and help find creative ways of dealing with this discarded tech in an environmentally sound way.*'

'WE OWE IT TO THE FIELDS THAT OUR HOUSES WILL NOT BE THE INFERIORS OF THE VIRGIN LAND THEY HAVE REPLACED. WE OWE IT TO THE WORMS AND THE TREES THAT THE BUILDINGS WE COVER THEM WITH WILL STAND AS PROMISES OF THE HIGHEST AND MOST INTELLIGENT KINDS OF HAPPINESS.'

– ALAIN DE BOTTON

Occasionally homes themselves – as well as other forms of architecture – function as serious works of art, as a mode of deep, personal aesthetic expression on the part of its owner, occupier, builder, designer or architect. 'Serious' buildings have attracted the attention of architecture historians because they were the creations of named architects or the fruit of commissions by named entities (whether clerics or nobility, or known individuals, praised for their vision and choice of the 'right' architect).

Architecture is normally based upon rules. With 'wild architecture' such rules do not always apply. Wild buildings are fascinating either because of their originality or eccentricity: they are often visually suggestive and even mesmerizing because they fall out of the operative categories used when gauging architecture. The creations of wild architecture display as many merits and awe-inspiring qualities as much of the 'named' architecture, but they call for new criteria of appreciation and demand a new vocabulary, as indeed does most of the art that is displayed in this book.

Some of this wild architecture has produced extraordinary homes, and some has resulted in surprising public buildings. This architectural prowess stands out because it not only reveals deep, personal modes of expression, but also embodies political or ethical messages that strongly resonate with viewers. The commonality of these wild architectural creations is that they are couched in a unique, if sometimes odd, aesthetic language. They certainly do not resemble most utilitarian habitations or office spaces we know. Just as graffiti or art of the streets embellishes and transforms any given street, so too do these examples of deeply original architecture give a new distinction to their surroundings and living environment.

This chapter offers examples of architecture that imitate an everyday object on a large scale – figurative architecture as one might call it – and also architecture that 'appropriates' other architectural sites.

Sleeping Beauty's Castle in California's Disneyland is perhaps one of the most recognizable examples of appropriational architecture. It was based on Glamis Castle in Scotland and Neuschwanstein Castle in Bavaria (*see following pages*). Created by Walt Disney and his 'Imagineers' in 1955, it is the oldest of his castles and comes complete with a working drawbridge. Sitting above the bridge is the Disney family crest. Unlike its inspirations, the building is quite small at only 23.5 m (77 ft) high.

Another example of appropriational architecture can be found in this replica of a medieval castle, built by Harry Andrews of Ohio. Andrews saw the architectural wonders of Europe during his service in the First World War, and was moved to create his own version. Construction for Château Laroche, also known as the Loveland Castle, began in 1929, with Andrews making and placing nearly every brick. Although no end date is given for the work, Andrews moved into the castle in 1955 and seems to have continued work on it until his death in 1981.

Glamis Castle in Scotland was originally a Royal Hunting Lodge, when in
1372 King Robert II granted the land and buildings to Sir John Lyon.
The structure is an amalgamation of added styles, creating a potpourri
of sorts, as the castle underwent developments from the fourteenth
to the twentieth centuries. Said to be haunted, Glamis's ancient and

uncertain origins, and its turbulent role in the bloody pageant of Scottish history, have wrapped the castle in centuries of mythology. The magnificently hybrid, excessive and unclassifiable castle stands as one of Disney's most essential inspirations.

Another source of inspiration for the iconic Disney fairytale castle was the famous folly of Ludwig II of Bavaria: Neuschwanstein Castle. The splendid neo-romantic, post-rococo eccentricity was created in the late nineteenth century. Just weeks after the king's death in 1886 the castle was opened to the public. Today it welcomes 1.3 million visitors annually. Thus, Neuschwanstein Castle marks one of the first major steps in the development of mass tourism and mass culture.

Released in 2004, the mainstream film *Van Helsing* depicts Dracula's castle, complete with spires and strange, spooky details. Created by renowned model-maker Tory Belleci, the castle comes to life for the movie. Belleci's work can also be found in other films, such as the *Matrix* trilogy, *Peter Pan* and *Starship Troopers*.

Ferdinand Cheval, also known as Le Facteur (The Postman) Cheval, created wild and totally eccentric architecture. He found recognition only at the very end of his life, after spending thirty-three years building this palace in Châteauneuf-de-Galaure in Drôme, south-eastern France. Beginning in 1879 Le Palais Idéal slowly took shape from rocks and stones carried to the site, often at night, by Cheval, who worked during the daytime as a postman. Not knowing what to do with this kind of creation, mainstream art history resorts to such misnomers as 'naive' or 'kitsch' architecture, which highlight the incapacity of traditional academic discourse to make sense out of such constructions.

This example of fifteenth-century Berber architecture at Ksour Ksar Ouled Soltane in southern Tunisia was given a new lease of life when it was

chosen as a filming location for parts of *Star Wars: The Phantom Menace* in 1999.

Created by architect Dang Viet Nga in Dalat, Vietnam, this extraordinary organic house offers the ultimate fusion between architecture and nature: a tree into a house; a house into a tree. This indefinable structure is known locally as the 'Crazy House'. Local authorities stridently opposed Nga's work, and it is only through perseverance and support from friends and family that she was able to complete and refine her fantastical building.

Here we see the interior of the 'Crazy House', which, like the exterior, employs trees to create an unconventional setting. Once a private residence, the building has since been opened to the public as a guesthouse and art gallery.

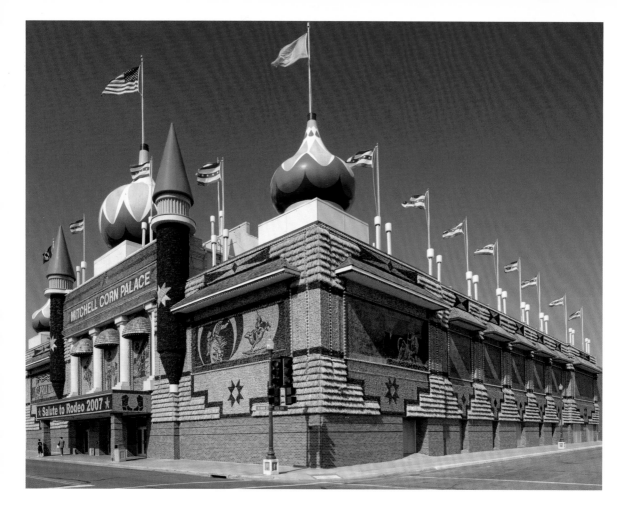

This building is a gathering place for residents of the small town of Mitchell, South Dakota, and the surrounding rural area. Every year the world's only 'Corn Palace' is covered in mosaic murals made entirely out of corn and grains. Refreshed every year with new corn, the city hires an artist to design and oversee the works that wrap two outer walls and the auditorium inside. The ceramicist Cherie Ramsdell created the murals shown here, following in the footsteps of a long list of local artists. Ramsdell, who works in *raku* pottery, had replaced Calvin Schultes in 2003, who took over the mural designing in 1977 from Native American artist Oscar Howe, himself working from 1948 to 1971. These are all names that merit admiration, but have not perhaps received the recognition they deserve.

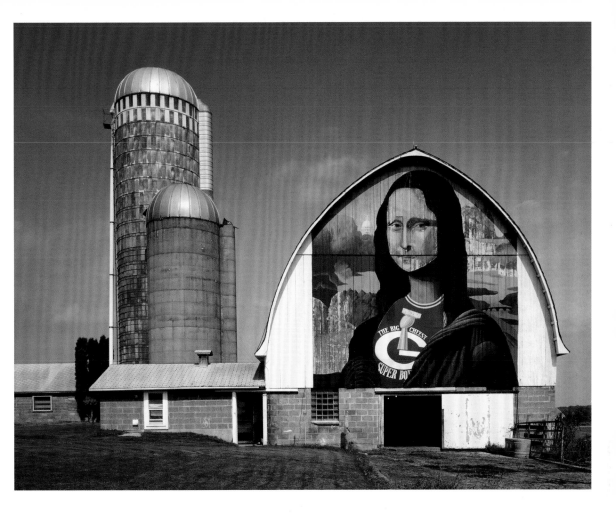

Also fusing art with its natural, agricultural context was this famous barn in Cornell, Wisconsin. Once a landmark that graced the cover of books with its depiction of Leonardo da Vinci's masterwork *Mona Lisa* sporting a t-shirt of the Wisconsin Badgers American football team, the barn has now been painted over.

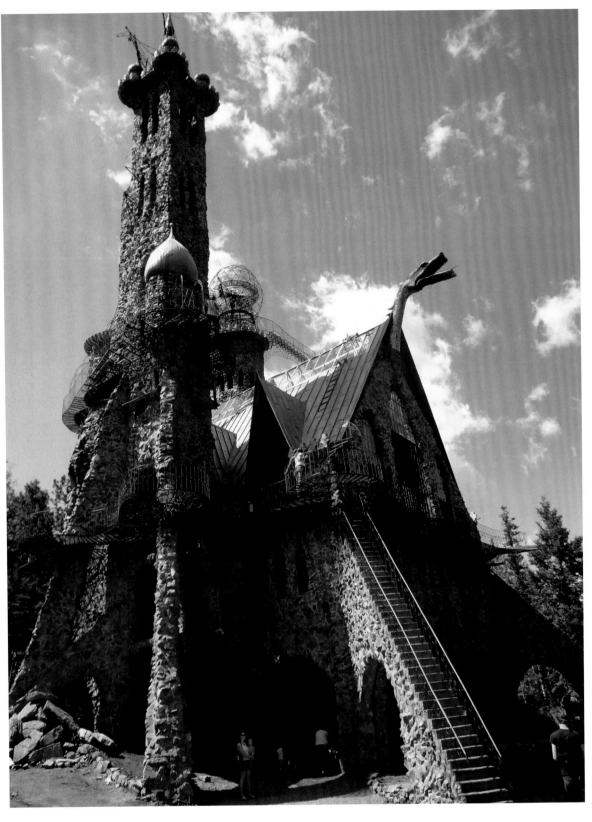

Bishop's Castle was established in 1969 in San Isabel National Forest, Colorado, by Jim Bishop. Although a tense relationship exists with the local authorities concerning the land and building, Bishop has persisted in adding, piece by piece, to this far-evolved masterpiece. Visitors are invited to climb at their own risk and marvel at the hand-built stone and iron structure boasting a fire-breathing dragon, which gushes a 1.8 m- (6 ft-) long flow of flames. The whole structure is decorated with stained glass and wrought-iron bridges.

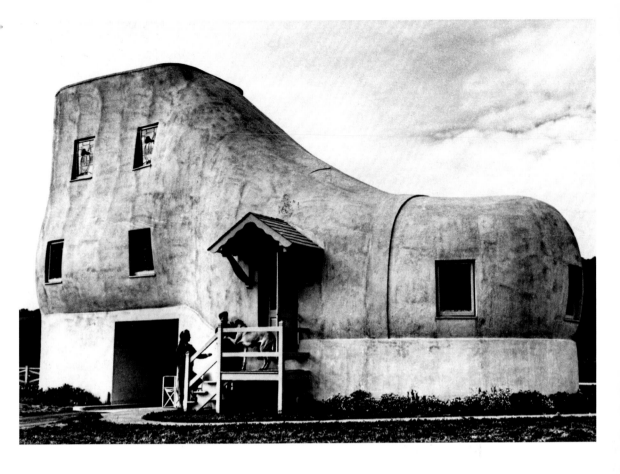

Some wild architecture shows its function in its shape. Looking rather like Claes Oldenburg's mainstream pop art, the Shoe House, built in 1938 as an advertising stunt, is 14.6 m (48 ft) long. It has bedrooms, bathrooms, a kitchen and a living room, just like a conventional suburban house.

Inspired by the fairytale illustrations of Jan Marcin Szancer and Per Dahlberg, this building bends and curves inside and out, housing shops, bars and cafés. Located in Poland, the Krzywy Domek, or Crooked House, was created by Polish architect Szoty scy Zaleski. It is possible to see similarities between this structure and Gordon Matta-Clark's split houses, which have entered the canon of post-modernist art history, while Zaleski remains an obscure curiosity.

Kansas City's library features this incredible wall of book spines, which run down 10th Street between Wyandotte Street and Baltimore Avenue. The twenty-two book spines, each measuring 2.7 x 7.6 m (9 x 25 ft), feature titles suggested by Kansas City readers, such as *Catch 22*, *Huckleberry Finn*, *The Lord of the Rings* and *Charlotte's Web*.

Javier Senosiain creates eccentric, organic architecture. *The Nautilus*, a work from 2007, is a house in Mexico City inspired by the spiral of a snail's shell. Created with the idea of 'Bio-Architecture', the entire dwelling focuses on the organic nature of life - from the very movement of a body within its own dwelling.

Communist countries also create wild architecture. This is North Korea's Ryugyong Hotel, an unfinished pyramid that is 305 m (1,000 ft) tall. Empty and incomplete, it is said to be structurally unsound.

The Tianzi Garden Hotel (also known as the Son of Heaven Hotel) in China stands as a ten-storey depiction of Fu Lu Shou, the three divine incarnations of good fortune, prosperity and longevity. Built sometime between 2000 and 2001, the hotel is considered the world's 'biggest image building', yet its architect remains unknown.

The Longaberger Basket Company building in Newark, Ohio, is the office complex for a basket-making enterprise. Designed by the company, this

16,723 m² (180,000 sq ft) building presents itself as the company's own signature: a gigantic basket.

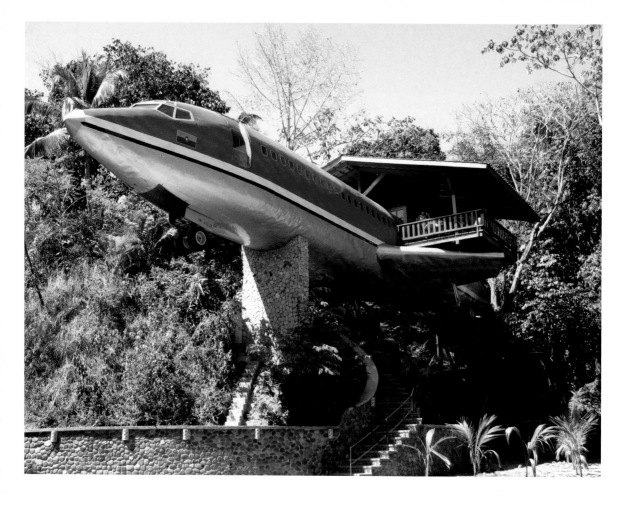

Nestled inside this 1965 Boeing 727 is the Airplane Hotel, in Manuel Antonio, Costa Rica. Painstakingly transported piece by piece from the San Jose airport, the plane rests just above the beach.

The Niimi kitchenware store in Tokyo uses wild architecture as a marketing tool. Its teacup-shaped balconies ensure that the building stands out amid the multitude of other kitchenware and restaurant supply stores in the Kappabashi district of the city.

James May's full-size home built out of Lego in 2009 was situated on the Denbies Wine Estate in Dorking, Surrey. This fully functional house, replete with Lego furniture, kitchen utensils and working plumbing (albeit some problems with leakage), was built by 1,000 volunteers out of 3.3 million Lego bricks for the BBC television show 'James May's Toy

Stories'. After completion, May intended for the Lego House to be donated to a nearby Legoland theme park, but the house proved too expensive to move. Despite attempts to interest art galleries, children's homes or wealthy private collectors, no one else stepped up to claim the Lego House and the building was torn down shortly after it was built.

This luxury rental, built by Earthship Biotecture in Taos, New Mexico, boasts three bedrooms, two baths, a full kitchen, a fireplace, a jungle greenhouse, waterfalls and a fishpond. Earthship follows strictly sustainable design principles, using solar and wind power, water from rain and snow, and heating and cooling from the sun and the earth. Earthships are built entirely from natural and recycled materials: walls are made from discarded car tyres filled with compacted earth, reused glass bottles and aluminium cans.

This wild architecture eschews environmental values in favour of conspicuous consumption. Swisshorn Gild Palace, a jewellery store in Hong Kong, is made from of two tons of gold valued at more than thirty eight million US dollars, designed to attract tourists in to purchase gold.

Created by architects Klaudiusz Golos and Sebastian Mikiciuk, this unique architectural sculpture in Trassenheide, Germany, is called *The World Stands On Its Head* and is located on the Baltic Sea Island of Usedom. Open to the public, its interior features furnishings and fittings installed entirely upside down.

The Spanish photographer Victor Enrich Tarrés uses Adobe Photoshop to create realistic-looking buildings, which are in fact totally imaginary. Using the latest techniques in digital rendering and photography, he makes his 'impossible-seeming' buildings look real. This work, *Shalom 2* (2010), is based on a photograph taken in Tel Aviv.

A 'house within a house', this residence designed by Adam Kalkin is built from recycled shipping containers, surrounding a traditional residence. The house plays host to a film studio and a cooking school and is the architect's primary residence.

The Au Vieux Panier hotel in Marseille features five rooms which wild artists are asked to adorn yearly. *Panic Room* was created by the graffiti

artist Tilt (*see also pages 32-3 and 437*) and is half decorated with
graffiti while the other half has been left plain white.

Designed by Markus Linnenbrink, the visitors' tunnel at the JVA Prison in Düsseldorf, Germany, features 40 m (131 ft) of wildly colourful stripes and drips. We wonder how it affects conversations between visitors and the prisoners at the other end of the hypnotic tunnel.

Built by Edward Leedskalnin between 1923 and 1951 from 1,100 tons of
coral rock, the entrance sign to this work of wild architecture reads:
'*You will be seeing unusual accomplishment*'. Visitors to the Coral Castle
in South Florida are encouraged to tour this home, whose highly secretive
builder left few records of his intentions, apart from this enchanting
building.

Built on the world's largest salt flats at Salar de Uyuni in Bolivia, this entire hotel, including its furniture, is made of salt. Several hotels in the area are also built from blocks of salt, due to the lack of more traditional building materials nearby.

'ICE IS ONE OF THE MOST EXCITING SCULPTURAL MEDIUMS THAT EXISTS.'
– JAMES HASKINS

'SAND IS QUINTESSENTIALLY ABOUT TIME. THERE'S A STRONG PACIFISTIC STATEMENT IN THE CHOICE OF SAND. DO NO HARM. DIVEST OURSELVES OF POSSESSIONS. LIFE IS SHORT.'
– WAYNE COE

Stone, bronze, steel, wood or even clay: these are the permanent materials out of which we tend to expect sculpture to be made. None of these materials melt under the sun or disintegrate under an ocean wave. Why, then, would sand and ice be used instead? Well, for one reason in certain parts of the world they are the most easily available resource. For many artists the temporary nature of the substance is also a part of its appeal. Both sand and ice are highly versatile and can be used to create artworks in a wide range of genres, from the fantastical to the political, from the religious to the historical, from erotic scenes to sheer displays of artistic bravura and architectural prowess. The range of themes and associations linked to these constructions is as unlimited as the imagination.

Although art made from ice and sand doesn't usually find its way into the mainstream art world, there was a time when the different worlds came very close. In Italy in 1494 Michelangelo was commissioned by the Florentine Medici family to create a snow-based sculpture, following a spell of heavy snowfall.

Sand conjures up infinity in a multitude of ways: from the microscopically small to unfathomable expanses of vastness. Very few materials carry the double capacity to evoke the microcosm, through each tiny grain of sand, as well as the macrocosm – any given beach contains trillions of grains of sand – not to mention the unfathomably vast expanses of the world's deserts. A grain is about half a millimetre in size, and is, as a result, very light. A larger mass of sand is thus relatively easy to manipulate.

Sand lends itself surprisingly well to sculpting because its properties are very close to other powder elements, like cement, plaster and gypsum. Mixed with water, sand is able to hold its shape and can be moulded into any number of forms. It also solidifies, as cement or plaster does, but unlike most materials used for sculpture, its shape is not permanent. For that reason, and because sand is associated with the first creative steps of childhood (think of sandcastles on the beach), sand constructions, or sand sculptures, are not usually taken seriously within the mainstream art world. Of course, there are a few notable exceptions: Olaf Breuning's *Sand Sculpture* at Miami Basel 2008 is one.

Today's highly competitive sand and ice art and construction competitions conjure up a deep sense of awe in the remarkable creations made out of these ephemeral and fragile materials.

These wild artists draw vast crowds for large-scale competitions. Some of the more famous and popular sand construction pilgrimage spots include: Sandsation, Berlin; FIESA, Pera, Portugal; The Haeundae Sand Festival, Corea, Long Beach, Washington; and the US Sandcastle Open at Imperial Beach, California. Ice sculpture competitions are similarly popular and include the Deep Freeze Festival in Edmonton, Alberta; the BP World Ice Art Championships in Fairbanks, Alaska; and the Harbin Ice and Snow Festival in China. Teams of highly skilled professionals, engineers and artists congregate and enter into raucous competition in order to produce the spectacular, gigantic, yet minutely detailed and exquisitely carved ice and sand sculptures which showcase technical and artistic skills that would have impressed Michelangelo himself.

This ice sculpture by Alexei Akhmetov (2012) was shown at the annual
competition in Yekaterinburg, Russia. This city in the Ural mountains

on the border between Europe and Asia is one of many Northern hemisphere sites for ice sculpture competitions.

World-renowned ice sculptor Takeo Okamoto transforms blocks of ice into wonderful sculptures. From complete human figures and interactive pieces including a children's train and ponies to ride, to serving dishes and glasses from which to drink, Okamoto makes it all from ice. For Okamoto, who is a part of the ice-carving artist collective Okamoto Studios, ice is a unique material, where '*forms follow timelines of existence as they gradually change from rigid to organic, eventually disappearing, melting away*'.

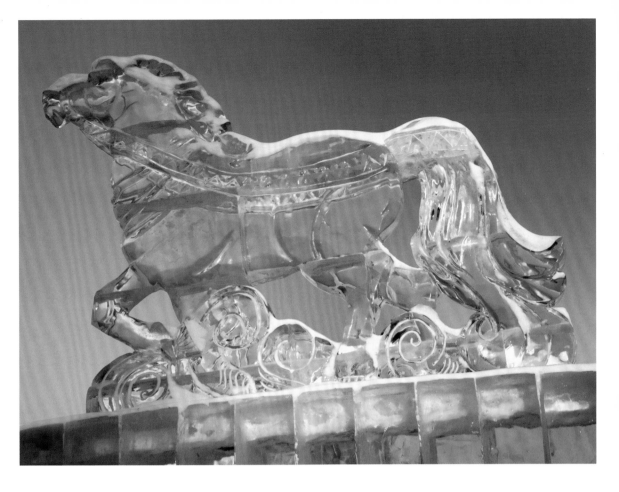

This is another sculpture from Yekaterinburg, Russia, a truly virtuostic exercise in carving and a demonstration of the potential for art made from ice.

Functional sculpture can also be made of ice. Sculptors Randy Finch and Derek Maxfield created this ice pool table, taking a common leisure pursuit and complicating the players' interaction by adding an element of icy, and maybe dicy, art.

A Canadian snow-sculpting team consisting of Carl Schlichting, David Ducharme, and Peter Vogelaar created this piece in 2006 for a festival in Whistler, Canada. This obvious reference to the *Winged Victory of Samothrace*, one of the most celebrated works of art in the Louvre, was not obvious to all: after being peppered with questions as to their figure's headlessness, the Whistler Arts Council chose to put up a sign to explain that its subject matter was the Greek goddess Nike.

Ice sculptures often employ the subjects of the traditional art world, as we see in this sculpture of a man flexing his muscles, shown at the Winterlude festival in Ottawa, Canada.

Wild ice art can present compositions as elaborate as any to be found in museums, as shown in this sculpture from the 2008 Sapporo Snow Festival in Japan.

As a transparent material, ice can be brought to life with intelligent lighting. Like many ice sculptures, this figure is best viewed at night, as seen in this dramatic photograph.

When the question of vacation locations comes to mind, most people lean towards tropical getaways. Given the opportunity, however, would you venture to the other extreme, a northern site? Approximately 40,000 people each winter make that choice and head north, 201 km (125 miles) past the Arctic Circle to the little town of Jukkasjärvi, Sweden. Here, they travel by snowmobile to their destination, the Ice Hotel, where they will sleep on a bed of ice and enjoy their palatial surroundings, also made from ice. Rebuilt each year, this was the hotel in 2011.

Norwegian artist Terje Isungset creates musical instruments from pure
ice. One of the most talented percussionists in the world, Isungset
had been working with numerous unconventional materials before being
commissioned to play a frozen waterfall in 2000. After incorporating the
ice of the waterfall into his commission, he began hand-carving musical
instruments, from which he creates haunting music for audiences across
the world. Isungset writes and plays each musical piece himself.

This icy DJ and turntable sculpture may not actually produce music as Terje Isungset's work (*left*) does, but it certainly makes a strong visual impression! It was created by Takeo Okamoto for Club Strata in New York.

It took giant feats of architectural and engineering prowess for a group of extraordinarily accomplished artists to erect this ice palace in Harbin, China in 2010. Every year, the Harbin International Ice and

Snow Sculpture Festival draws crowds for a month-long event, featuring palaces, giant sculptures and the tiny, icy details painstakingly created by artists.

From its humble beginnings - a group of local high school students who started building snow sculptures in Odori Park in 1995 for fun - the Sapporo Ice Festival in Japan has now grown to be an internationally known, week-long festival. With magnificent buildings such as this one from the 2008 festival, the winter wonderland does not disappoint.

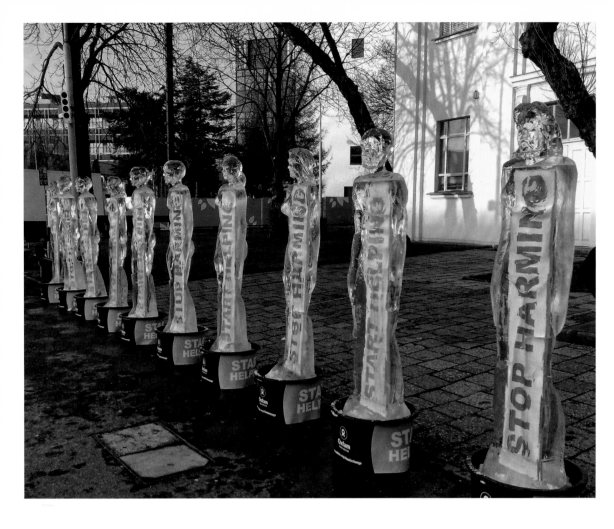

This political ice art stood at the entrance to the conference centre at the UN Climate Talks in Poznan, Poland, in 2008. Delegates and the media on their way into the building could not miss the message: rich countries should 'Stop Harming, Start Helping'.

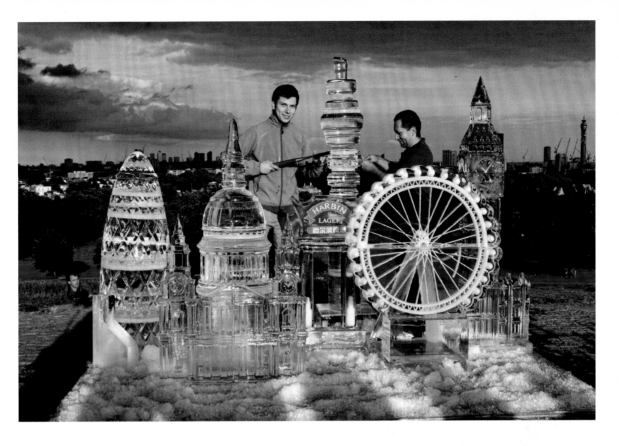

In this work, Percy Salazar Diaz and Clemente Gava are challenging, or maybe deliberately emphasizing, global warming by exhibiting ice sculptures of London landmarks outdoors at the height of the British summer. Entitled *London Cityscape*, the work was exhibited on Primrose Hill, London, in 2009, with the actual landmarks visible in the distance.

This Russian street artist calls himself 'P183'. Like Bansky, he keeps his identity hidden, stating only that he is 28, his first name is Pavel and that he has studied communication design. Here is his eyeglasses artwork in Moscow, one arm made from a lamp post.

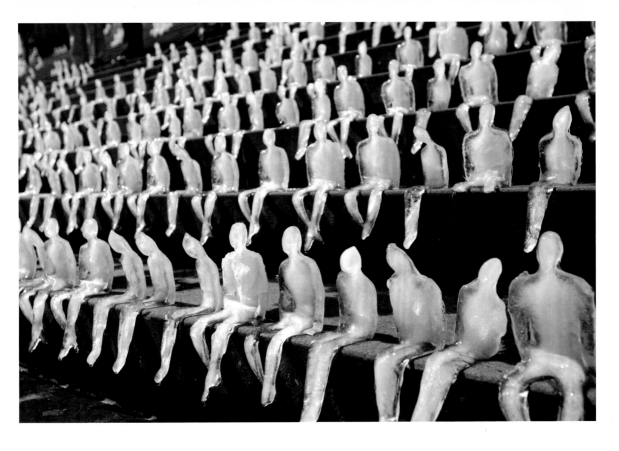

Staging icy interventions all around the world, Brazilian artist Nèle
Azevedo sculpts these small multiples in the name of a greener world
consciousness. The fragile ice in this work *Minimum Monument* looks simply
beautiful as it dots the urban landscape and slowly melts away, before
breaking down to rejoin the water cycle.

This art by Simon Beck, which covers an area as large as two-and-a-half soccer fields was designed for Lac Marlou, a site which offers excellent vantage points for photographs of his wild earth art.

The British, American and Soviet heads of state met at Yalta, a Black Sea resort, in February 1945 to create a plan for governing post-war Germany. This sand sculpture depicts Winston Churchill, Franklin D. Roosevelt and Joseph Stalin at the historic event.

While some sand sculpture depicts real historical figures, other wild
artists are inspired by film, such as the person who created this
sand sculpture in Zhoushan City, 2012, based on the film *King Kong vs.
Godzilla*.

You don't have to live on the ocean to find beaches. Sand art can be made wherever there is sand — in Berlin, for example, which has a large festival. Sudarsan Pattnaik is a world-renowned sand sculptor from India, and presented this piece at Berlin's Sandsation competition in 2010.

This pile of televisions, crafted out of sand, also appeared at the Sandsation competition in Berlin in 2010. Sandsation is known by the locals the 'biggest sandpit', and it is the only large-scale urban sand art festival in Europe.

Since 2003 Pera in Portugal's Algarve has been home to the FIESA sand sculpture exhibition. Each year the exhibition has a different theme, and in 2012 this was 'idols', prompting one artist to create this sculpture of *Star Wars* character Yoda.

Constructed by a team of ten sand artists headed by Paul Hoggard, this castle was made of 300 tons of sand. It was part of a Dutch festival in Scheveningen celebrating twenty years of sand art in the town.

The Blankenberge Sandcastle Festival has long been an attraction on the Belgian coast, and this Disney-themed castle was one of the creations in 2012. The visitors walking past the sculpture give some indication of the impressive size of the structure.

Many master sand sculptors make a living from commissioned pieces. Team Sandtastic is a sand-sculpting business in Fort Lauderdale, Florida. Owned by Mark Mason, the company builds over 75 sculptures a year. This is an example of a Team Sandtastic sculpture of Christmas lights.

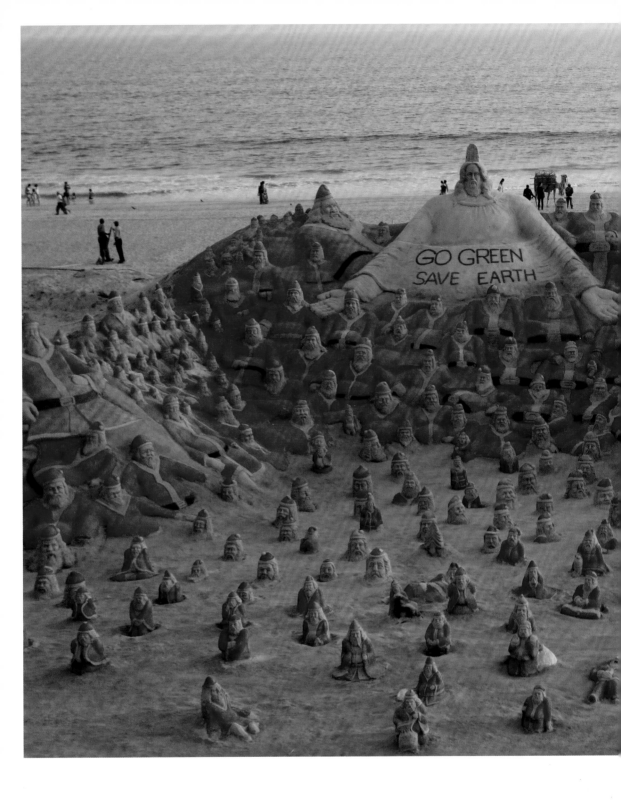

These sand sculptures of Santa Claus (500 in total) were created by students of world-famous sand artist Sudarsan Pattnaik (*see also page 348 and following pages*). They were made in December 2012 on the beach of Bhubaneswar in eastern India.

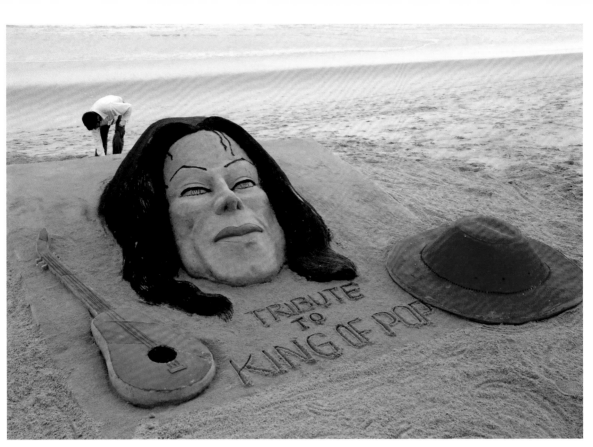

Sudarsan Pattnaik made this memorial to Michael Jackson at Golden Sea Beach, Puri, India, on 26 June 2009, thus illustrating the extraordinary range of interests that this artist formulates through sand.

Once again we see the influence of politics and political event in wild art. This is a sand sculpture of Osama Bin Laden marking his death in Pakistan in May 2011. It was also created by Sudarsan Pattnaik on Puri beach in eastern India.

New Zealand artist Peter Donnelly has produced sand-based ephemeral art for the last decade. He works mainly on Sundays at the New Brighton pier, carving sand on the beach. Donnelly says of his work: '*It's a celebration, in a sacred way, sharing the process of creation.*'

Andres Amador creates his sand art on Ocean Beach in San Francisco. He originally started making long, straight geometrical marks, just following various mental contraptions he had in mind. He now helps other people realize their own ideas in sand as well as creating his own guided meditation walks, ascribing a spiritual connotation to sand.

Andres Amador shares these comments on his wild art practice: '*My first
explorations were with line-design style geometric sculptures. This led
into studying "sacred" geometry and the cultural significance of symbols.
That led to interest in crop circle designs. And then one day in 2004
while visiting the ocean, drawing circles with my walking stick to show a
friend the things I had been learning, the incredible canvas of the beach
revealed itself to me … These days I do commissioned designs and medi-
tation art walks, as well as leading work teams, schools and groups of
friends in creating large-scale group artworks.*'

Jim Denevan, a surfer, chef and sand artist, makes massive drawings on sand, earth and ice. The expanses on which his works are spread out are so vast that they require aerial photographs for the full effect. His art is eventually erased by crashing waves and gusting wind. He embraces the ephemeral nature of his chosen medium and looks at the forces of nature, such as tides, as collaborators in his temporal work. This example was created on a beach in California in 2010.

In La Orotava, Tenerife, in the Canary Islands, sand carpets and frescos illustrating scenes from the Bible are made every June for Corpus Christi festival. In 2011 the theme was *Dios nos entrega a su hijo Jesús* (God gives us his son Jesus).

king
ctacle

'POPULAR-FESTIVE IMAGES BECAME A POWERFUL MEANS OF GRASPING REALITY; THEY SERVED AS A BASIS FOR AN AUTHENTIC AND DEEP REALISM.'
– MIKHAIL BAKHTIN

Festivals, parades and carnivals take us back to the origins of mankind. From Beijing to Rio, from the Chinese New Year festivals to the famous Rio Carnival. From the burlesque of Mardi Gras to the Berlin Love Parade, these public forms of collective aesthetic outburst have long been a topic of admiration, fascination and awe. They provide the public, whether audience or participants, with a mode of access to the spectacular, the fantastic; they enable both participants and audience to exit the sphere of everyday normalcy and accede to their own dreams, and beyond, for a few hours, or a few days.

Festivals and carnivals are art performed in the street. Art made for parades and art made as parades constitute one of the most popular and universally admired forms of art. It is totally disconnected from the gallery or museum world, past or present, and enlivens daily life, bringing pleasure to anyone who is open to public, unclichéd aesthetic experience.

The public spectacle is not a new idea. Writing in the eighteenth century the philosopher Jean-Jacques Rousseau said:

'*Let us not settle for these exclusive spectacles that lugubriously enclose a small number of persons in an obscure den, that holds them, timorous and immobile, in silence and inaction. No, dear happy ones, this is not your kind of festival! You need to go outdoors: it is under the sky that you must gather together and give yourselves over to the sweet feeling of your happiness.*'

Theme parks, aerobatic displays and light shows are all forms of wild art that bring people together in this spirit. Whether they present displays for spectators or encourage active participation, these spectacles are forms of wild art which attract vast audiences.

Starting as a small beach party in San Francisco, the Burning Man festival has become a highly organized, week-long annual event in Black Rock Desert, Nevada, with more than 48,000 visitors. Pavel Antonov's photographs (*shown above and right*) reflect the unbounded creativity that took place at the 2009 and 2010 festivals.

There are no rules at the Burning Man festival. The goal is to teach
people to express themselves in ways that they don't in everyday life.
Art-making plays a key role in this process.

The Love Parade, first held in Berlin just before the fall of the Wall in 1989, has long been a symbol of open, social performance entertainment, and total acceptance of any other forms of being and creativity. Standing for love, peace and liberty, participants take to the streets ready to show off their creative (and sexiest) best.

By the second year of the Love Parade both East and West sides of Berlin took part, swelling the crowds from 150 to 2000, with each subsequent year seeing more and more participants.

The Samba School parade in Sambodromo, Rio de Janiero, Brazil, 2011.
Said to be the largest carnival in the world, this event hosts more than
500,000 foreign visitors each year.

The Trinidad Carnival is the major local cultural event and the elaborate costumes are worked on all year round in studios and shops around Port of Spain, the island's capital, ahead of the event each February.

The carnival has spread as people have migrated around the world.
Although the UK may not enjoy the same climate as Trinidad or Rio de
Janiero, it still enjoys colourful and vibrant expressions of this art
form. Bristol, in south-west England, has a large West Indian population,
mostly centred around the St Pauls area of the city. The annual carnival
is now one of the city's cultural highlights and draws people from all
backgrounds and ethnicities. The 2010 event, shown here, attracted over
70,000 people.

The Notting Hill Carnival transforms a normally genteel and peaceful part of west London into a three-day carnival each August. Here is a performer from the 2011 parades.

We have already seen examples of animal wild art from the the Dutch festival of flowers Bloemencorso Zundert (*see pages 154-5*), and here is another wild float creation. Entitled *Tuin der Lusten* (The Garden of Delights) this amazing wheeled work of art was awarded third prize in the 2008 festival. Its design was based on a work by the medieval Dutch painter Jeroen Bosch.

The Tournament of the Roses Parade in Pasadena, California, is another parade dedicated to organic sculpture. This New Year's celebration features floats constructed from flowers, such this one, *Preserving Paradise*, from the 2012 parade. All inorganic and artificially coloured materials are banned as decoration. The art of flower arrangement at its grandest, most floats are constructed by professional companies, taking up to an entire year to complete each piece.

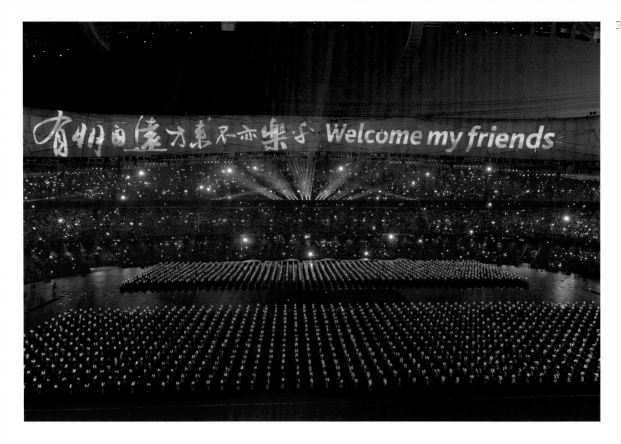

有朋自遠方來不亦樂乎 Welcome my friends

The opening and closing ceremonies of the Beijing Olympic Games in 2008 were undoubtedly some of the most extravagant and watched public art performances in the history of mankind, with an estimated two to four billion spectators!

China, a very large and heavily populated country, is extremely good at putting on very large spectacles.

China invented the firework. As can be seen in this image from the
closing ceremony of the Beijing Olympic Games at the National Stadium,
the Chinese continue to be experts in this form of wild art.

What does it take to make a great fireworks display? The combination of technical success (the explosions working as they should) and the effective fine-tuned coordination of colour, form and timing makes shows stand out. The height of the display and the creation of exquisite, unexpected images in the sky are all part of the equation, too. Artists have the chance to test their talent and skill at a number of international competitions. The image above shows a moment from a display at the Jinshan International Beach Music Fireworks Festival in Shanghai, China, in 2012.

Across the world, humankind has come to view fireworks as a way to mark and celebrate many of our major events. Cities spend millions of dollars on creating, designing, installing and executing breathtaking symphonies of light that turn the skies to flame. The Sydney Harbour Bridge New Year's Eve festivities are one of the first to explode each year, and one of the most famous. Often timed to music, the displays are awe-inspiring productions, combining the visual and musical arts.

This street performer at the World Buskers Festival in Christchurch,
New Zealand, in March 2011 shows that very small bicycles can attract
large crowds.

Performance artists who work directly in front of the public on the
streets or in other public spaces are usually anonymous; however, a few
have become tourist attractions in their own right, such as the Naked
Cowboy of New York City. Real name Robert Burck, the Naked Cowboy braves
all sorts of weather to perform for the tourists who flock to Times
Square.

The Crow Fair Powwow is a celebration of Native American culture, held every year in Crow Agency, Montana, and involves dances carried out in full traditional regalia. It serves to preserve an ancestral tradition within a rapidly changing culture. Time and dedication have obviously been spent on these dancer's dresses, not to mention their own highly complex dance practices. From the finely crafted moccasins and the ornately sequined fabric, to the flowing fringes and carefully selected feathers, every detail has been considered. Only the best artists are able to use the dance movements to perfectly complement and enhance the outfit's ornaments.

Here is another form of public spontaneous art performance in the United States: sports fandom. An NFL fan at a match in 2011 expresses his boundless support for his team – today's American form of tribal practices, except that this form of artistic expression is conspicuously devoid of any spiritual intent.

In a celebration of Spring's arrival, the Hindu Holi Festival of Colours fills streets with an absolute riot of colour. Celebrated around the world, the festivities include throwing coloured powders in the air to create magnificent sights, such as the one shown here. Just as amazing

are the images of people taken just after the celebration, when skin and clothing take on the exquisite colours of these intoxicatingly beautiful and inspirational communal celebrations.

Even the most stalwart of passers-by may become fixated, if not hypno-
tized, by performance artists who work well outside of stadium and
gallery tracks, directly in public view. This is the artist 'Fyregod'
performing in Joshua Tree National Park in California.

Fire-breathing is an ancient art form that was used to gain spiritual ascendancy. It became a part of circus lore towards the end of the nineteenth century, and has continued into the twenty-first century as a popular and mesmerizing form of human ability. Here, acrobats perform fire-breathing as part of the entertainment at Singapore Zoo's Night Safari in 2012.

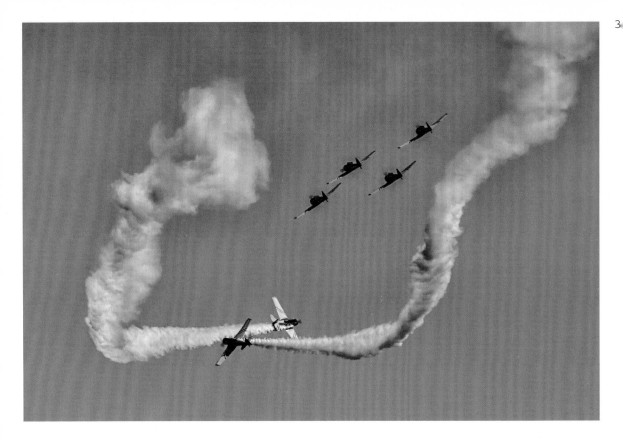

Loops, curves and spirals are an everyday occurrence in the world of
air shows. Performing amazing aerobatic feats, pilots manoeuvre their
aircraft in a thrilling dance far above a captive audience's heads.
Shown here is the 'solo drop' manoeuvre at the beginning of a routine in
Maryland, US, where two pilots switch on their smoke, descend away from
the formation and turn 90 degrees as they cross close by each other.

Staying up in the air with this next piece of wild art, here we see a marvellous group of kites at a beach festival in St Peter-Ording, Germany, in August 2011.

Growing in popularity, the 'flash mob' is a marvel of what communications technology and social media can achieve in the hands of creative individuals. Site- and time-specific works emerge for minutes or mere seconds before participants dissolve back into their everyday lives. Often with an anonymous or loose group organized through various social media,

groups of participants - anybody - are called to join and assemble. This might be for a dance or for complete stillness, for silence or … almost anything. If you're lucky, you'll run into the 'free-hug flash mob' and not the 'pillow-fight flash mob'. Here, a group performs a choreographed dance in London's Covent Garden.

The 'Thrill the World' project uses Michael Jackson's world-renowned *Thriller* music video to encourage people to dance, simultaneously, worldwide. Started in 2006, the project initially set the Guinness World Record for most people simultaneously breaking into dance. In the image above, eager participants in Austin, Texas, have taken the time to go all-out in costume for this 2008 performance, which included 4,179 participants from 13 different countries. Since then, on 24/25 October 2009, 22,571 people in 264 cities across 33 countries danced to *Thriller* at exactly the same time!

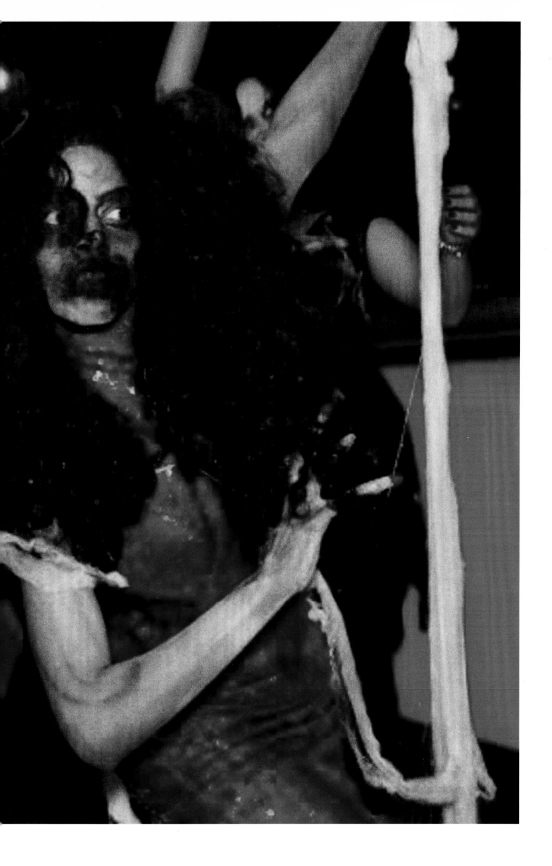

The city of Blackpool in northern England (often considered the British equivalent of Las Vegas) boasts illuminations that are among the oldest and most extravagant in the world. The display stretches along the city's promenade, from Starr Gate at the southern end of the town to Bispham

at the other. Measuring 9.7 km (6 miles) long and using over one million bulbs, it is the greatest, free lightshow on earth. We can see the streaming and brilliant illuminations running the length of Blackpool's seafront, with the world-famous Blackpool Tower visible near the centre.

Who could deny the visual allure or the artistic and architectural inventiveness of Las Vegas's neon excess? Sculptural works on a massive scale recreate entire cities, such as Venice and Paris. The city even has its own Neon Museum dedicated to preserving the unique role that neon plays in Las Vegas's story. The museum has been collecting signs since 1996. This photograph shows the world-famous Vegas Strip, stretching 6.75 km (4.2 miles) and home to some of the largest hotels and casinos in the world.

This grand spectacle in November 2011 at the Marina Bay, Singapore, shows the full potential of wild light art.

Every December in Lyon, France, a Festival of Lights is held, dedicated to the Virgin Mary. During the festival many buildings and landmarks around the city are illuminated, such as the Saint-Jean Cathedral.

Here is a home decorated with Christmas lights in Vancouver, Canada. At Christmas it seems all of the usual rules of taste go out of the window, and normally private people put on very public displays - especially in cities in the northern hemisphere, where the colourful lights offer a welcome break from the darkness and chill of winter.

For fifteen years the electrician Alex Goodhind has been creating a Christmas light spectacle at his house in Melksham, England. This elaborate display, which raises money for a local charity, uses over 100,000 bulbs and requires a special power supply.

Lights and theme parks go together well, and it is difficult to imagine one without the other. The light shows and displays at parks across the world are an integral part of the entertainment and experience, and should be considered as works of great artistic merit. They offer a heightened sense of wonderment, escapism and fantasy, especially at night. This dazzling firmament is at Nabana no Sato theme park in Nagashima, Japan. For their Winter show, millions of LEDs light up the sky with a 'tunnel of lights'.

Grizzly Peak is just one of the impressively scaled attractions at the
Disney California Adventure Park. While made for entertainment rather
than artistic critical analysis, it would be fair to say that the ambi-
tion of its designers and engineers is on a level with the largest
of public art projects. If this were presented within Tate Modern's
vast turbine hall, our appreciation of this massive sculpture would be
entirely different, as would its audience.

Suoi Tien Cultural Amusement Park is located in Ho Chi Minh City, Vietnam. The artistry and design that has gone into the park is staggering. The landscaping and even the attractions echo Vietnam's history and mythology. The wonderful and exotic man-made Tien Dong beach is a major attraction, with a thunderous waterfall and the face of legendary figure Lac Long Quan carved into the towering rock. It is an imposing wild art backdrop to the commercial water park concept.

The Big
all
Art

'BOLD, OVERHANGING, AS IT WERE THREATENING CLIFFS, THUNDER CLOUDS TOWERING UP TO THE HEAVENS, BRINGING WITH THEM FLASHES OF LIGHTNING AND CRASHES OF THUNDER, VOLCANOES WITH THEIR ALL-DESTROYING VIOLENCE, HURRICANES WITH THE DEVASTATION THEY LEAVE BEHIND, THE BOUNDLESS OCEAN SET INTO A RAGE, A LOFTY WATERFALL ON A MIGHTY RIVER … MAKE OUR CAPACITY TO RESIST INTO AN INSIGNIFICANT TRIFLE IN COMPARISON WITH THEIR POWER.'
– IMMANUEL KANT

If the Grand Canyon was only a few feet deep, we would not experience the same sense of the sublime as we faced it. If Michelangelo's *David* was just a few inches tall, none of its awesome majesty would be apparent to us. The cogent aesthetic impact depends in large part upon the fact that, in both cases, we are facing a landscape or a work of art whose stature and dimensions extend vastly beyond what we regard as average size. Jonathan Swift's *Gulliver's Travels* (1726) offers a classic tale exploring the effect of changes of scale, while Lewis Carroll's *Alice's Adventures in Wonderland* (1865) presents another. Both novels play with the uncanny effects of changes of changing the size of the characters. The impact is quite analogous to our sensations when we are confronted by the Grand Canyon or St Peter's Basilica in Rome.

Some works of art in museums are small enough to be held in our hands,
while some, like the ceiling of Michelangelo's Sistine Chapel, fill a
vast room and expand well beyond the scope of our visual field. On the
whole, however, a work of art is usually an object of human scale. A
painting hangs on a wall; a sculpture fits within a gallery space.

This final chapter explores works of wild art that in some way utilize
size or scale as part of their artistic proposition. We are looking here
at works that can be very small, even too small to be viewed with the
naked eye; or very large, even too large to be displayed on earth. The
art forms we are now looking at call for the microscope and the tele-
scope: from the minute to the monumental.

If less can be more, then can much less be much more? Willard Wigan
created this miniature sculpture of *Superman* in 2006, one of the smallest
sculptures in the world. Certainly it seems paradoxical that the 'Man of
Steel' be so tiny!

A trip to a miniature model shop inspired photographer Vincent Bousserez to create his 'Plastic Life' series of photographs featuring miniature plastic figures shot against real backdrops. He carries a selection of mini characters around with him wherever he goes so that he can take a photo when inspiration strikes.

Here is another work by Vincent Bousserez, this time placing the minia-
ture figures on a human body. The 36-year-old from Paris now has 80 such
photographs in his collection.

Miniature sailing ships, beautiful and evocative of a golden age can be seen in maritime museums and private collections the world over, but their artistic merit is not always fully appreciated. These examples are owned by The International Maritime Museum in Hamburg, Germany. Their makers resort to extraordinary measures to produce a miniature ship of such detail. It's no small artistic feat!

The name says it all: Small Artworks. This company in Nova Scotia, Canada, creates small-scale models. This detailed model of the Nostromo spaceship from the movie *Alien* is 36 cm (14 in) long.

This sensational watercolour measures only 82 x 57 mm (3¼ x 2¼ in) and is reproduced here at actual size. *Pensive* is a tiny yet incredibly detailed depiction of a western lowland gorilla by artist Tracy Hall. While there are many organizations to support the careers of artists whose interests lie on the smaller end of the scale, they remain decidedly outside of the sphere of mainstream contemporary art.

Here is the world's smallest sculpture: a three-dimensional bull that is
invisible to the human eye. In fact, it is the size of a red-blood cell.
This scientifico-aesthetic exploit was realized by Japanese scientists
at the University of Osaka, Japan. Unveiled in 2001, the sculpture was
created using a process called two-photon photo polymerization, whereby
a pair of finely focused lasers mould a plastic resin into various forms.
This is literally the 'cutting edge' of nano-art technology! Would the
established art world ever be able to consider a work that could not be
seen by the naked eye as worthy of its attention?

The British wild artist Andrew Nicholls painted the world's smallest *Mona Lisa*. As you see, it's less than a quarter of the size of a British postage stamp.

Fabergé is world famous for its exquisite, intricate and extremely expensive ornamental eggs. Utterly beautiful, they are stunning evocations of grandeur and vast wealth, on a miniature scale. The eggs, made from precious metals and decorated with gemstones, have become a symbol of luxury, artistic opulence and societal decadence. This one is 12.7 cm (5 in) in length; the carriage is almost 10.2 cm (4 in) and was presented by Tsar Nicholas II to his wife in 1897.

The Azorean weekly newspaper *Terra Nostra* is the world's smallest newspaper according to the *Guinness Book of Records*. It's a literary downsizing of epic proportions. On the occasion of the World Day of Social Justice, the newspaper publisher came up with the idea for a special issue about immigrants travelling to the Azores, printed in a mini format of 25 x 18 mm (1 x 7/10 in). It can only be read using a small magnifying glass with a x8 magnification.

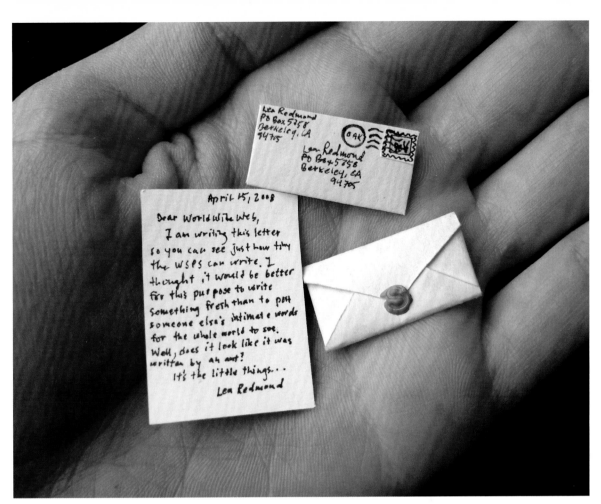

Does the size of a message say something about its importance? World's Smallest Postal Service (WSPS) in San Francisco is run by postmistress Lea Redmond, and she certainly belives that smaller is better. Her service is particularly popular for sending Valentine's messages, which have to be written in a minuscule script before being sealed in a stamp-sized envelope with wax bearing the sender's initial.

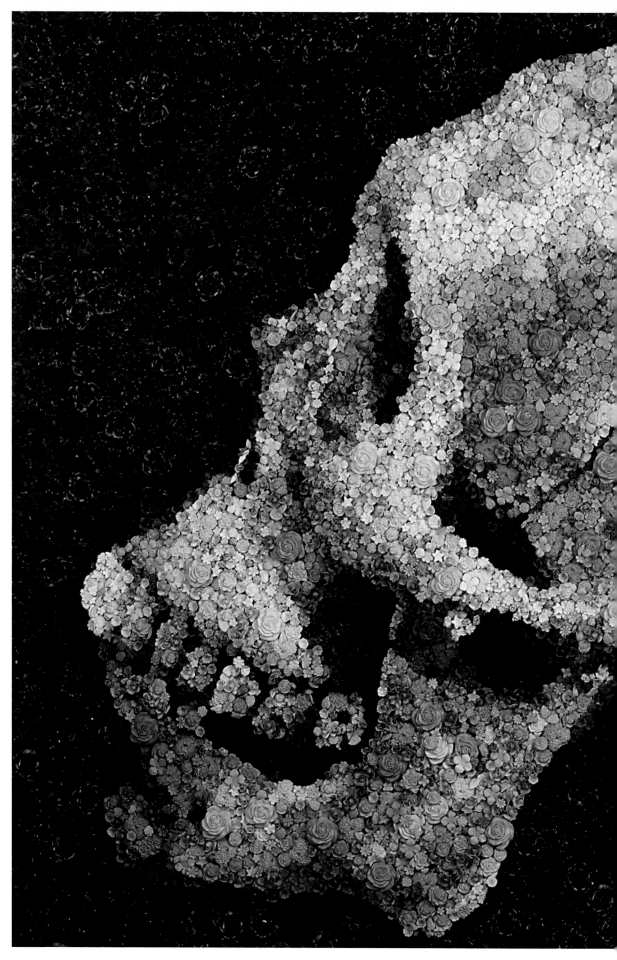

Made from over 35,000 hand-cast urethane flowers, this skull combines the micro and the macro in one exceptional artwork, *What Remains*. The mosaic

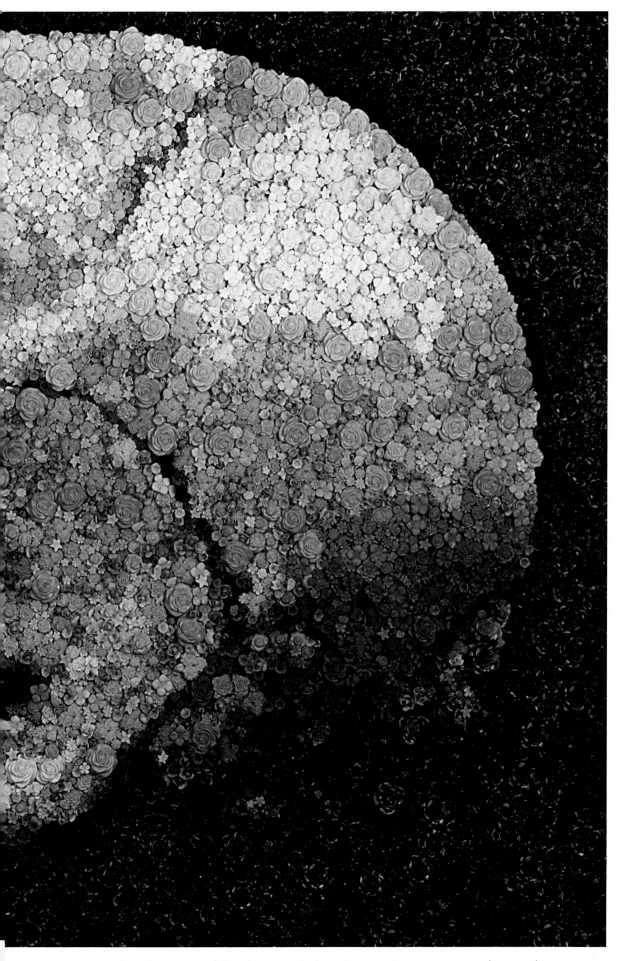

measures 122 x 152 cm wide (4 x 5 ft). The work's creator is Kevin
Champeny from New York. It is a beautiful evocation of life and death.

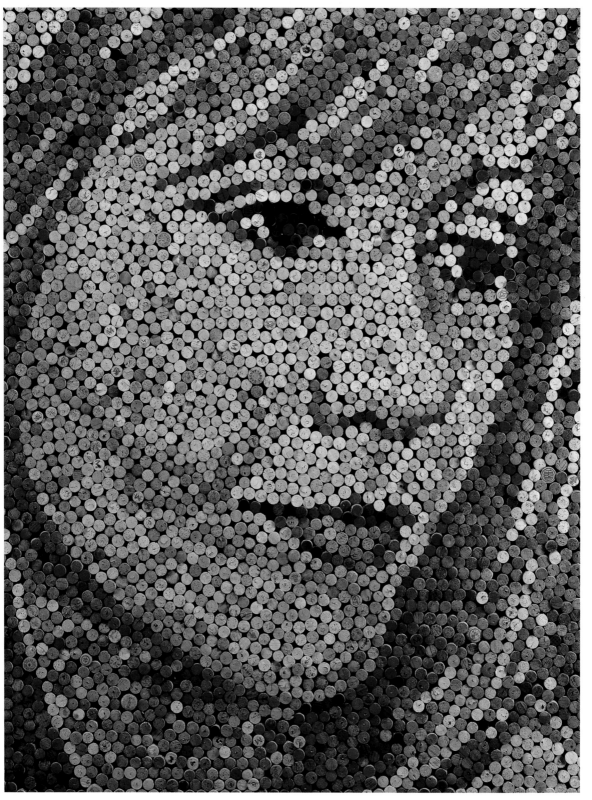

Scott Gundersen makes large-scale creations from tiny objects, constructing the great from the small. This artwork, *Trisha*, is made from 3,621 wine corks and measures 1.7 x 1.4 m (46 x 56 in).

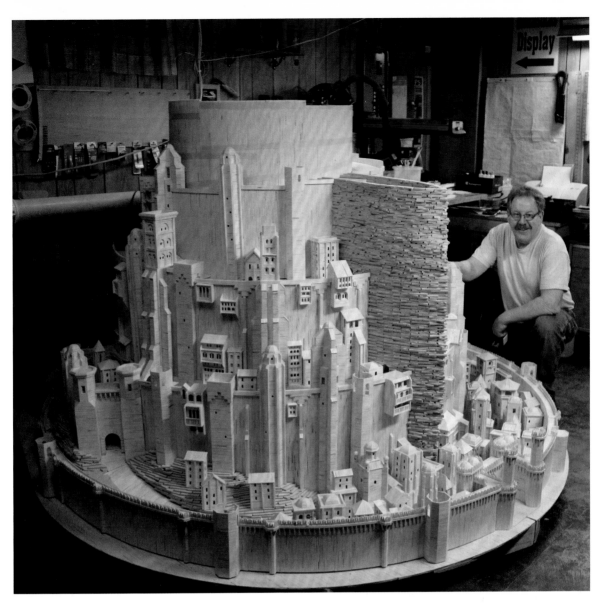

Patrick Acton is a wild artist who uses matchsticks to make sculptures of large objects, such as the buildings of Lower Manhattan, the fantasy school of Hogwarts and even the Space Shuttle. Acton had no particular woodworking skills when he first began matchstick sculpting in 1977. Above, we see Acton's matchstick version of the mountain city, Minas Tirith, from J. R. R. Tolkien's *The Lord of the Rings*.

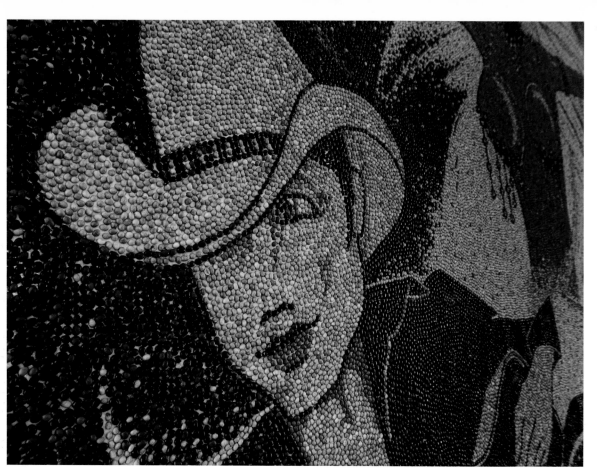

Created by mosaic artist Saimir Strati, the world's largest coffee bean mosaic is located in Tirana, Albania. The mosaic uses over one million beans from various countries, including Brazil, India and Venezuela. The work was finished in December 2011 and measures 25 m^2 (269 ft^2). This prolific artist has set new mosaic-related Guinness World Record every year since 2006.

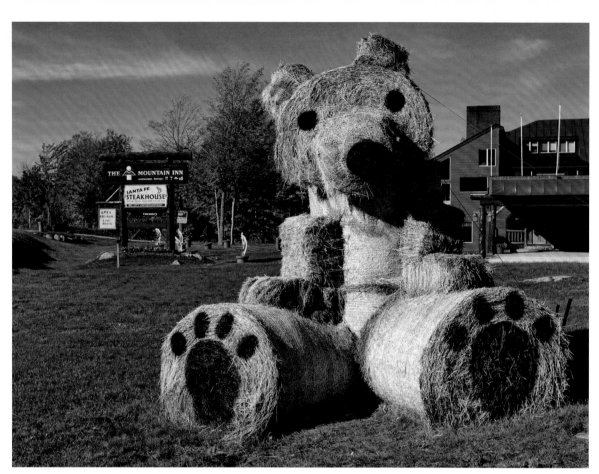

The Killington Hay Festival is a popular Vermont gathering where one can rub up against massive sculptures of animals, such as a 363 kg (800 lb) snail or this 10.7 m (35 ft) bear, *Hay Teddy Bear*.

The Big Easel Project began in 1998 when artist and teacher Cameron Cross decided to contribute a work of art to the town in which he was teaching, Altona in Canada. He created an enlarged, hand-painted reproduction of one of Vincent van Gogh's sunflower paintings, resting on an enormous easel, at a total height of 25 m (82 ft). The project soon acquired the status of a cultural landmark for the town of Altona and Cross decided to expand the project to seven other cities. With two easels already completed (Altona and Emerald in Queensland, Australia) Cross approached the city of Goodland, Kansas, for the location of a third easel site. 'Sunflowers USA', a group of dedicated locals, helped bring the project to completion.

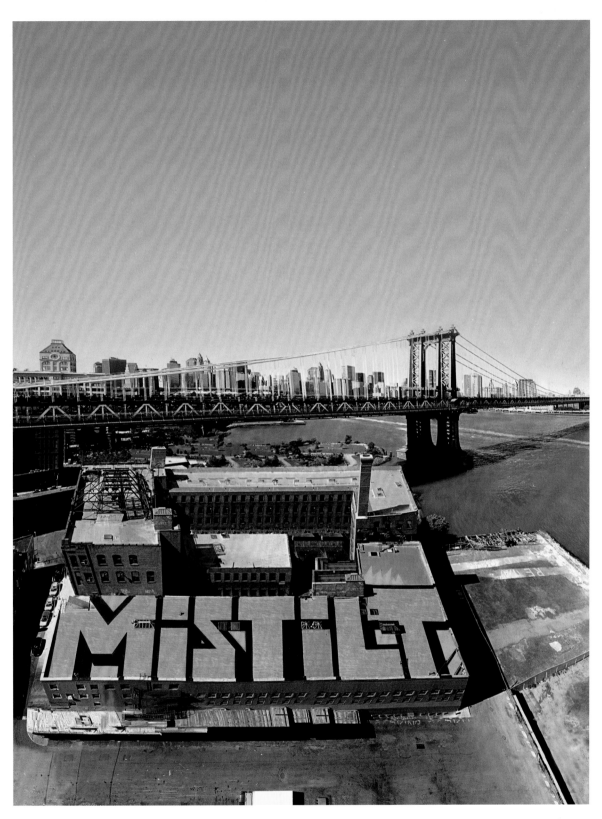

Fellow wild artists Tilt (*see also pages 32 and 312*) and Mist collaborated
to create this giant artwork *Target 5* in New York in 2010. Measuring
17 x 71 m (56 x 233 ft) the two artists united their artistic names in
acrylic and spray-paint to create an artwork best viewed from above.

Stuart Murdoch created the world's largest deckchair for the beach at
Bournemouth, England. Based in Speyside, Scotland, Murdoch works with
natural materials. This particular project was commissioned by the makers
of the iconic British drink Pimm's.

This massive sculpture of the iconic Hollywood star in one of her most famous poses was made by the artist J. Seward Johnson, Jr. Installed in Chicago in 2011, *Marilyn* drew mixed reactions from the public.

Bather is a giant sculpture created by Oliver Voss, head of the Miami Ad School. When installed in Alster Lake, Hamburg, local people protested. Even the mayor of the city said it 'sullied' the lake. Like it or not, this giant woman watched over the lake for ten days to promote tourism and encourage people to enjoy the water.

Towering over Mecca, Saudi Arabia, is the Albraj Al-Bait Tower, the building with the world's largest floor area. Like most works of art that play upon gigantic scale, it inspires awe and a sense of the sublime. Under the breakneck competition of trying to claim the title of world's

tallest or largest building, what often gets lost is the implausible
scale and artistic expansiveness that goes into the design and construc-
tion of these monuments. They are true architectural wonders.

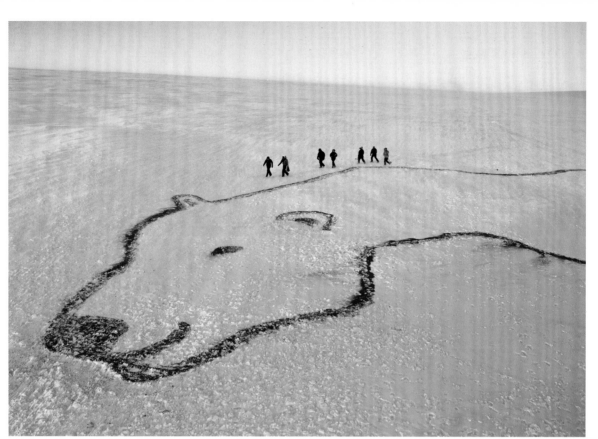

This giant illustration of a polar bear was created by Bjargey
Ólafsdóttir using organic red food dye on Langjökull Glacier, Iceland's
second largest glacier. Temporary artworks that interact with the natural
environment on this scale are rare; this giant bear was created as part
of the environmental project, 'Earth'. The red dye also acts as a comment
on the demise of the bears' natural habitat and their related endanger-
ment. The work is a vast attempt to speak of our role in the future of
the planet via the medium of art.

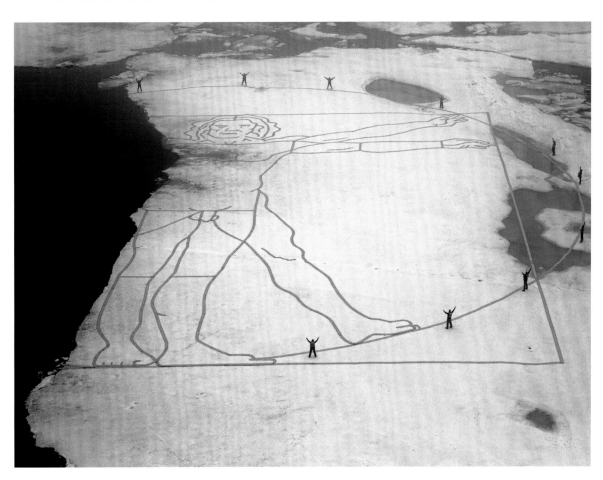

Funded by Greenpeace, this enormous copper image on the Arctic sea ice
was created by artist John Quigley, after Leonardo da Vinci's drawing
The Vitruvian Man. This work is called *Melting Vitruvian Man* and Quigley
explains its origins in global environmental concerns: '*We came here to
create the* Melting Vitruvian Man, *after Da Vinci's famous sketch of the
human body, because climate change is literally eating into the body of
our civilization. When he did this sketch it was the Enlightenment, the
Renaissance, the dawn of this innovative age that continues to this day,
but our use of fossil fuels is threatening that.*'

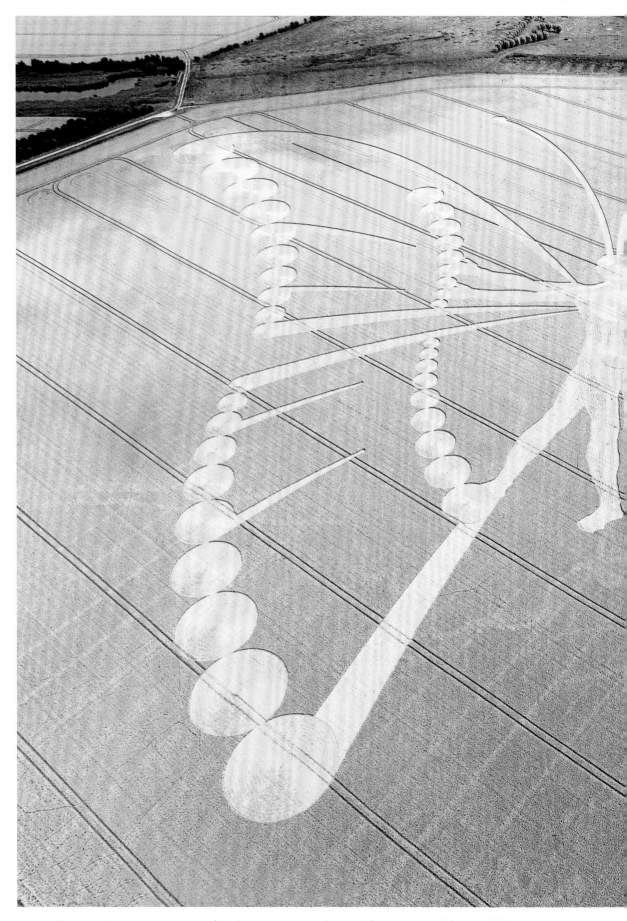

One of the largest crop circles ever made, this astounding wild art achievement has no extraterrestrial origin. It was made in the province of Zeeland in the Netherlands, its production recorded for the reality television show, 'Try Before You Die'. It took 60 volunteers working through the night to create this colossal crop design, which we think

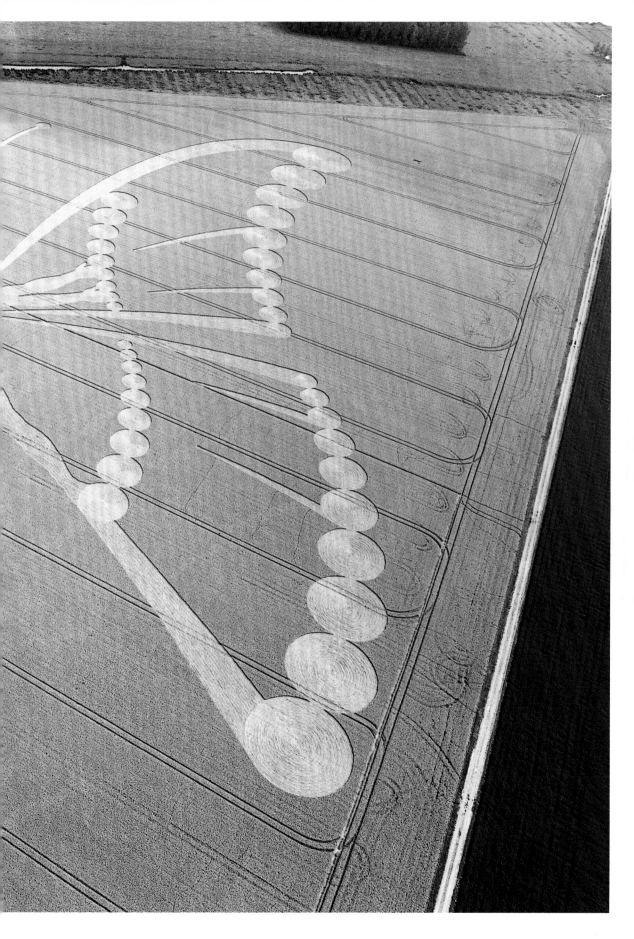

measures up in every compositional aspect from scale to design, to accuracy and beauty. This is a great example of humanity showing just how much we can do, expressed through the medium of collective art on a superlative scale.

Gutzon Borglum's monumental sculpture on Mount Rushmore has become an American icon. In 1927, working with his son, Lincoln, and numerous workmen, Borglum began drilling and blasting, and shaped the mountainside into the envisioned sculpture, which was completed in 1939. Today, the site in South Dakota's Black Hills draws crowds who marvel at the sheer size and accuracy of the work, but how many people consider it a work of art?

'Palm Islands' in Dubai are the world's largest man-made islands, and represent a human endeavour to deliberately shape the natural environment for artistic purpose. The full project is still under construction, and each settlement has been, or will be, created in the shape of a palm tree

surrounded by a crescent. They are designed to add 520 km (323 miles) of beaches to the city of Dubai and are an enormous undertaking. One of the islands, Palm Deira, is composed of approximately one billion cubic metres of rock and sand.

'The World', a man-made archipelago 4 km (2.5 miles) off the coast of Dubai, is constructed to form a rough map of the world. The scale of the project is vast: islands range in size from 13,935 m² (150,000 sq ft) to 41,806 m² (450,000 sq ft) and utilize approximately 25,485 m³ (900,000 cubic ft) of sand and 31 million tons of rock, covering an area 5.6 by 8.9 km (3.5 by 5.5 miles). Buyers will purchase not a house, not an acre, not an island, but a country. This giant, sculptural residential endeavour pushes human capacity for expansion to another level.

This magnificent photograph was assembled in 2003-4 by combining ten years of NASA Hubble Space Telescope photographs of a tiny patch of sky. Collecting faint light over many hours of observation, this image revealed thousands of galaxies, including the faintest and most distant ever seen. It is the deepest image of the universe ever taken, and as such could be considered the ultimate artwork on a monumental scale.

PAGES 2–3
Banksy quote taken from *Wall and Piece*, Century, 2006.
John Cage quote taken from the television series 'American Masters', Season 5, Episode 8, John Cage: *I Have Nothing to Say and I Am Saying It* (aired on 17 September 1990).
Thomas Kinkade as quoted in M. Stephen Doherty, *The Artist in Nature: Thomas Kinkade and the Plein Air Tradition*, Crown Publishing Group, 1902.
Sister Wendy Beckett quote taken from *Joy Lasts: On the Spiritual in Art*, J. Paul Getty Museum, 2006.

INTRODUCTION
p.7: Barry Schwabsky quote taken from 'Signs of Protest', *The Nation*, 2 January 2012.
p.10: Alfred H. Barr as quoted in Sybil Gordon Kantor, *Alfred H. Barr, Jr and the Intellectual Origins of the Museum of Modern Art*, Massachusetts Institute of Technology, 2002.
p.11: Kant as quoted in Tzvetan Todorov, *The Fear of Barbarians: Beyond the Clash of Civilizations*, translated by Andrew Brown, University of Chicago Press, 2010.

CHAPTER 1
p.14: Banksy quote taken from *Wall and Piece*, Century, 2006.
p.15: Car ownership statistics taken from a *Ward's AutoWorld* magazine report of 2010.
p.26: Utah quote taken from an interview with webzine 'Blogue', 10 February 2010.
p.30: Clet Abraham quote taken from *The Florentine*, online edition, issue no. 136, February 2011.
p.44: Agata Oleksiak (Olek) quote taken from *The New York Times*, online edition, 19 May 2011.
p.52: Marco quote taken from New York *Daily News*, online edition, 9 May 2010.
p.55: Brian Donnelly (KAWS) as quoted in Germano Celant, 'B D and K' in Monica Ramirez-Montagut, *Kaws*, Rizzoli, 2010.
p.62: Sara Watson quote taken from *The Telegraph*, online edition, 2 May 2009.
p.74: Drew Brophy website drewbrophy.com.
p.76: Trevor Moran quote taken from blog suferscandy.com.

CHAPTER 2
p.80: Margot Mifflin quote taken from *Bodies of Subversion: A Secret History of Women and Tattoo*, June Books, 1997.
pp.80-1: Michel Foucault quote taken from *Dits et ecrits* (1954-1988), Gallimard, 2001.
p.81: For more details on the prevalence of tattoos in modern culture see Leanne K. Currie-McGhee, *Tattoos and Body Piercing*, Lucent Books, 2005.
p.82: Details of Samoan saying taken from the website 'Traditions and Customs All Over the World by Mislav Popovic', traditionscustoms.com.
p.85: Stelarc quote taken from an interview with *Bizarre* magazine online edition, April 2009.
p.101: Mickie Wood quote taken from Eden Wood Facebook page.

CHAPTER 3
p.118: Jean de la Fontaine quote taken from Dedication 'To Monseigneur the Dauphin', Book 1, 1668.
p.119: Stefan St-Laurent quote taken from *Animal House: Works of Art Made by Animals* published on Galerie SAW Gallery website galeriesawgallery.com.
p.120: Details of 'When Elephants Paint' exhibition taken from the Museum of Contemporary Art Australia website mca.com.au.
p.138: Sarina Brewer quote taken from 1800recycling.com.
p.146: Kyle Bean quote taken from foodrepublic.com.
p.148: Emily Valentine quote taken from artist's website emilyvalentine.com.au.
p.159: Paul Koh quote taken from artist's blog paulmysh.blogspot.co.uk.

CHAPTER 4
p.164: Norman Douglas quote taken from *South Wind*, Capuchin Classics, 2009.
p.181: Ginou Choueiri quote taken from trendhunter.com.

CHAPTER 5
p.202: Kenneth Clark quote taken from *The Nude: A Study in Ideal Form*, Doubleday Anchor, 1956.
p.204: Adam Harvey quote taken from *Wired* magazine, online edition, 14 April 2006.
p.217: Barney Smith quote taken from an original interview at roadsideamerica.com, 24 April 2007.
p.223: Sprinkle Brigade quote taken from artists' website sprinklebrigade.com.

CHAPTER 6
p.226: Jeremy Mayer quote taken from *American Craft Magazine*, December/January 2011.
p.229: David Mach quote taken from an interview in *The Telegraph*, online edition, 11 January 2011.
p.237: Gugger Petter quotes taken from artist's website guggerpetter.com.
p.245: Simon Rodia quote taken from the Watts Towers Arts Center website wattstowers.org.
p.247: 'Dr Evermor' quote taken from Wikipedia entry (unreferenced).
p.249: Diane Kurzyna quote taken from artist's website rubyreusable.com.
p.255: Jolanta Smidiene quote taken from an article in *Demilked* online magazine, 9 December 2011.
p.268: Kris Kuksi quote taken from artist's website kuksi.com.

55 p.271: Urban Trash Art quote taken from artists'
blog urbantrashart.blogspot.co.uk, 2011.
p.273: Gabriel Dishaw quote taken from artist's
website gabrieldishaw.squarespace.com.

CHAPTER 7
p.276: Alain de Botton quote taken from
The Architecture of Happiness, Penguin, 2007.

CHAPTER 8
p.322: James Haskins quote taken from *Snow
Sculpture and Ice Carving*, Macmillan, 1974.
p.322: Wayne Coe quote taken from
manhattansandpaintingproject.com.
p.326: Takeo Okamoto quote taken from artist's
website okamotostudionyc.com
p.360: Peter Donnelly quote taken from blog
post 'Sand Art by Peter Donnelly and Andres
Amador' on chirag3065world.blogspot.com,
August 2010.
p.363: Andres Amador quote taken from blog
post 'Sand Art by Peter Donnelly and Andres
Amador' on chirag3065world.blogspot.com,
August 2010.

CHAPTER 9
p.370: Mikhail Bakhtin quote taken from
Rabelais and His World, translated by Hélène
Iswolsky, MIT Press, 1968.
p.371: Jean-Jacques Rousseau quote taken from
Lettre a M. D'Alembert Sur Les Spectacles
(Letter to d'Alembert on Spectacles) (1758),
Editions Flammarian edition, 1993.

CHAPTER 10
p.416: Immanuel Kant quote taken from *Critique
of the Power of Judgement* (1790), Cambridge
University Press edition, 2000.
p.445: John Quigley quote taken from
Greenpeace website greenpeace.org.

PICTURE CREDITS

Luke Jerram, Play Me, I'm Yours: 48-9; M&Y Media/Rex Features: 166; Marie Appert/Shutterstock.com: 381; Photo Mark Maas: 380; Photo Mark Pickthal: 236; Markus Linnenbrink: 314-15; Artist Mary Ellen Croteau. Photo Stephanie Dean: 250-1; Masatoshi Okauchi/Rex Features: 141; © Matt Cohen/ZUMA Press/Corbis: 391; Maximo Riera: 145; MAXPPP - agence de presse photo: 132; Photo Maxwell Holden: 222; ME contemporary: 214; meaothai/Shutterstock.com: 40-1; Photo Michael Allen Smith, taken at Dubsea Coffee (Seattle, WA) 12/17/2009: 168; Photo Michiel de Boer: 124; Mickie Wood: 101; Molly B. Right: 233; Molly Crabapple: 208; © Moviestore collection Ltd/Alamy: 284; Artist MSLK. Photo credit: Sheri L Koetting: 262; Nada Sehnaoui: 216; NASA; ESA; G. Illingworth, D. Magee, and P. Oesch, University of California, Santa Cruz R. Bouwens, Leiden University; and the HUDF09 Team: 453; Natalia Bratslavsky/Shutterstock.com: 70-1; Photo Natalie Hegert: 292; Néle Azevedo: 343; © Niels Quist/Alamy: 349; Nikolaj Arndt: 156-7; © Nick Cobbing/Greenpeace: 445; O'o Murbiyanto: 206-7; © Oliver Benn/Alamy: 413; Okamoto Studio: 326, 335; P183/Rex Features: 342; Patrick Acton: 433; Patrick Boothman: 77; © Paul Gibson/Alamy: 441; Pavel Antonov: 372, 373; Percy Salazar Diaz and Clemente Gava - Eskimo Ice (London) LLP: 341; Artist Peter Donnelly. Photo Steve Taylor Photography: 360-1; © Peter Foley/epa/Corbis: 189; Photo Peter Hinson: 364-5; Pico De Gallo by Harrod Blank (1998). Photo Hunter Mann: 65; Pierre-Jean Durieu/Shutterstock.com: 406-7; pjhpix/Shutterstock.com: 378; Ppl: 346-7; Randy Finch www.iceguru.com: 328; Ray Mock: 260; Artist Rebecca Caldwell. Photo Harrod Blank: 61; Recycleart.ch: 256; Photo Reney Warrington: 264-5; © Reuters/Corbis: 389; Rex Features: 86, 94, 98, 100, 106, 137, 419, 425, 429; Richard Austin/Rex Features: 125; Richard Gardner/Rex Features: 422; Richard Nowitz/Getty Images: 330; Robb Havassy, Havassy Art: 72-3; Robert Burkat, Ice Team: 340; © Robert Janson 2011: 252-3; Robert Lenkiewicz/The Lenkiewicz Foundation: 112; Romakoma: 408-9; Artist Russ Foxx russfoxx.com, Vancouver, BC, Canada. Model: Scarlet D'Arc: 89; Ryan Alexiev and Hank Willis Thomas: 175; Photo Ryoichi Keroppy Maeda: 88; Sam Barcroft/Rex Features: 241; Sandra Hartness: 133; © Sandra Nykerk/Alamy: 390; Sara Watson: 62; © Sarina Brewer: 138; Photo Scala, Florence: 8; Schadeburg/Rex Features: 169; Scott Aiken/Rex Features: 352; Scott Bibus, DeadAnimalArt: 139; Scott Gundersen: 432; Sean Avery: 272; Artist Sebastian Horsley. Photo © Dennis Morris - all rights reserved: 108; Sinopix/Rex Features: 218; Solent News & Photo Agency/Rex Features: 426; Solent News/Rex Features: 243; Photo Sophia Kleinsasser: 22-3; spirit of america/Shuttertock.com: 290; © SprinkleBrigade: 223; © Stan Rohrer/Alamy: 279; Artist Stelarc. Photo Keisuke Oki: 110-11; Artist Stelarc. Photo Nina Sellars: 85; Stephanie Kilgast/Rex Features: 188; StephanScherhag/Shutterstock.com: 286-7; Steven Kutcher: 121, 122-3; © STR/epa/Corbis: 358, 359; The Suzanne Geiss Company, New York. © The Estate of Carmela Zagari Rammellzee: 239; Suzanne Noll: 150; Szoty scy Zaleski: 294; Photo T. Karson: 136; TAWUTSN99/Shutterstock.com: 179; Ted Sabarese, 2009: 186; Tess Peni/Rex Features: 240; The 'Thrill the World London' team: 400-01; The Elephant Art Gallery: 120; Artist The Glue Society (James Dive). Photo Derek Henderson: 192-3; Tilt: 312-13, 437; © Tim De Waele/Corbis: 383; Time & Life Pictures/Getty Images: 170-1; Times Newspapers/Rex Features: 427; Tom Deininger: 227; TonyV3112/Shutterstock.com: 336-7; Top Photo Group/Rex Features: 190; Photo Toshi Kawano: 329; Tracy Hall: 424; Trevor Moran: 76; Tristan J.M. Hummel: 57; tristan tan/Shutterstock.com: 151; Unimediaimages Inc - ADC/Rex Features: 195; Photo Urban Trash Art: 270-1; Artist Utah. Photo Ray Mock: 26; Ute Lennartz-Lembeck: 47; © Urbanmyth/Alamy: 303; Víctor Enrich Tarrés: 309; © Victor Fraile/Corbis 384; Victoria Inoue/MagSpace/Shutterstock.com: 196-7; Vincent Bousserez/Rex Features: 420-1; VisitBritain/Pawel Libera: 402-3; Vladimir Dimitroff: 51; Photo www.TeamSandtastic.com: 355; Wikipedia: 82, 103, 278, 295, 298, 306; © Wolfgang Kumm/epa/Corbis: 374, 375; www.jackdawsart.com. Photo Richard Nicol: 174; © Yan Ting/Xinhua Press/Corbis: 354; © Yang Lei j/Xinhua Press/Corbis: 382; YaYa Chou/Rex Features: 178; Yong Ho Ji: 144; Yuki Kawamoto: 209; © ZEVS2006: 31; © ZUMA Press, Inc./Alamy: 210; ZUMA/Rex Features: 356-7; Zzvet/Shutterstock.com: 102.

FRONT COVER IMAGES
(Clockwise from top left)
Getty Images; Artist: Emily Duffy. Photo: Harrod Blank; Artist: Utah. Photo: Ray Mock; Artist: The Glue Society (James Dive). Photo: Derek Henderson; MAXPPP - agence de presse photo.

BACK COVER AND SPINE IMAGES
(Clockwise from top left)
© Reuters/CORBIS; Ted Sabarese, 2009; Trevor Moran; Brad Downey; KeystoneUSA-ZUMA/Rex Features; © Gleb Garanich/Reuters/Corbis; Jason Mecier.

BACK COVER QUOTE
Barry Schwabsky, 'Signs of Protest', The Nation, 2 January 2012.

ACKNOWLEDGEMENTS

We thank our assistants: Natalie Hegert,
Darren Jones, Kristen Studioso and
Sarah Young.

We also thank Cathleen Chaffee for introducing
us; Nataliya Chorny, Marianne Novy and Adele
Tutter for aiding the authors; and Lynn
Berger, Illana Hester, Catherine Krudy,
Samantha Bard and Martha Kirszenbaum for
contributing to the project in multiple ways.
The Studio School, through Graham Nixon, has
provided an institutional foil for discussing
ideas that formed the core argument of this
book by inviting us to test our hypotheses
through public lectures. Likewise, Ivan
Gaskell invited us to participate in his
CAA panel in February 2011. David Carrier
thanks the hosts of his various lectures
on themes developed through this book:
'Kant and Modernism', Albritten Lecture,
Baylor University, 9 April 2010; 'Painting
and the Photograph Within and Outside the
Art World System', Columbus Museum of Art,
16 April 2011; the Fourth Guangzhou Triennial
Exhibition, 22 September 2011; the Columbia
University Art Studio Department, 18 October
2011; the Art Department, University of
Toronto, 6 November 2012; and the Art
Department, University of Kentucky, March
2013. Joachim Pissarro presented a portion of
this book at Case Western Reserve, Cleveland,
in 2010, and invited David Carrier to present
the content of this book within his graduate
seminar on 'Aesthetics and Art Theory' at
Hunter College/CUNY in 2011. Philippe de
Montebello generously critiqued and commented
on parts of our manuscript. *Artforum* published
our review 'Painter of Lite (Thomas Kinkade:
The Artist in the Mall)', *Artforum* (April
2011): 76. More recently, our essay 'How
Modernism Revolutionized Taste But Left the
Art World Prone to the Judgments of the Few'
appeared in *The Art Newspaper* 239 (October
2012): 21.

At Phaidon we benefitted from the generous
editorial support of Amanda Renshaw, whose
initial enthusiasm for this book and its
concept has meant the world to us. Throughout
the various phases of the editorial and
production process of this book Jenny Lawson,
Rebecca Price, Sarah Bell and Abbie Coppard
have been a delight to work with.

THIS BOOK IS DEDICATED TO TZVETAN TODOROV,
IN DEEPLY RESPECTFUL HOMAGE, AND TO THE MEMORY
OF PAUL JOSEFOWITZ.

Phaidon Press Limited
Regent's Wharf
All Saints Street
London N1 9PA

Phaidon Press Inc.
180 Varick Street
New York, NY 10014

www.phaidon.com

First published 2013
© 2013 Phaidon Press Limited

ISBN 978 0 7148 6567 6

A CIP catalogue record for
this book is available from
the British Library.

Designed by HORT

Printed in China